Edmund Morris

Frontier Artist

by Jean S. McGill

Edmund Morris: Witness

Edmund Morris, witness,
New Brunswick House,
July 25, 1906,
interrupts his painting
of Alex Peeketay, headman,
to sign the document whose calligraphy
he observed: the spectacular script
of the King's printer against the careful
syllabics of the chief's signature. He executes
the pen like lightning banging
the highest point on the horizon

– Excerpted, with permission, from John Flood's *The Land They Occupied* (Erin, Ont.: Porcupine's Quill, 1976), p. 35.

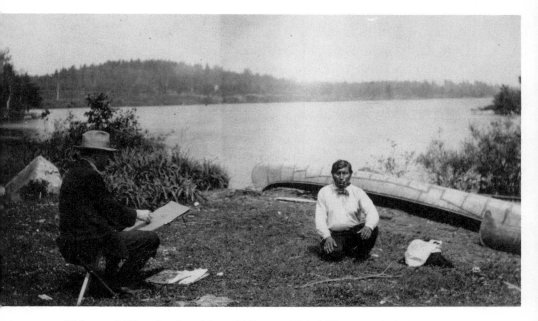

Edmund Morris sketching Ojibway Chief Cheesequinini at Chapleau, Ontario, Treaty 9 Expedition to James Bay Territory, 1906.
Public Archives of Canada, Ottawa (PA-59587)

Contents

List of Illustrations and Photographs

Foreword

Edmund Morris first came to my attention when I was doing research for *A Pioneer History of the County of Lanark* in the 1960s. In investigating his family's history in the Queen's University archives, I came across Morris's first and second diaries, written in his largely illegible script.

Some years later, I saw several of his Indian portraits in an Indian cultural display. It was noticeable even in this small representation of his work that each portrait depicted distinctive structural differences, a quality which sets his work apart from stylized versions of the North American Indian by, for instance, Paul Kane. Subsequently, at an exhibition of Kane's work at the Royal Ontario Museum, I noted that many of the Indian artifacts displayed with the paintings bore the label, "The Edmund Morris Collection." Contacting the Museum, I learned that the R.O.M. did, indeed, own a large collection of Indian artifacts once belonging to Edmund Morris, and also a collection of sixty Indian portraits originally painted by him for the Ontario government. This collection represented the western Plains Indian tribes, as well as several Ontario tribes – a representation of the pure-blood native peoples no longer available to an artist.

I went again to Queen's archives and attacked the illegible script of Morris's first diaries. (His handwriting improved somewhat in later years, but was always a problem to his correspondents.) Through the correspondence, diaries and other records, Edmund Morris emerged as a sensitive young man and a serious champion of causes. He also appeared to possess a deeply religious nature which, had his family been Roman Catholic rather than Presbyterian, might have led him into the priesthood. There was only a suggestion, in the material available, of the lighter side of his personality shown to family and

9

friends – an aspect that can only be hinted at in this biography. It is not known whether the sheltered and comfortable life he led as youngest of a large family (only four of whose members married) kept him a bachelor. It was apparent, however, that the gradual dwindling of that family had a devastating effect on him. The opinion of senior artists seemed to have had a strong influence, and affected his personal satisfaction with his painting. Unlike many artists, he appeared to have a'good business sense, although he obviously did not have to rely on the sale of his work for subsistence.

Morris spent a considerable amount of his time in espousing worthy causes and was involved in several of a cultural nature at the time of his unfortunate death at age forty-two.

Paul Kane and George Catlin have long since been lauded for their paintings of the North American Indian; Edmund Morris's pictorial record of the Indian has remained in obscurity. It is hoped that this short biography, illustrated by a small selection of his work, will help to awaken public interest and give Morris his deserved place among Canadian artists.

The author was assisted in her research by many individuals and organizations, and wishes to express her appreciation for information and courtesies extended by the following individuals: Fern Bayer, Lois Buckley, Marjorie Cochrane, R.G. Forbis, Mary FitzGibbon, James Christie, Helen Kilgour, Morris Lambe, Dorothy Morris, J.D. Morris, L.R. MacTavish, Q.C., Dr John Newton MacTavish, Mrs D. McLeod, Ross A. Morris, William M. Morris, Dr E. S. Rogers, G.D. Tibbits, and Marion Stewart.

Acknowledgements and appreciation are owed to John Bovey, former Archivist of the Provincial Archives of Manitoba; Alberta Provincial Museum, Edmonton; the Arts and Letters Club, Toronto; the Government of Ontario Art Collection, Queen's Park, Toronto; the Canadiana Collection of the Glenbow Museum, Calgary; the Department of Indian Affairs and Northern Development, Ottawa; the Manitoba Club, Winnipeg; the Metropolitan Toronto Library; le Musée des Beaux-Arts de Montréal; the National Gallery of Canada, Ottawa; the

10

Norman Mackenzie Art Gallery, Regina; the Ojibway and Cree Resource Centre, Timmins, the Archives of Ontario, Toronto; the Art Gallery of Ontario, Toronto; the E.P. Taylor Reference Library, Art Gallery of Ontario; the Peabody Museum of Archaeology and Ethnology, Cambridge, Mass.; Queen's University Archives, Kingston; Canadian Collection and Ethnology Department, Royal Ontario Museum; Saskatchewan Archives Board; Thomas Fisher Rare Book Library, University of Toronto Library; City of Toronto Archives; Toronto Historical Board; Toronto Public Library; Office of the Mayor, Town of Morris, Manitoba; Office of the Mayor, Town of Fort Qu'Appelle, Saskatchewan; and l'Universite de Montreal.

Special thanks, finally, are due to Michael Parke-Taylor and Geoffrey Simmons, joint authors of *Edmund Morris "Kyaiyii: 1871-1913*, the catalogue of the retrospective exhibition mounted by the Norman Mackenzie Art Gallery, University of Regina, in 1984, for generously supplying information and for granting permission to quote from their critiques of Morris.

Jean McGill
Toronto

Editorial Note

All unfootnoted quotations in Chapters One and Three are from Morris's unpublished holograph *Diary*, 1886-1904, in the Library of Queen's University, Kingston, Ontario. All unfootnoted quotations in Chapter Four are from Morris's unpublished holograph *Diary* of 1906, in the Library of Queen's University, Kingston. All unfootnoted quotations in Chapter Six are from *The Western Diary of Edmund Morris*, the manuscript of which is in the Ethnology Department of the Royal Ontario Museum, Toronto.

11

Alexander Morris, c. 1871
Public Archives of Canada, Ottawa (C-7104)

A Genealogical Introduction

The Morris family was of Welsh origin, settling in Kilmarnock, Ayrshire, Scotland, in the seventeenth century. William Morris was treasurer of the Burgh of Kilmarnock in the late 1700s. In 1801 his grandson, Alexander Morris, a merchant whose ships traded between the port of Glasgow and Montreal, brought his family from Ayrshire to Canada, settling first in Montreal and later in Elizabethtown (now Brockville). He had three sons: James, William, and Alexander. William served as an ensign in the War of 1812-14, then in 1816 went with other disbanded soldiers to settle north of the Rideau River, in what was known as the "District of Bathurst."[1]

Between 1816 and 1819, surveys were carried out in this wilderness territory by the government, and families of disbanded British soldiers as well as civilians flocked to this part of Upper Canada, most of them emigrating from Scotland.

William Morris opened the first general store in the first village of Perth. With his brother, Alexander, he formed a partnership in mercantile trade, his brother opening a store in Elizabethtown. Later, James joined Alexander in the Elizabethtown operation.

In 1820 the first election was held for the new constituency and William Morris was elected and took his seat in the Legislative Assembly of Upper Canada legislature at York as the first Member of Parliament for the District of Bathurst. On a visit to Scotland in 1823, he married Elizabeth Cochran, daughter of a kinsman, John Cochran, of Kirkcudbright, Renfrewshire.

He became the champion of the Scottish population in Upper Canada and led protests in the Upper Canada legislature, calling for the cessation of discrimination against the Church of Scotland. This eventually led to concessions for Presbyterians. William Morris was also

13

one of the prime movers in establishing a college for Presbyterian divinity students: Queen's College, Kingston, which later became Queen's University.

John Ross Robertson, in his *Landmarks of Toronto*, relates a story of how Old St Andrews Church came into being in the Town of York through the efforts of William Morris. The Parliament Buildings, situated at the southwest corner of Church and Adelaide, had burned down in 1824. One Sunday morning in 1830 Morris was hurrying along to the Anglican church and passed the ruins. It occurred to him that the foundation might be used to build a church for Presbyterians. As he entered the church late, the Episcopal clerk was reading the 132nd Psalm: "I will not go into my house, Nor to my bed ascend: No soft repose shall close my eyes nor sleep my eyelids bend, Till for the Lord's destined abode, I mark the destined ground, Till I a decent place of rest for Jacob's God have found." Morris took the reading to heart and next day called together some prominent Presbyterians. "The list" writes Robertson, "bears the names of some of the most prominent men of the time, among them men of the 71st and 78th Highlanders and regiments then stationed at York."[2]

In 1836 William Morris was called to the Legislative Council of Upper Canada where, in 1838, "he protested singly and alone against the adopting of the Report of the House on the state of the provinces because it failed to countenance the most important measure, namely, the Union of Upper and Lower Canada."[3] However, in 1841 the Union took place. Morris was appointed Warden of the District of Johnstown, and in 1843 moved with his family from Perth to Brockville and then to Montreal, which became the new seat of government in 1845. He was appointed Member of the Executive Council and Receiver General of Canada in 1844. While he was in office he induced John A Macdonald to join the Ministry, and it was then that this famous statesman entered upon his public career.[4]

William Morris was offered a knighthood but declined, declaring such honours unsuitable for Canada. He died in 1858.

His son, Alexander, born in 1826 in Perth, attended schools and university in Scotland, and later articled in

John A Macdonald's office in Kingston, where he began his long association with politics and government in Canada. After attending McGill University, of which he was the first graduate in Arts, Morris established a legal practice in Montreal in 1851. In the same year he married Margaret Cline, daughter of William Cline, of Cornwall. Ten years later he was asked by his father's old constituency of South Lanark to represent that riding in Parliament. The family then moved to Perth, where Alexander entered a law practice with Judge Deacon.

Alexander Morris was one of the first advocates of union of all the provinces and worked behind the scenes for eventual confederation. His *Nova Britannia*, which appeared in pamphlet form in 1858, dealt with the advantages he saw to confederation. A comment in the press at the time reported, "Mr Morris sees in the future a fusion of races, a union of all existing provinces to grow up in the west, and a railway to the Pacific." Morris played an important role in the coalition of George Brown and John A Macdonald in 1864, which broke the deadlock preceding confederation. It is interesting to note the end of Morris's speech during the confederation Debate in Parliament in 1865. After discussing the economic necessity of developing the land west of the Ontario border, Morris stated: "If Canadians are to stand still and allow American energy and enterprise to press on as it is doing toward that country, the inevitable result must be that that great section of territory will be taken possession of by the citizens of the neighbouring state."

From 1869 to 1872 he served as Minister of Internal Revenue in the Macdonald administration, and in 1872 was appointed first Chief Justice of Manitoba. Six months later he became the second Lieutenant-Governor of Manitoba, where he was saddled with the difficult task of negotiating treaties with the Indian tribes of Manitoba and the Western Plains.

Colour Illustrations

The following colour illustrations have been selected to indicate the diversity of style and subject in the work of Edmund Morris. The author and publisher are grateful to the following institutions for permission to reproduce these pictures in their respective collections:

Front cover:
Indian Teepees n.d.
Oil on canvas, 10.8 cm × 15.2 cm. ($4^{1}/_{4}"$ × 6")
Provincial Archives of Manitoba, Winnipeg

Back cover:
High Eagle (Pitauspitau) 1909
Government of Alberta

Plates:

Page 17 **Landscape,** *Quebec* n.d.
Collection of John Newton MacTavish, M.D.

Page 18 **Chief Moonias** 1905
Glenbow Museum, Calgary

Page 19 **Chief Running Rabbit** 1907
Royal Ontario Museum, Toronto

Page 20 **Bad Boy** 1907
Glenbow Museum, Calgary

Page 21 **High Eagle** *(Pitauspitau)* 1909
Government of Alberta, Edmonton

Page 22 **Chief Star Blanket** *(Achchukakopetokopit)* 1910
Norman Mackenzie Art Gallery, Regina

Page 23 **Acoose** *(Man Standing Above Ground)* 1910
Saskatchewan Government Art Collection, Regina

Page 24 **Pimotat** *(The Walker)* 1910
Saskatchewan Government Art Collection, Regina

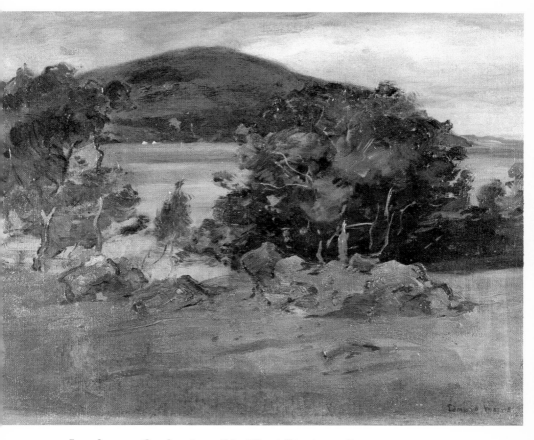

Landscape, Quebec (possibly Mont Ste-Anne from
Ile d'Orléans), n.d.
Oil on canvas, 35 × 45 cm. (14 × 18 ins.)

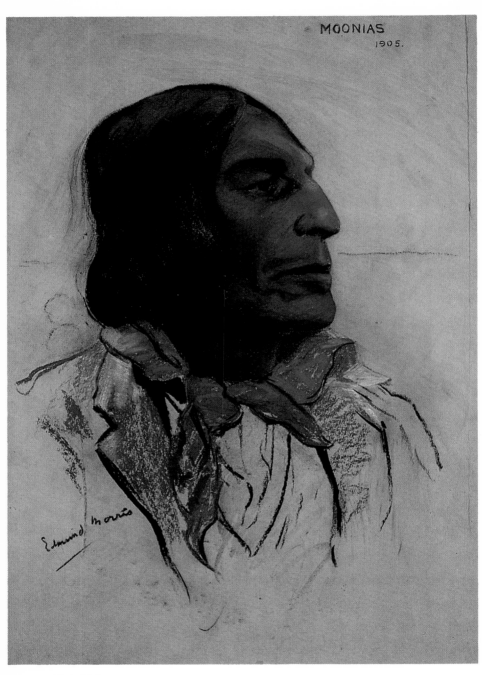

Chief Moonias 1905
Pastel on paper, 59.6 × 41.9 cm. (23½ × 16½ ins.)

18

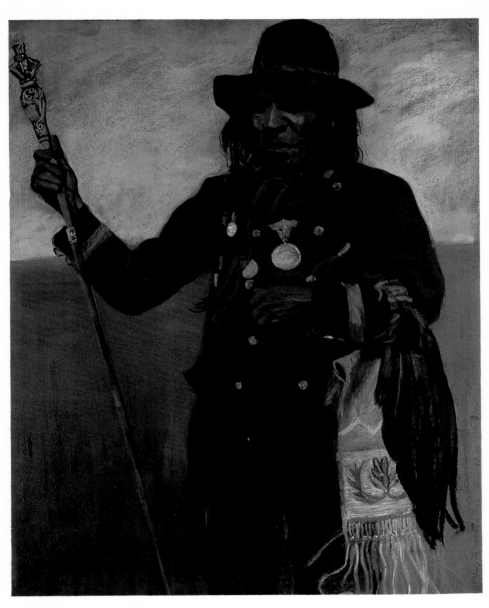

Chief Running Rabbit 1907
Pastel on paper, 63 × 51 cm. (24⁵/₈ × 20 ins.)

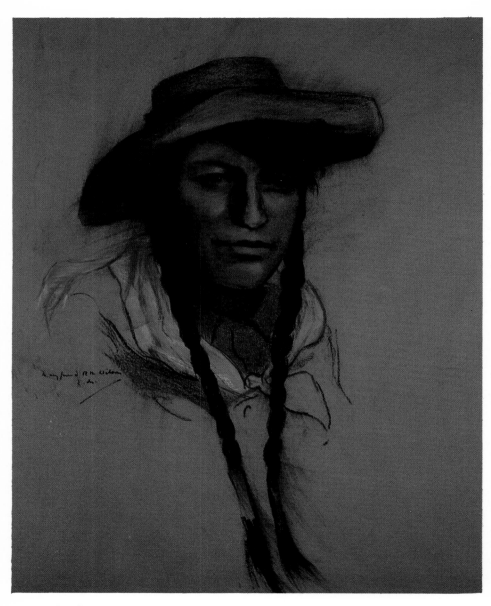

Bad Boy 1907
Pastel on paper, 60 × 50.8 cm. (24 × 20 ins.)
Inscription: *"To my friend, R. N. Wilson/E.M."*

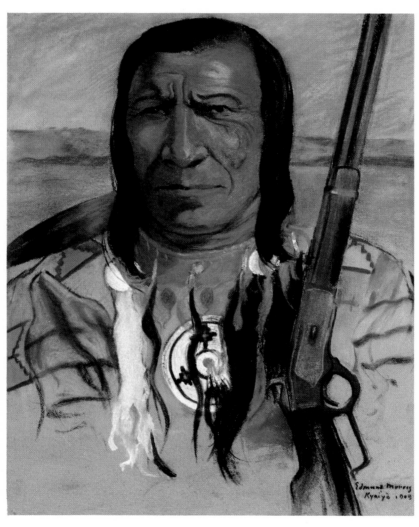

High Eagle (Pitauspitau) 1909
Pastel on paper, 64.0 × 49.8 cm. (25³/₄ × 19⁵/₈ ins.)

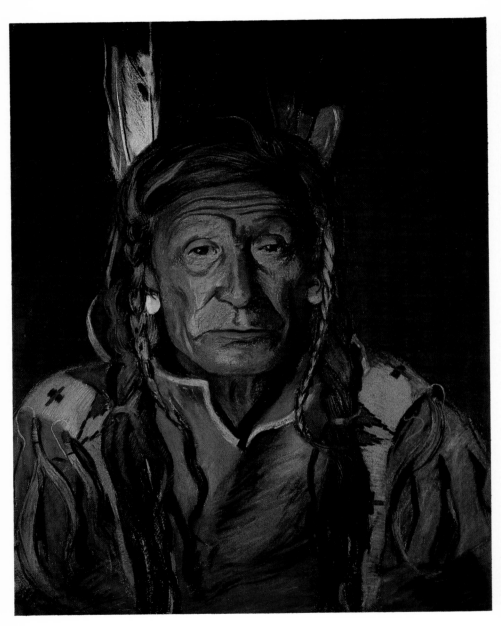

Chief Star Blanket (Ahchukakopetokopit) 1910
Pastel on paper, 63.8 × 50.0 cm. (25¹/₈ × 19¹¹/₁₆ ins.)

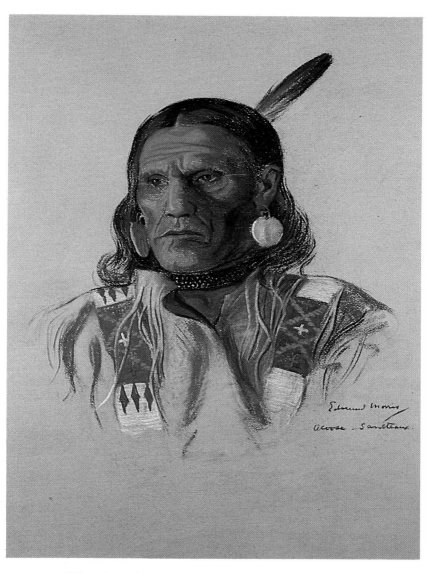

Acoose (Man Standing Above Ground) 1910
Pastel on paper, 63.9 × 50.1 cm. (25³/₁₆ × 19³/₄ ins.)

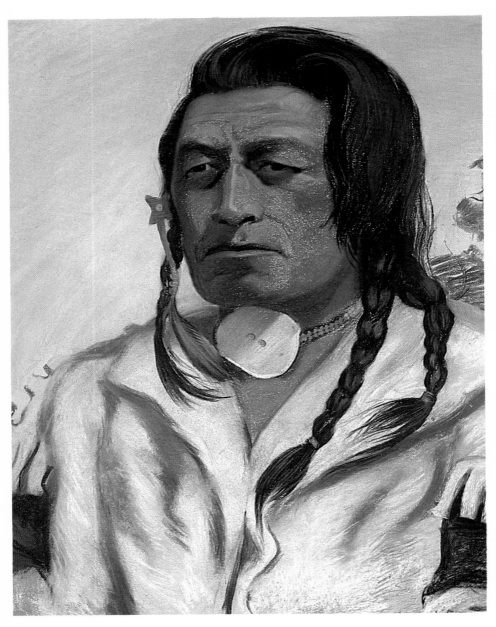

Pimotat (The Walker) 1910
Pastel on paper, 63.9 × 50.1 cm. (25³/₁₆ × 19³/₄ ins.)

Chapter One

The Early Years

Edmund Montague Morris was born at Perth, Ontario on 18 October 1871, the sixth son and youngest child of the Hon. Alexander Morris and his wife, Margaret Cline. It was a large family, including eleven children, one of whom had already died in infancy and another at the age of five. When Edmund arrived on the scene, all the children were still living at home. In July of the next year, Alexander Morris was appointed Chief Justice of the Queen's Bench of Manitoba, and soon afterward replaced A.G. Archibald as Lieutenant-Governor of Manitoba, the Northwest Territories and Kee-wa-tin. The Morris family's official residence at Fort Garry was Government House.

Alexander's brother, William John Morris, visited the family one winter and described the fort as a

> Large enclosure of stone walls perhaps twenty feet high, and inside the gate two brass field pieces facing it. Further back was Government House, a large 2-storey building of solid oak logs, clapboarded and painted white. This was the residence of the Lieutenant-Governor and not very long before had been the headquarters of the rebel chief, Louis Riel. Behind the main building were a number of smaller buildings used as servant quarters which in former times had been store houses for the Hudson's Bay Company where the Chief Factor had resided.
> Prairie stretched between the fort and the nearest building, the Hudson's Bay Company's new store. Other buildings including the Legislative offices solidly built of oak logs, made up the then village, on both sides of the Main Street which seemed to be about 150 feet in width A number of cottage residences had been erected on the bank of the Assiniboine which here joins the Red River. I was much

interested in my stroll over this prairie village des-
tined in a few years to be a great city.[1]

William Morris, in his narrative, mentions his as-
tonishment at the pioneer state of the province. For in-
stance, an old friend he encountered was preparing to go
on a trading expedition to Edmonton, 1,900 miles distant,
with a dozen Red River carts — "that peculiar vehicle
made entirely of wood with great high wheels tired by
rawhide," he related. "With grease never applied to the
axle, the screams and groans of them were easily heard
a couple of miles away."

Alexander Morris asked him if he would act as leader
of a small party to visit Indians north and east of Win-
nipeg in the Brokenhead River area, warning them to
avoid an Icelandic settlement then stricken with small-
pox. The party were also to intercept some American
whisky smugglers then reported to be on their way to the
district. William willingly accepted, and had a number
of adventures in carrying out the duties assigned.

In addition to his other responsibilities, Alexander
Morris was then engaged as one of the special government
commissioners to negotiate treaties with the Indian tribes
of the Western plains. This necessitated travelling over
thousands of miles from the Lake of the Woods on the
east to the Rocky Mountains on the west. Often his party
would arrive at a camp to find a number of the Chiefs off
on a hunting or other expedition; often many days were
spent at one camp while the Chiefs or Head Men delib-
erated upon the conditions of the treaty. Christena and
Elizabeth Morris were witnesses to the signing of Treaty
No. 3 (The Northwest Angle Treaty), convened at the
Lake of the Woods in October 1873, and the Lake Win-
nipeg Treaty (No. 5), convened at Norway House in Oc-
tober 1875.

At the signing of the Qu'Appelle Treaty (Treaty No.
4) the Cree Indians gave the twin Morris sisters Indian
names, Eva being called *Tabis Roo Amikook* (Equal to
the Earth), and Madge, *Tabis Roo Kijick* (Equal to the
Sky). The Cree named Alexander Morris *Kitchiokismow*
(The Great Chief).

At Government House, the Lieutenant-Governor entertained a steady stream of official and unofficial visitors. The busy, varied life of the frontier town and the colourfully-garbed Royal Mounted Police and Indians undoubtedly made a lasting impression on the young Edmund Morris, drawing him back to the west as an adult when opportunity beckoned. Memorable too, were the gifts, ranging from necklaces to peace-pipes, which the Indians brought the Lieutenant-Governor and Mrs Morris.

Government House became a repository for a considerable collection of Indian artifacts. Lieutenant-Governor Morris received two war coats during his term of office. One, from the Chief of the Plains Crees, Sweet Grass, given to him at Fort Pitt in 1876, was decorated with bead-work and ermine. Another, made of deerskin decorated with beadwork was presented to him by Yellow Quill, Chief of the Saulteaux, at Round Plain on the Assiniboine, in 1876. Mrs Morris was recipient of a buckskin dress decorated with porcupine quill, a gift of the Sioux. No doubt Indian moccasins were brought by visiting Chiefs for the Morris children. When Alexander Morris returned to eastern Canada in 1878, he took with him a sizable collection of gifts from the Western Indians.[2]

While serving as Lieutenant-Governor, Morris and his commissioners completed the negotiation and signing of Treaties Nos. 3, 4, 5, and 6, and revision of Treaties 1 and 2. He appears never to have been very robust, and the strain of performing the duties of Chief Justice and Lieutenant-Governor of a frontier territory took its toll on his general health. As early as 1873 he was urging the Ottawa government to provide the west with a "respectable [police] force" to maintain law-and-order, for outbreaks of hostility between the Indians and American traders were occurring regularly. The surveys then taking place were another cause of dissension.

In addition, during his term of office Morris had to contend with a smallpox epidemic. Despite repeated requests to Ottawa for vaccines and medical help, little response from the Prime Minister, the Hon. Alexander Mackenzie, was forthcoming. The experience of having his advice and frequent entreaties to Ottawa fall on deaf

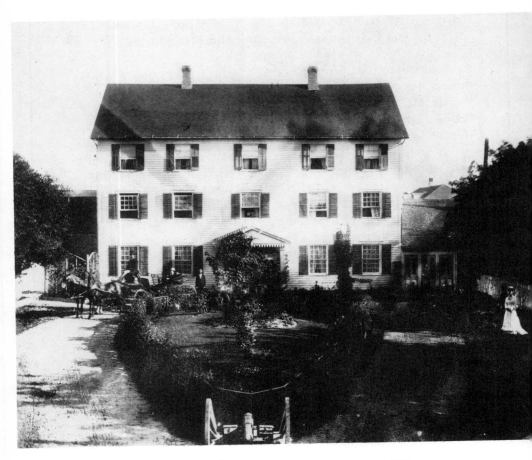

Government House at Fort Garry, Manitoba, c. 1876:
Edmund Morris's early home
Provincial Archives of Manitoba, Winnipeg

or unsympathetic ears doubtless contributed to the ill-health which brought Morris back to Perth in eastern Canada in 1878. Later, he was persuaded to enter the political arena in Ontario, and defeated the Hon. Oliver Mowat in the riding of East Toronto. He held this seat until his retirement in 1886.

Edmund was nine years old when the Morris family moved to Toronto in 1880. They first lived at 412 Parliament Street (where the Winchester Hotel now stands), next door to the residence of Byron (later Sir) Edmund Walker, president of the Canadian Imperial Bank of Commerce. In 1884 Alexander Morris purchased a two-and-a-half-storey house at 401 (later changed to 471) Jarvis Street, between Wellesley and Carlton Streets.[3]

Jarvis was then one of Toronto's most fashionable residential streets. Next door and south of the Morrises lived the Hon. Edward Blake, a distinguished politician who had succeeded John Sandfield Macdonald as premier of Ontario in 1872 and later represented West Durham in the federal government. Neighbors north on the same side of Jarvis Street included Frederick W. Jarvis, Sheriff, and, beyond Wellesley Street, the Hart Massey and Chester Massey residences. Dr George S. Ryerson, physician and author, lived further along on Jarvis, and Charles Moss, later Chief Justice, dwelt on the east side of Jarvis just south of Isabella Street, at number 475.

The first break in the close-knit family occurred in 1881, with the death of Emily, who was only fifteen years of age; Edmund was ten at the time.

In 1886 Alexander Morris retired from politics due to ill-health. That year, Edmund, fifteen years of age and attending Jarvis Collegiate, began to keep a diary.[4] His first entry reads: "Spent the summer camping on Wanishing Island in Lake Joseph, Muskoka, having them all to myself – Mother and Father A memorable sail with Aunt Agnes." The entry for 10 August relates that "Father slept under canvas on the island. It makes him think of the times when he and old Dobbs used to go shooting on the prairies. Lots of canoeing, boating, sailing. I learn to swim this summer."

Next summer his father bought Wegausind Island, about two miles from Wanishing Island, in Lake Joseph,

and spent considerable time there under doctor's care. Edmund writes in his diary of big storms blowing down from Georgian Bay: "One can hear them afar off and when they strike the islands, play great havoc. I remember this year that twelve big pines were uprooted and twisted in two and we thought the house would be blown down."

The diary, which he seems to have kept only during summer months, also describes their house on Wegausind Island: "A long walk leads up to it amongst rocks and waving pine. It has a broad veranda on three sides and one above. A party of us go to Lake Kapuskasking. Stop at a big lumber shanty. The men are not of the best sort." Of Muskoka, he claimed that the air was "perfect."

His interest in art first announces itself in the 1888 diary:

> At this time I was unsettled [age 17] and did not know exactly what I wanted although I had often thought of going right in for art. It was thought better that I should try architecture and my father wrote Frank Darling [1850-1923], an old friend of the family. It was settled that I should enter his office for a time and follow up with a course at Cornell University or the School of Technology, Boston.[5]

On 2 January 1889, Edmund entered the offices of Darling and Curry, located in the old Imperial Building on King Street. Their major project at the time was the construction of the Toronto Club. Edmund's hours were from 9:30 to 5:30, but, as he commented in his diary, "I still keep up my painting though."

His father, then only sixty-three years of age, was failing in health, and in April went to Atlantic City with Christena, thinking the sea air would help but rain and high winds drove them to New York. In June, feeling better, Alexander Morris journeyed with Christena and Edmund to Sault Ste Marie, where Edmund noted in his diary, "Father has a great deal of land We go by CPR to Owen Sound and from there by steamer, Alberta, a Clyde-built ship, 270 feet A lot of Finns on board going to settle in the States." He did not elaborate on this journey, but returned to the main concern of his life at

30

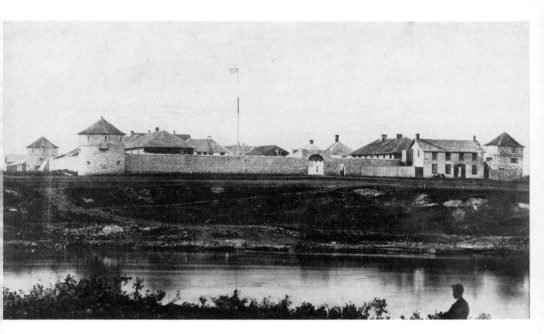

Fort Garry, Manitoba, c. 1878
Provincial Archives of Manitoba, Winnipeg

this time: "Architecture is incongenial to me. Lengthy calculations are not in my line. I always disliked figures. After six months I abandon the idea of going in for it."

A prophetic occurence took place that summer. Out sailing on Lake Joseph that summer, Edmund and his brother Robert capsized in a storm and narrowly escaped drowning. News of the accident reached their uncle, John L. Morris, in Montreal, who wrote to his brother, Alexander, "This should be a lesson to them in future to leave sail boats alone. They ought to consider the feelings of other people I hope the fresh air you got in Muskoka will tell and that you will soon be as strong as ever again. You must try to rouse yourself and eat well and take exercise. As all the doctors say, there is nothing organically wrong with you."[6]

However, late in September, while still at their cottage, the recurring malaria suddenly hit Alexander Morris in the middle of the night. Christena and Edmund being the only members of the family present, Edmund set out to row to the head of the lake for a doctor. When he reached his destination, he could still only contact the doctor by wiring Parry Sound. Fortunately, a Mr Fraser loaned his steam launch for the return journey to the island and the following day they were able to bring Alexander home to Toronto, too weak to walk.

His health continued to deteriorate and on 28 October 1889 he died.

One newspaper reported a poignant scene:

Enclosed in a plain casket covered with a black cloth, the body of the late Hon. Alexander Morris lay in a darkened room of the family residence on Jarvis Street today. Outside the rain fell softly from leaden clouds, fitting accompaniment for the sorrow within . . . At 3 o'clock the remains were taken to Old St Andrews Church, corner Jarvis and Carlton Streets. Rev. G.M. Milligan conducted the service. Pallbearers – four sons; Robert Morris, William, Alex, and Edmund; his brother, John L., Q.C., and Mr. Malloch. Followed by a long line of carriages containing hundreds of prominent citizens the remains was borne to Mount Pleasant cemetery where the body of one who had served his country well was laid to rest.[7]

Another newspaper, outlining Alexander's career, commented, "He felt it better to be useful than famous and took quiet satisfaction in having negotiated difficult treaties with Indians."

Present among the mourners at the funeral was a Manitoban Cree chief named *Iandwa-wa* (Thunderbolt). A cousin of Alexander Morris's wrote to Edmund's brother, William, on 26 November 1889, relating the incident. This letter was later passed on to the artist when he was engaged in painting portraits of the Western plains Indians. It read as follows:

> In 1889 when at your late father's funeral, I saw this Indian Chief at your house. His appearance was striking. Tall, lithe, active as a man of 50 although I was told afterwards he was 90. He told me he was in Toronto in connection with a deputation to the government. I noticed him approach the coffin and his gaze was fixed on the face of your father with a blessedness of expression on his face.[8]

Later, the Chief called at the cousin's house in Toronto, and through an interpreter related that he felt his presence in Toronto at the time was not by chance but part of the plan of the Great Manitou (Spirit) that the Great Chief, Governor Morris, who had done so much for the red men in his country (the far west) should be followed to his grave by some of them. The letter continues:

> *Ian-dwa-wa* is the Chief who at the outbreak of the first Red River Rebellion refused to join the insurgents and stood firm in his allegiance to the Great Mother as the Indians called our Queen.
> The other Indians at the funeral were also prominent in their way. One was *Ma-Shuck-e-wa-we-tong* (Earthquake), the guide of Capt. Butler in his escape from Riel and who also conducted Dr Schultz when he had escaped from prison and was being pursued by Riel's forces. He also led Lord Wolseley's expedition across the plains to Fort Garry. The third Indian, James Settie, is a government school teacher on the Indian Reserve near Winnipeg and an interpreter.[9]

Edmund's grief was not expressed in his diary and bears out a comment made many years later by a friend of his, to the effect that he was "tactiturn". His diary notation reads simply: "28th October: Our father died."

The Morris family drew more closely together with the loss of the father to whom each member had so often turned for advice and wise counsel. Early in October Edmund had met Ernest Thompson, later Ernest Thompson Seton [1860-1946], who was then planning a career as a painter of animals. Morris had also sought out a leading Toronto art teacher, William Cruikshank (1848-1922). Cruikshank, a Scotsman, had studied at the Royal Scottish Academy, Edinburgh, the Royal Academy Schools, London, and the Atelier Yvon, Paris. He had become an illustrator for London newspapers, then emigrated to New York, where he was credited with having conducted drawing classes which later developed into the Art Students League.

Cruikshank came to Canada in 1871 and painted and instructed at the Ontario Central Schools of Art for twenty-five years. He was noted for his strong individualism and rugged philosophy laced with salty wit and wisdom. Few of his paintings remain, but the Art Gallery of Ontario received from the artist a large collection of his pen and ink drawings. Of his work, one writer commented, "He has a Scotsman's love of observation and commentary." Edmund Morris's diary notation for 11 October 1889 reads, "To William Cruikshank's studio. He is an artist and excellent draftsman. He looked at my sketches."

Trying to justify his feelings for making art a career, Morris had written to his uncle, W.B. Lambe, of Montreal. Replying in November, Lambe recalled some discussions he had had with Edmund's father a quarter of a century earlier on their own professional prospects. His words of advice included:

> Never doubt you will succeed in anything you undertake on one principle . . . that is, by hard work focussed on the subject you will master. Bear in mind that the more congenial to your tasks the less irksome will be the labor and I refer to the two professions indicated by yourself – art and science. As Sir

The Alexander Morris home at 471 Jarvis St., Toronto,
c. 1885
Provincial Archives of Manitoba, Winnipeg

William Dawson says: 'There is no money in the latter and unless with rare excellence there is none in the former.' . . . Sir William Logan and Sir William Dawson are self-taught men who had a taste for science and worked to master the subject by study and observation. Should you select a scientific life I consider Prof. Wright's suggestion and advice sound — take your course in Toronto University and work as much as you like at your specialty . . . Should you select an artist's life, the same principle obtains. At Kensington, in Paris, and especially in Rome, as well as in Russia, first-class schools exist but you have those of Toronto, Ottawa and Montreal. The first being your home will suit you best. [Lucius R.] O'Brien is self-taught. So are [John A.] Fraser, [Henry] Sandham, and so was [Aaron Allan] Edson. The latter went to Paris and his originality was lost. [Frederick Charles] Ede of Toronto has gone to Paris and so have several of our Canadian young men and have turned out well . . . Life in Paris is risky as to moods and is expensive so I should advise you to work in Canada . . . If you are wise and work you will succeed. If you are lazy or a fool then don't blame me."

"Now, dear Eddie, this is the true base on which to stand and I doubt not in the future when you look back you will realize it. Money is a common sort of thing nowadays. Fame is a vapor. Knowledge is valueless unless applied to wisdom to which science is the grandest road decked with wondrous beauties of the Creator's universe. On such a path he who has a narrow competancy even would desire to travel. It is the thing most suited to develop reverence and act as the handmaiden of what is styled religion. If this be love and service to our Creator, well and good — render it and you will be happy and save yourself many vain regrets hereafter . . . I shall be glad to hear of your progress and success in life . . ."[10]

The Rev. George M Grant, Principal of Queen's University, had also been approached for an opinion as to where Edmund's real talents lay, he had sent some of the boy's sketches to Ernest Thompson in New York city. Thompson returned the sketches to Dr. Grant writing that he had not seen enough of the boy's work to judge his potential as an artist, "but this much I can say safely

– his etchings are very good. They show much promise and as the demand for that class or work is the largest and most accessible I doubt not he could command a fair living at it in any of the great art centers after taking a course in a good school."[11] Thompson recommended the French schools, where the cost of living would be relatively inexpensive compared with New York, which was about twice as expensive to live in as London or Paris.

Principal Grant forwarded the letter to Mrs Morris in Toronto, adding that perhaps it would be best for Edmund to spend a year or two in Toronto, then go to New York and later Paris; "Meanwhile he should keep up his French, especially by conversation and reading French books."

In January 1890 Morris began his art studies in William Cruikshank's studio in the Imperial Building on Adelaide Street East. At night he attended the Toronto Art Students' League for drawing practice. In April 1890 the Morris family suffered yet another loss: Edmund's brother-in-law, Andrew Malloch, husband of his sister Margaret, died at the age of thirty-three. Morris recorded little in his diary that year. In October he wrote of going to Kingston to see his brother, Bob, graduate with honours from the Royal Military College. Bob was given a commission in the Royal Artillery with a subsequent posting to a field battery in Ceylon: another break in the family.

At the end of February 1891 Edmund discontinued his night class in drawing at the Toronto Art Students' League. By June he had completed his course with Cruikshank. He spent the summer at the family cottage and in September left Toronto for New York.

A Block House, Fort York c. 1890
Graphite on paper, 17.8 × 22.9 cm. (7 × 9 ins.)
Royal Ontario Museum, Toronto

Chapter Two

New York and Paris

In New York City Edmund Morris found a comfortable, old-fashioned boarding house at No. 61 West 17th Street, not far from the Art Students' League of New York. He began to find his way around the city, exploring Central Park, the Metropolitan Museum, Trinity Church, Castle Gardens, Wall Street – all so different from Toronto. Cruikshank had given him an introduction to Charles Broughton, the illustrator and a former Canadian, and Morris looked him up. He also met John A Fraser, a noted watercolourist who until 1884 had painted in Canada.

At the Art Students' League he took an antique class under Kenyon Cox and a painting class under William Merritt Chase. Both men were masters in their line. "The League is the best art school on the continent [Benjamin] Constant says – it equals those of France", he wrote in his diary.

Though Edmund found the city full of interest, the climate was another matter. He caught frequent colds and during his years there was never very healthy. As for his social life, some old friends of his mother's were kind to him and frequently had him to their homes. He joined the Players Club at Gramercy Park, a club started by E.T. Booth to bring actors into contact with men of other professions. Booth himself lived in a flat in the same building. Morris met him and saw the portrait of him done by John Singer Sargent, and also Sargent's portrait of Thomas Jefferson, which impressed him greatly.

Writing to him in October that year, William Morris offered some brotherly advice,

> "I am glad to hear that you are getting on so well. It must be very gratifying to you that you were placed in the advanced class under such a good man. You will be alright; stick to it; moderation and

perseverence is what the world calls genius which you may well be said to have. See to it that you take lots of exercise and recreation . . . how nice everyone is to you and so kind. You will enjoy yourself after you are amongst them for awhile. It will give you a grand chance to develop your character and independence which you never could do at home. Take advantage of going out and rubbing up against people . . . You will see in after life the advantage of this as it gives a fellow a good manner of address . . . You should hear Wilkie talk to his daughter on the subject. He says one loses great advantages or opportunities in not going about . . . and he is right as it takes you out of yourself and lets you see something of the world . . . I am glad your boarding house is comfortable and meals good . . . Be sure of your home and don't get into a cheaper place as it is poor economizing . . . if you do move, go to a better place . . .[1]

Home for Christmas, Edmund found his brother William ill with typhoid fever, but this did not postpone the wedding of his sister, Eva, to James Cochrane of "Edgefield," Compton, Quebec. Edmund returned to New York on the nineteenth of January.

During the summer of 1892 he sketched in and around Toronto: Weston, on the Humber, on the Toronto Islands, and at Old Fort York, going later on to Muskoka to join the family on Wegausind Island. The first summer residence on the Toronto Islands had been built by his second cousin, barrister James Morris (eldest son of the Hon. James Morris of Brockville) in 1871.

In October he returned to New York City and his old boarding house, but found the League had moved to new quarters: a handsome white marble building at 2150 57th Street, which it shared with the galleries of the Society of American Artists and the Architectural League. Morris moved to a boarding house at 7 West 61st Street, which contained a lot of medical students and two brothers named Scudder who were going to India as missionaries. The differences in studies made for some lively discussion. He stayed in New York for Christmas 1892, spending the day with the Torrances. Mrs Torrance was a Vanderbilt and in his diary he remarked dryly, "We fared royally."

40

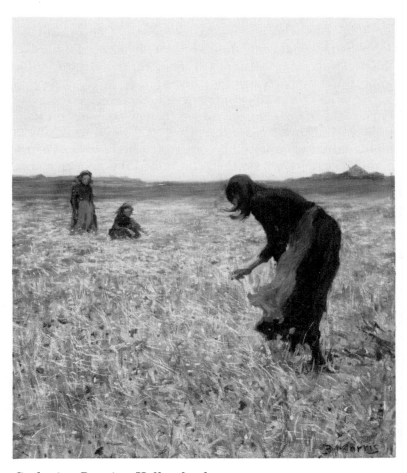

Gathering Poppies, Holland n.d.
Oil on canvas, 70.5 × 58.1 cm. (27-³/₄ × 22-⁷/₈ ins.)
Art Gallery of Ontario, Toronto

Back at school, he continued his work in life classes conducted by H Siddons Mowbray. Charles Hopkinson joined the life classes and he and Morris became friends.

By the end of his third year at the Art Students' League and after much observation of artists' work in New York, Morris concluded in his diary, "Looking at the work of men who impressed me most – George Inness, John Singer Sargent, John Fraser, Thomas Dewing. I shall never forget Manet's 'Boy with the Sword.' Also some Romney portraits that I saw."

At the end of his studies there, he prepared to go to Paris, and in October entrained for Quebec, stopping off in Montreal to see his sister, Eva, at Compton. While in Montreal, he went with his cousins to see the noted Drummond art collection. He then sailed for Liverpool, arriving on 28 October, and proceeded to London, where he did the things Canadians generally did on a first visit, visiting Westminster Abbey, Henry VII's Chapel "with the monstrous ceiling", the parks, the Royal Academy, Kensington, the old Guild Hall, Grey Friars Chapel, the National Portrait Gallery . . . "But" he confessed, "where I love to go most is the National Gallery . . . the Constables I shall never forget."[3] He also looked up his old Toronto art student friend, Alfred Boultbee, who also was heading for Paris to study art.

At the end of the week, Morris left for Paris, where he found many of his New York friends. There he began his studies at the Académie Julian under Jean-Paul Laurens and Benjamin Constant. He shared an atelier at No. 52 Avenue du Moine with Boultbee.

On 9 January 1894 Morris recorded in his diary, "I am unwell and rest up in my studio not being able to go out in the damp air. It is slow work."[4] His susceptibility to humidity, evidenced in New York, was plaguing him again. A letter from Alex in Toronto arrived in February to cheer him up:

I am glad that you are getting along so well, old fellow. From what you say, your masters must see considerable merit in your work – stick to it. You are apparently a chip off the old block and have a bulldog grip . . . take care to conserve and not impair

42

your health which is your capital in trade . . . You
inherit a good name – make the best of it . . .⁵

Elizabeth evoked nostalgia with a letter to him dated 17
March:

> This is Father's birthday and Christena went to Mount
> Pleasant cemetery with a few daffodils and daisies.
> Father was so fond of flowers . . . I suppose the flow-
> ers are beautiful in Paris now . . . Madge was so
> pleased with your letter this morning. You are a dear
> brother. We always say that when your letters come
> and there is something so *nice* about your letters.
> What a list of books! Most of them, in fact I think I
> may say all of them, we have read . . . ⁶

Morris welcomed the spring with its warmth. In April
he went to Chartres, "a place I love . . . the glorious old
cathedral, the coloured windows, the most beautiful, I
believe, in France . . . the vespers in the dimly lighted
cloisters in the evening. I made some drawings here."

Boultbee departed for Canada in May but Morris
remained. The Salon shows disappointed him; "the work
I admire most", he commented, "is not by Frenchmen but
by others: in sculpture – Henry Moore, in painting – Sar-
gent, Whistler and [Frank] Brangwyn." He had decided
to spend the summer of 1894 painting in Scotland and
left Paris in June, stopping at Amiens to see the cathedral
and spending three days there. He mentioned Dieppe as
a good place "for boating pictures. The sailors and fish-
ermen are fine subjects."⁷

A Dutch painter accompanied him to London where
he went to see the work at the Academy and later dined
with his favourite aunt and uncle, Agnes and John Mor-
ris, then on vacation. From there he went to Dartmouth,
followed by two days of sketching in York, where for the
first time he heard skylarks sing.

On to Scotland where Edinburgh enthralled him;
here he would have liked to be able to work for the entire
summer: "One gets such good contours of the Castle."
Relatives of his grandmother Cochran lived there and he
looked them up. On 9 July he went on to St Andrews –
"beautiful, quiet, grey old town by the sea" – where his

father had gone to Madras College before entering Glasgow University. He spent a week there sketching; "I am out of doors the whole time," he wrote, "generally alone."[9] His Uncle John and Aunt Agnes joined him in St Andrews on 17 July.

On 1 August Edmund left for Portobello, a suburb of Edinburgh on the Firth of Forth, and walked to Roslyn Chapel. He spent a month at Innerleithen near Peebles in the mid-Lothians, and from there went on to Paisley, where his grandfather, William, had been born. Then on to Kilmarnock, Ayr and Glasgow, the region the Morris family had lived in when his great grandfather was a Glasgow merchant. In his diary he recorded, "We have no connections of the name Morris in Scotland."[10]

"The Glasgow Art Institute is an excellent one" he noted. "I saw Whistler's portrait of Carlyle. It almost equals the one of his mother in the Luxembourg. There is a group of painters here who have become celebrated, their merit being first recognized on the continent."[11] At the end of a month he returned to London to meet "old Bob", his brother, who had suffered an eye injury in the Army and was being sent home on sick leave. Edmund commented, "Bob is more of Father's height than the other brothers. He is 6 feet – I am 5 feet 9 inches."[12]

After Bob left for Canada, Morris continued on with his tour. He walked from Kew to Richmond and out to Windsor, where he was disappointed to find that he could not see the collection of Holbein drawings without special permission.

Early in September he returned to the continent. "How light and clear Paris seems after the London fogs," his diary observes. "I begin to hunt for an atelier and fix on No. 95 rue de Vaugirard."[13] His work was examined by Gérôme and he was given letters admitting him to the Ecole des Beaux-Arts, but although he went occasionally, he seldom stayed except for criticism. He shared a model with another artist at the studio. At this time he was the only Canadian at Gérôme's, as opposed to ten American students. Morris did not like Gérôme's painting, but considered him a great sculptor. "The picture in the Luxembourg painted when he was 21 shows an absolute

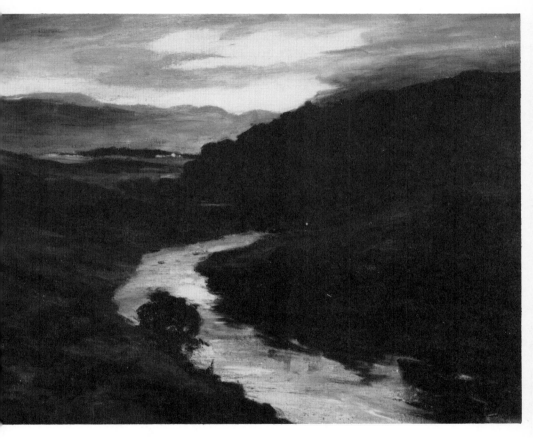

Last Light n.d.
Oil on canvas, 61.0 × 76.5 cm. (24 × 30 ins.)
Art Gallery of Hamilton

knowledge of form. Strange that he does not wish to continue in sculpture."[14]

Ernest Thompson was then in Paris, and early in 1895 Morris ran into Charlie Hopkinson, who had also come over to study. In April Morris took off for the forest of Fontainbleau and *en route* came across several artists he knew working in the French countryside – Harrison, Montreal's F.C.V. Ede, and the American painter Winslow Homer. Morris went to Fleury to see a fine old chateau, then returned to Paris for the opening of the Salon. He was introduced to Julius Gari Melchers, who was showing portraits and whose work impressed him. They arranged to meet later when Edmund was sketching in Holland.

Edmund left Paris and on his way to Holland stopped at Antwerp to see the gallery and commented on a self-portrait of Simon de Vos. "It is the only work known to be in existence painted by him. It equals a Velazquez. He gave most of his goods to the poor all his life and from his expression, found happiness." Edmund found the Antwerp cathedral impressive: "its tower of wonderful tracery is fine. The Reubens ... however ... do not take great hold on me. At Antwerp there is lots of great art to be seen."[15]

He rented the upper floor of a house in Egmond aan Zee, a small village where Melchers also had a studio. Meals were obtained at the home of the village treasurer, "a fine specimen of a peasant. I afterwards found he could paint and carve in wood. He showed me portraits of his father and mother. They were charming in their naivete."[16]

Here Morris painted landscapes, peasants, interiors. His *Girls in a Poppy Field* and his *Dutch Interior*, the latter of which was later shown at the Berlin International Exhibition, were painted from sketches made here. He spent the entire summer travelling about Holland, a country that seemed to attract him very much, painting and sketching as he went. He visited Amsterdam and Haarlem and in the latter found "Frans Hals seen at his best", and The Hague, an aristocratic little city where, in the Royal Museum, he was "fortunate enough to see a collection of Jacob Maris's work. He and George Inness are the two landscape ones of the masters who influence

me most," he wrote in his diary. "I will choose Inness most for his sympathy."[17]

Maris, a Dutch painter of the nineteenth century, was noted for his domestic scenes and landscapes and for the delicate way in which he painted skies. George Inness, an American who had studied the landscapes of the French Barbizon school, notably that of Corot, was more impressionistic and mystical in his treatment of scenery.

From The Hague Morris travelled on to Brussels, stopping at Dordrecht on the way south where his friend, James Wilson Morrice, of Montreal, sometimes painted. Back in Paris, he took a room at No. 13 Campagne Première. "The house stands back in a courtyard, a flight of stairs leading down from the street and back of it a monastery . . . I hear the chimes ringing in the evening."[18] At this time Morris was studying at Julian's under Jean-Paul Laurens. Old friends were there, among them Murphy, Charles Broughton, Carl Sanders, Tanner, and Hopkinson.

Before his return to Canada in the spring of 1896, Matthews Gallery, in Toronto, showed some of Morris's watercolours. A review by Lynn Doyle in *Saturday Night* compliments the work:

> Nothing as unconventional, showing such vigor and breadth in treatment, has been seen here for some time as the watercolors by Mr Edmund Morris, now on view at Messrs. Matthews Bros., Yonge St. whether it is a view of Notre Dame, with the rosy band of sky behind the towers and the cool green of the water in front, with the brown boats floating lazily; whether the old woman at the window with her sewing, or the little girl knitting, her figure casting a long blue shade from the firelight; whether the moonlight scene or the old street at dusk, with a lamp burning at one of the open sheds or entrances – in each and all is seen the same grasp of the subject, the same simplicity and strength, so that most other work in the room looks tame and "niggled" by comparison . . . The figure of the old Dutch woman sewing referred to above, was very favorably spoken of in the Paris papers. Mr Morris expects to return this spring to Toronto.[19]

47

Morris returned to Toronto with a stop-off in New York later in the spring, and spent the summer on the family island in Muskoka. He commented in his diary that he did little painting that summer.

In the fall of 1896 Matthews showed much of his work of the previous year. Lynn Doyle commented in a review that

> The art beloved of artists often fails to win the approval of the public and this may to some extent be the case with the work of Mr Edmund Morris now on view in the Matthews Art Gallery, Yonge Street. There will be little doubt in the minds of his fellow artists as to the promise in these pictures as to the grasp of subject and the essentials but many of them are so simple in subject or sketchy in treatment as to be only studies though studies full of suggestiveness. The portrait of the Italian girl is most interesting in the scheme of color, dull blues and greens in very low tones, with slight modelling of hands and face. *Moonlight on the Down, Holland* shows the moon just rising above the purple haze at the horizon and revealing the cluster of houses on the summit of the rising ground, scarcely a hill. It is admirably truthful in its values and gradations of color and is the most important of the landscapes. *Grandmother and Child* in watercolor is spirited and sketchy and much in the manner of the Dutch masters. *Muskoka* is intense in color in the blue water and white sail boat and green pines against a sunset sky. *St. Andrew s (Fifeshire), Plains of Barbizon, Nedpath Castle (Peebleshire)* are among the most striking of the landscapes, but each and all are better appreciated at a distance when their best qualities are felt without any idea of 'paint' which closer inspection is apt to call up.[20]

Morris sold a few of his works at this exhibition. Byron E (later Sir Edmund) Walker purchased *Girls in a Poppy Field* or *Gathering Poppies, Holland*, and gave it to the Art Gallery of Toronto in 1918.

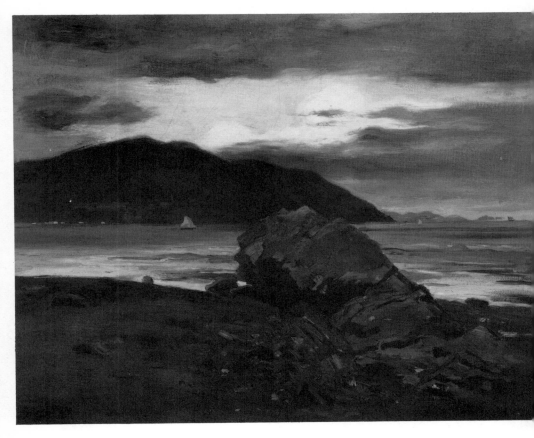

Cap Tourmente n.d.
Oil on canvas, 59.7 × 74.9 cm. (23-$^1/_2$ × 29-$^1/_2$ ins.)
National Gallery of Canada le Musée des beaux-arts du Canada,
Ottawa

Chapter Three

Landscape:
Quebec and Scotland

In 1897 Morris was elected an Associate member of the Royal Canadian Academy. It was in the summer of that year he first discovered the Quebec landscape when he went to Beaupré for the first time. He described the locale in his diary:

> A little village on the St Lawrence, three miles below Ste Anne, the Lourdes of Canada, and 23 below Quebec. No tourists, only a few Quebecers. I find Dyonnet and Maurice Cullen here. I paint the habitants. So much which impresses me but they are extremely hard to get as models even when one pays more than they earn.[1]

"We cross with a small boat to the end of the island [Orléans] hoping to see Cruikshank there. Lunch at Mme. Chagrin's. Our friend was not home so must have carried out his plan of stopping at Ste Famille." Later they found William Cruikshank "in his old house alone two miles from the village ... He has done little work." Fellow painters Charlie Porteous and Horatio Walker came to visit. It was Morris's first meeting with Walker and the beginning of another important friendship in his life.

Walker, a New Yorker, spent much of the latter part of his life painting on the Île d'Orléans, and, when Edmund first made his acquaintance, was spending eight months of the year on the island. Walker's studio and home were located at the head of the island in the village of Ste Petronille, immediately across the river from Montmorency Falls. The citadel of Quebec was a little upstream. Walker was accustomed to outdoor sketching all over the island but completed his paintings in his studio.

51

One of his nieces acted as his chatelaine. It was Horatio Walker who later, with Morris and a few other artists, was to form the nucleus of the Canadian Art Club.

Edmond Dyonnet was then Director of the Ecole du Dessin of l'Ecole des Arts et Métiers, Montréal, and later a professor at l'Ecole Polytechnique de Montréal. Primarily a portrait painter, with William Brymner he was a leading figure in Montreal's artistic circles at this time. Both bachelors, they founded the Pen and Pencil Club, which met in an old house – No. 1207 Bleury Street – where each had a studio and living quarters. Artists and art students met there, as did musicians, architects and other creative types.

When Morris returned to Toronto from sketching in Quebec, he took a studio in the old Imperial Building where he had worked with William Cruikshank.

In the summer of 1898 he returned to Quebec. At Beaupré he stayed at the artists' rendezvous, Raymond's Hotel, and later drove to Lac Ste Joachim, owned by Raymond, a beautiful lake high up in the mountains overlooking the St Lawrence at St Tîte. Back at Beaupré, he set to work. Dyonnet and Cullen were also there. In his diary he noted, "Paul Lafleur spent a week with us. Brymner has been in Acadia but the weather was so hot he came on to Beaupré in August." Again Morris spent the summer painting the Quebec landscape.

In October he left Beaupré and spent a week in old Quebec City with Brymner and Cullen, staying at Blanchard's Hotel – an old hostelry in the square of Nôtre-Dame-du-Victoires. "It is convenient" he noted, "and one sees characters – old men with shawls pulled around them and others, odd types that you would not meet elsewhere but the face is kind." He continued to paint near there and later went to Hillhurst to see his sister, Eva, then very ill.

In January 1899, back in Toronto, he took a studio at No. 32 Adelaide Street East. That same month, *The Spinners*, painted in Holland, was purchased by the Ontario Government for the Speaker's Chambers (the work was later destroyed in a fire). Major A.B. Wilkie bought his painting *A Windy Morning – Beaupré* and *Troquair*. E. B. Osler called at his studio and "liked Rapids of St

Ann – he has the best collection in Toronto," wrote Morris in his diary. Over a number of years, E.B. Osler purchased other works by Morris.

That summer, Morris returned to Beaupré to paint. Brymner and Cullen had taken a scow as far as Île aux Canôts, and at the end of August Morris took a steamer, stopping at Baie St Paul, Les Éboulements, Île aux Canôts, Ste Irénée, Pointe au Pic, and finally Murray Bay, then a popular resort. Here he stayed with the Crosbys, friends from New York, and visited with his relatives, the Lambes, and others. In a few days he rejoined Brymner and Cullen in Beaupré. In his diary he mentioned that William Maclennan, author of *Spanish John*, was there with his family and in very poor health. Friends whom Morris described as "bright southern women from New Orleans, Grace King and her sister," were staying there. Grace King was a short story writer. Morris took them out by buckboard to see Seven Falls.

Brymner and Cullen had a studio and Morris rented the well-lighted upper floor of the same house. In October Morris left Beaupré for Quebec, then went on to Montreal. Paul Lafleur and William Brymner took him to lunch at the St James Club, followed by a visit of the Angus Collection: "He has a Brangwyn and has just added two Raeburn portraits." Angus's collection included among other works, a Romney portrait of Mrs Wright, a Constable and a Rembrandt. In his diary Edmund called it the "choicest . . . Ross and [Sir William] Van Horne, then Angus are the finest in Montreal."

Visiting the Art Association of Montreal, Edmund was impressed by their membership of 850, their facilities for lectures and exhibiting, and their reading room. Contrasting Toronto with Montreal, and exasperated at the lack of facilities for artists in Toronto, Morris wrote in his diary, "I will take steps to have a proper art museum for the city," adding with great faith, "The citizens will contribute the funds."

He spent the most of the summer of 1900 near Ste Anne, Quebec, later going to Isle Maurice in Muskoka, Ontario, for sailing, canoeing and swimming, and in September began preparing for a one-man exhibition to be held at Matthews Art Gallery in Toronto in November.

At it he sold ten paintings. In his diary he recorded that Lord Minto had bought pen and ink drawings of Chief Big Bear and Chief Crowfoot. He later learned that Lord Minto's wife claimed descent from Pocahontas and was very pleased with the choice of purchase. The wealthy Toronto financier and art collector, E.B. Osler, purchased a sketch of Chief Big Bear. Crowfoot and Big Bear were both dead, their portraits having been done from photographs. These appear to have been his first portraits of specific Indians. No clue appears in his diary as to what led him into Indian portraiture at this point.

He wrote in his diary for 1900, "This was a happy year and one I like to look back to in the old home."

His happiness was short-lived.

Early in 1901 his Aunt Agnes died in Montreal after a long illness. Uncle John Morris came to Toronto and stayed for a time in the Morris home but, wishing to return to Montreal persuaded Mrs Morris to let one of the girls come with him. Christena accompanied him but later returned to Toronto and Madge (Mrs Malloch, then widowed) took her place. "Little did I think our parting at the station was to be our last in the world," Morris wrote later.

> At first she enjoyed the life in Montreal so much, seeing her old friends, but then took ill and the doctor advised her to come away . . . she packed and feeling tired went to rest and passed away in her sleep . . . This was followed by dark, dark days. She had been so much to us all. Everything seemed to go wrong. My poor mother was so ill the next summer she was unable to move or use her hands.

Madge died in March and was buried in the Morris family plot in Mount Pleasant cemetery.

Morris had made the arrangements for some Canadian artists to send work to the International Exhibition held in Glasgow in April 1901. Included were sculptures by Louis-Philippe Hébert of Montreal and Phimister Proctor, a former Canadian living in New York City. Morris was represented by his oil painting entitled *Cote de Beaupré*. This exhibition helped to improve the British view of Canadian art.

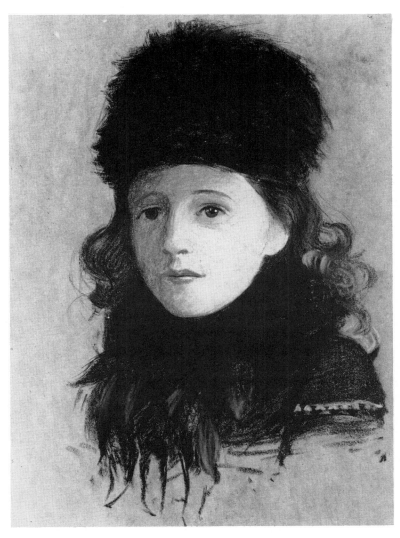

Portrait of Marjorie Cochrane as a Young Girl 1904
(niece of Edmund Morris)
Pastel on paper, 34.9 × 24.8 cm. (13-³/₄ × 9-³/₄ ins.)
Glenbow Museum, Calgary

In the fall of 1901, Morris's painting, *Girls in a Poppy Field*, and some others were loaned from B.E. Walker for showing at the Pan American Exhibition in Buffalo, where Morris was awarded a bronze medal. He was in distinguished company at the Exhibition, in which portraits by John Singer Sargent, Augustus St Gaudens, and Charles S Shannon, and landscapes by George Inness, were featured. Horatio Walker was represented by *Oxen Ploughing*.

In an effort to raise his depression in May of 1902, Morris went abroad again, this time via Boston, where he stayed with Herman Murphy, an old Paris friend and artist, who lived at Worcester, Mass., and maintained a studio in Boston. He also looked up Charles Hopkinson, who was then living in Cambridge. Morris then sailed for England, landing at Liverpool, then went to London, where he looked up Robert Brough, a noted painter he had studied with at Julian's. Brough had done well in London and "has all the orders he can fill." Brough's studio was next to Sargent's.

It was the Coronation Year of Edward VII and the London streets were crowded. William Brymner was in town and wanted Morris to join J.W. Morrice, Maurice Cullen and himself in celebrating, but Morris escaped the crowds and went to Edinburgh with B.E. Walker and his family. There he stayed for a time with the Morrisons, cousins through his grandmother, Elizabeth Cochran. He met Sir George Reid, President of the Royal Scottish Academy, who invited him to his residence on the Royal Terrace, where he met the painter Roche. He also visited Professor and Mrs Gregory Smith; Smith taught English at the University. Morris had met his brother, Michael, in Paris.

Joseph Thorburn Ross, the painter, gave a dinner for Morris, inviting Roche and other painters. With Roche, Morris visited Edward Alexander and his father, both of whom were animal painters living in the country.

The Duke of Argyll had given Morris an introduction to Lorimer, another painter, whom he visited at Kellie Castle. Lorimer took him to see a typical Fifeshire house – the home of Sir Ralph Anstruthers, who was away. However, Lady Anstruthers showed them the house and

the garden, the latter of which Morris described as "so fine, terraced with frescoes of the old Roman Emperor's in the wall, and an avenue leading through the estate." Sir Ralph had been in Canada and had brought back wild goldenrod and hepaticas for the garden, which though not native to Scotland, flourished and were much admired.

At the end of the month Morris went to East Kilbride where he met up with Morrison, another Paris friend and painter. They stayed in the same house, painting the countryside. One weekend Morris walked to Ayrshire, staying overnight with some distant cousins who lived at Kilmarnock and had a summer place at Androssan on the sea, a most enticing painting-spot. Morris visited friends or acquaintances near there, then set out for Kirkcudbright to visit a group of painters whose addresses Sir George Reid had given him. *En route* he called on Macaulay Stevenson, one of the group, and delivered a letter from Professor James Mavor of the University of Toronto. Stevenson welcomed Morris and invited him to spend the night. From there Morris went on to Kirkcudbright, where he met several of the Glasgow School. In his diary he commented, "Hornel is the strong man. Shows excellent work . . . The coast here is great. Here is the scene of Crockett's *Raiders*. The town belonged to Capt. Hope who succeeded to the estate of the Earl of Selkirk. It was once a big seaport town. E.A. Hornel lives here." Morris found a room and learned that his landlady had been a cook to the Earl of Selkirk. He painted there for awhile, then returned to Edinburgh, where he met Principal Storey, of Glasgow University, who had been a friend of his father's during university days.

Returning to London, he went to see the Wallace Collection. Impressed by the works of Velazquez and Watteaus on display he wrote later, "By Jove, some of these old fellows knew how to paint."

On 19 November he sailed on the *Minnehaha*, Atlantic Transport Line. The sea voyage was made pleasurable by the company of some Canadians he knew – Col. Whitehead, a Mrs King, and a Mrs Thomas. Arriving in New York City, he spent a few days with his old friends, the Crosbys, and dined with Moncur Conway and his

daughters. He had met Moncur Conway, clergyman and writer, first in Paris when Conway was collaborating with a historical writer, Felix Rabbe, on a French translation of Conway's *Life of Thomas Paine*. Morris wanted to send first editions of his father's works to Paris and corresponded with Conway from 1899 on.

When they met in New York in 1902, Conway was then at work on his reminiscences, and the next year, writing to Morris from Paris, said that he had almost completed his autobiography and was looking for a publisher not likely to be afraid of his unorthodox views. In 1862 he had founded an anti-slavery organization, and in later years had travelled to the far east, writing of his experiences there. One of his titles was *Demonology and Devil-Lore*, and he seems to have been unorthodox, even for a Unitarian Minister, which he was when Morris met him. Morris appears to have invited him to come to Canada to work on his memoirs, but he chose Paris instead. He had provided Morris with letters of introduction to some prominent people in Britain.

While in New York City, Edmund visited with artist friends as well, such as William Merritt Chase and Louis Miron, and looked again at the paintings in the Metropolitan Museum before returning to Toronto.

"How hard it is," he recorded in his diary, "coming to the old home and dear Madge not there to meet me. She and the mater were always the first to greet me."

Next summer (1903) he returned to Beaupré. J.W. Morrice and Maurice Cullen joined him and they sailed across to the Île d'Orléans, where they found William Brymner and Paul Lafleur at work. Later Morris painted at Cap Tourmente, staying with the Pritchards, then went on to Port Neuf. In his diary he recorded that he was "Stopping at Mme. Langlois'. She is the daughter of Sandfield Macdonald and a good friend of Mother's. Her mother, Mrs Macdonald is here and Mrs Waggaman from New Orleans, her aunt."[2] Morris left Beaupré in October staying a day with Eva at Compton. In Montreal he arranged a one-man show at the Library.

In October he welcomed his brother, Bob, home from the far east on a year's leave. At this time their mother was seriously afflicted by rheumatism. "She has never

been quite well since we lost Madge," Edmund wrote in his diary.

In January 1904 he had an exhibition at Messrs Scott and Sons, 1799 Nôtre-Dame Street, Montreal. Only a few small paintings were sold. Mr David Maurice purchased *Stranded Ships, Village, Evening,* and *Galway Coast,* Mrs James Ross *The Dunes,* and Sir George Drummond *The Blue Ocean,* for his son-in-law, E. Parker. Morris did not recover his expenses, including framing costs.

Coming back to Toronto, he held another show at Matthews Art Gallery from the 8 to 22 February. He noted in his diary, "These are hard times. Everyone has suffered and we suffer most of all. Nothing sold at the exhibition." Later D.R. Wilkie bought his *Wolfe's Cove,* which had been included in the show. In March he exhibited at the twenty-fifth annual exhibition of the Royal Canadian Academy, showing *Cap Tourmente, A Quebec Landscape, The Coast, The Laurentians,* and *Old Fort – Toronto.*

Again he spent the summer at Île d'Orléans. Dyonnet and Williamson joined him for two weeks, then Cruikshank arrived for the remainder of the summer.

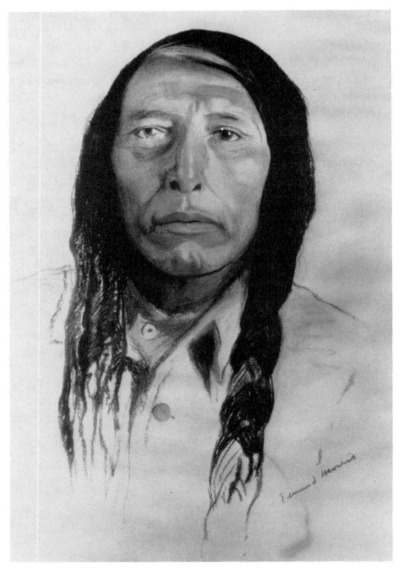

Chief Poundmaker
(Believed to be the portrait purchased by D.C. Scott for
Department of Indian Affairs in 1907)
Photo: Edmund Morris
National Museums of Canada: National Museum of Man, Ottawa

Chapter Four

Painting Among the James Bay Indians

At a one-man show held in Ottawa in 1905, Morris exhibited portraits of Chief Poundmaker, Big Bear, and Crowfoot. Subsequently, Dr Duncan Campbell Scott, (1862-1947), Superintendent of Indian Affairs as well as a noted poet and writer of fiction, wrote to him, saying that Sir Wilfrid Laurier, then Prime Minister, had ordered the purchase of the three portraits. Morris's uncle, W.B. Lambe, heard of the sale and wrote from Montreal, "Catlin, although he never studied in Paris, made his mark as an Indian delineator . . . cannot you do likewise for our North West Indians with whom your late father made treaties."[1]

This was precisely what followed, although it is not known whether his first commission to go among the Indians and paint their portraits was initiated by him or was recommended by Dr Scott. Suffice it to say he was commissioned by the Ontario Government in 1906 to accompany the James Bay Treaty party into northern Ontario and record pictorially as many Indian chiefs and head men as he could persuade to sit for him as the party travelled from place to place.

Edmund had inherited from his grandfather, William, and his father, Alexander, a sympathetic interest in the Indians of Canada. In the 1920s his grandfather, while making his living as a merchant at Perth, in the Ottawa Valley, had periodically employed Chippewa Indians of the region and was regarded by them as a friend; they named him *Shakushreik* (The Rising Sun).

The first treaty with Indians of Ontario had been negotiated and signed in 1850 under the Robinson Treaties. By it, the Indians gave over to the Province of Canada, as it was then called, their right and title to a large tract of land lying along the shorelines north of Lakes

61

Huron and Superior. They further relinquished lands under the Manitoulin Island Treaty, signed in 1862. No further treaties had been signed since then in Ontario.

Increasing settlement, mining activity, and railway construction in Northern Ontario deemed it advisable, as the federal government put it so nicely, to "extinguish" the Indian title to land in Northern Ontario. An Order in Council was passed to appoint commissioners for this purpose, entrusting them with the negotiation of a treaty with the Indian inhabitants of the 90,000 square miles of land drained by the Albany and Moose River systems. This treaty was called the James Bay Treaty, Treaty No. 9. The commission was headed by Dr Duncan Campbell Scott.

During 1905, the Treaty party travelled through Northern Ontario, meeting with Ojibway, Cree and other Indian bands to secure signatures to the Treaty, and by September had covered the northernmost part of the territory. There remained several bands still to be visited in 1906.[2]

In May 1906, Dr Scott wrote to Morris outlining the party's itinerary, saying he would very much enjoy the pleasure of his company on the journey. Consequently, in July Edmund left Toronto by train and met the Treaty Party at Biscotasing, northwest of Sudbury. The party consisted of Dr Scott and Samuel Stewart, representing the Dominion of Canada; Daniel McMartin, representing the Ontario Government; Pelham Edgar, Secretary; Dr Alex G Meindl, physician, to examine the Indians; Constable J.L. Vanesse; two voyageurs, and a cook. Scott, Stewart, and McMartin were the commissioners.

Up until this time, Edmund had been primarily a landscape painter; now he was faced with a new challenge. He abandoned the more cumbersome oil paints and chose pastels for the trip, pastels being an easy-to-transport and fast medium with which he could complete a "painting" on the spot. Later, he would turn some of his pastel studies into oil paintings. He soon found that pastel was a wise choice for another reason: the Indian temperament was not given to sitting still for any length of time, at least not for the purpose of serving as an artist's model.

Travelling by canoe and over portages through rugged terrain was a new experience for the urbane Morris,

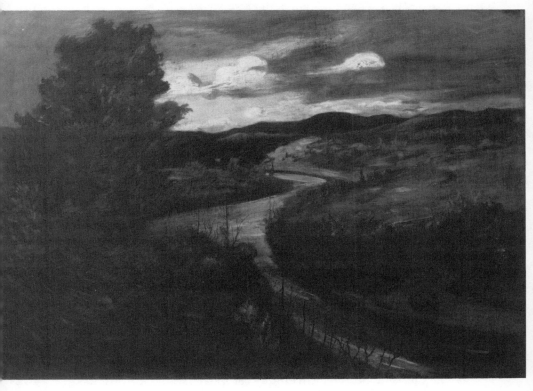

Country of the Ojibways (Pic River) c. 1906
Oil on canvas, 74.9 × 99.0 cm. (29-$^1/_2$ × 39 ins.)
Government of Ontario Art Collection, Toronto

used as he was to the domesticated landscape of Beaupré, Quebec. He wrote in his 1906 diary that "There is a joyousness in the life of the forest which is splendid . . . I was the first artist to go among them [i.e., the Woodland Indians] and they were superstitious but finally agreed to sit for their portraits and they thought it was great magic." He described them as a "stalwart race carrying their heads high, of a rich colour like old copper and black straight hair but cut short. Their eyes are of a deep brown."[3]

It was his first experience in living on a day-to-day basis among Indians, and he was appalled by the conditions of their lives, such diseases as tuberculosis annually carrying off members of the tribe. One of his first encounters with this then fatal malady occurred at New Brunswick House, the Hudson's Bay Company post on Lake Missinaibi, which the party reached on 25 July. "The night we arrived," wrote Morris in his 1906 diary,

> a young Indian was dying of consumption and we visited him. It was a picture of loneliness. His wigwam was placed by the lake, far removed from the others. Boughs of trees had been placed over it to keep off the scorching sun but they had become dried up. Day after day like a wounded animal he awaited the end. It came quickly that night. A bull strayed into his tent and the boy died of fright, doubtless thinking in the dusk that it was an evil spirit. He had no near kin. The Indians were afraid to enter the wigwam but the Chief knelt by his side and read a sermon from their syllable bible or prayer book.

On the party's three-day stopover, Dr Meindl examined natives assembled at the little church. Morris noted, "Many of them have a cough which often leads to consumption." While other government business proceeded, he sketched his first portraits of Indians and voyageurs. One of these was of Peter Mitagonabie, a carpenter, who had come from Lake Missinaibi and was one of the party's voyageurs. Mitagonabie was also a signee to the Treaty. One of Edmund's few portraits of Indian women was sketched here: that of the *Widow Betsy*,[4] who lived in a tent on the opposite shore of the lake with a girl as a companion. Other portraits included: Daniel

64

Kushkawin (a Frog-Cree from James Bay), Pierre Moses, alias Mahawte (an Ojibway from James Bay) and Denis Deschamp, a voyageur, half-French Canadian and half-Ojibway. Morris apparently did not sketch the landscape, although Dr Scott, in his report, called Missinaibi a beautiful lake and the view from Brunswick House "delightful."

Morris participated as a witness at the signing of the Treaty. Payments were made to 100 Indians and a conference was held after the signatures had been secured, designating the boundaries of the reserve which the government was to set apart.

On the morning of 26 July the Treaty Party rose at five a.m. Lake Missinaibi was wreathed in mist but at seven they struck camp and departed, the Indians firing a farewell salute. The party traversed land studded with lakes linked by rivers, over which the Indians travelled by birch-bark canoe. "Some of them work in the transport for the railway, the Hudson's Bay Company and the rival fur-trading company of Revillon Frères; others as mail carriers to James Bay from the [C.P.R.] Line," recorded Morris. "Sometimes they carry as much as 500 lbs. having great endurance and these voyageurs are stamped – the 7th vertebrae of the neck becoming a huge lump . . ."

He observed the transitional stage of the natives: having discarded buckskin, moccasins and fire-bags of former years, they were wearing, for the most part, European costumes. "But in other respects," he noted, "they are not much changed through the influence of white blood creeping in." They still lived in birchbark wigwams and when hunting rolled up the sheets of bark and took them along, leaving the birch poles of the wigwams standing. Near settlements they built wooden houses.

Some of the Indians were afraid of Morris's "image-making" and he was told by a French-Canadian voyageur that some, after his departure, threw bullets at the rocks which, in their belief, would follow him and "kill" the portraits.

Morris was impressed by the work of the missionaries present at the company posts. Later he wrote, "If our people realized the conditions of these wards of the Crown, more would be done to further the work carried

on amongst them by two excellent clergymen [Rev. C. Banting and Rev. C.D. Ovens], the Anglican Bishop of Moosonee [Rt. Rev. George Holmes], and the Catholic priest, Father Dugas, who work strenuously."

At the Hudson's Bay post at Missinaibi, Morris left some of his portraits with Mrs Smith, the factor's wife, to be picked up later, and with the Treaty Party took the train to Heron Bay on Lake Superior. Here the party was held up while arrangements were made to secure canoes for the last post to be visited at Long Lake. Morris left some more portraits at Heron's Bay with the storekeeper, a Mr Miller, to be retrieved on his return journey.

While awaiting canoe arrangements, he took a little steamer along the lakeshore line to the mouth of the Pic River, where he found "an admirable composition for a landscape." (Later, in 1907, he painted *The Pic River, Thunder Bay District*).

The District Inspector for the Hudson's Bay Company, H.A. Tremayne, arrived at Heron Bay on 1 August, bringing his wife and daughter with him. He had agreed to take charge of the journey to Long Lake, a difficult route in any season, particularly so at this time when the Pic River's water-level was unusually low. A birchbark canoe had been forwarded for the party to Heron Bay by rail, but the Indians claimed it was too long for the river. Tremayne located some Peterborough canoes for the party, which left Heron Bay the evening of the first of August. They had not gone far when one of the canoes sprang a leak, which delayed the journey. The canoe was patched but again gave out and finally it was abandoned altogether; the party ventured on, doubling up in the remaining canoes.

The scenery along the Pic River was spectacular, the terrain being wildly irregular. White Otter Falls, reached on 5 August, Edmund described as being four-and-a-half metres in height, with foaming water, which necessitated a portage over a high hill. Ascending the hill for fourteen kilometres they came to Big Sand Hill Falls, twenty-three metres in height, flowing through a narrow, rocky gorge. Again they portaged, this time over a small mountain, descending the Pic River to their fourth in a day, called Deadman's Portage. Two more portages were necessary

Pic River, White Otter Falls, James Bay Treaty Party in the
Thunder Bay District, 1906
Archives of Ontario, Toronto

before the party camped for the night, only around twenty-four kilometres from their last camp "as the crow flies."

On 6 August they ascended the Pic River, traversing small lakes and marshes for five kilometres until they reached the Sangonbou Rapids. Tracking was necessary as they continued, their canoes being pulled by ropes in some places to negotiate the rapids. Ascent of the river continued to be difficult and dangerous in places, causing frequent portages, as they were climbing steadily and travelling against the river current. Finally, on 8 August, they arrived at the Long Lake post, worn out by the journey, and encamped in front of the Hudson's Bay store. Next day, Dr Meindl proceeded to examine the Indians. In his diary Morris wrote;

> Most of the old widows ask for medicine for loneliness. Most of the children were examined. I make a pastel study of a squaw and her two children in the little church where the doctor examines his patients. When the doctor was examining the Indians, a little fair-haired boy of nine came walking into the church all by himself to be examined. The mother is an Indian girl, the father unknown. Many of the children are bastards. Twenty-seven years ago measles swept off 45 heads of families and others were so ill they could not bury many of them, so left them to the open and some others had to put them down under the soil when they came upon them.

On 9 August a conference was held with the Indians, at which their adhesion to the Treaty was obtained. Peter Taylor spoke for them and said they desired to have Joe, *Newatchkigigswabe*, the Robinson Treaty Chief, recognized as their chief. This was agreed to, and at the feast held in the evening, he received the usual flag and a copy of the treaty on their behalf. In his speech to the assembly of Indians and whites the Chief (whom Morris sketched) hoped the government would provide for the sick and destitute, as the Indians of the District found it difficult to make a living and could do little to help each other. The reply to this was that the government was always ready to assist those actually needing help, but that the

Indians must try to rely on their own resources as much as possible.

The commissioners paid 135 Indians their treaty money and discussed the boundaries for the reserve. It was agreed that it should stretch from Long Lake a distance of four miles along the shore, and should encompass forty-three-and-a-half square kilometres of land.

The Treaty Party departed on 10 August for Heron Bay, and thence homeward. "I shall miss the good companionship of the voyage and short story lore," Morris wrote in his diary; "I will remain till about September 18th to carry on my work."

Included among the Long Lake portraits were depictions of *Odogamie*, a Cree trapper and voyageur; *Shabokamik*, or Through the Earth, also Cree; and the following Ojibways: *Sakegijickweyabow*, Man Whose Head Touches the Sky; William Odicon; *Imjnagijich*, or Changeable Weather; *Kushkawin*; and Alexander Tawrdo.

In September Morris joined a party of sixteen Indians and half-breeds who were on their way to the Nipigon country. Bush fires had swept over the country and portage trails had been obliterated for miles, making the journey difficult. Also, the heat had caused some riverbeds to dry up.

The Pic River country particularly interested Morris, with its rock outcrops, orange-red in places, and covered with grey-green moss. The river itself he described as "deep brown."

At Heron Bay he boarded the train, stopping off at Missinaibi to pick up the paintings he had left with the Smiths, and from there proceeded to Toronto. He had completed thirteen portraits and a number of landscape sketches to be turned later into oil paintings. Two of these are *Indians Descending the Pic River*, and *Indians on the Pic River*.

During 1907 Morris also painted portraits of Indians at the Six Nations Reserve, Brantford. One is of Chief Frank Davey; two others, now owned by the Royal Ontario Museum, are entitled *Chief Fish Carrier*, Chief of the Cayugas, and *Too Cloudy*, Chief of the Oneidas.

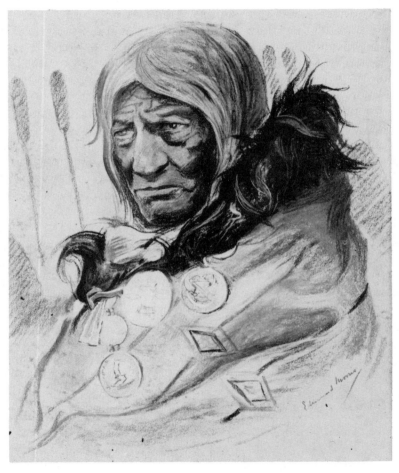

Sisuiake (The Cutter Woman, widow of Crowfoot) 1907
(Photograph of the original pastel in collection of Royal Ontario
Museum, Toronto)
Photo: Edmund Morris
Manitoba Archives, Winnipeg

Chapter Five

The Indians of the Western Plains

In March of 1907 the Art Gallery of Scott and Sons, Toronto, held a one-man show of Morris's work, including many of his James Bay District portraits of Indians. A review in the 23 March Toronto *Star* commented that

> All look as if modelled in terra cotta, carved out of mahogany. Many of the physiognomies are distinctly unpleasing but nonetheless interesting on that account; others show the fine aquiline features we see in the best specimens of the race. Most of these are life-sized heads done on grey paper drawn with a bold line and direct modelling; others are smaller, full-length figures.

Landscapes of Quebec also were included in the show. "On several large canvasses", it was remarked, "Mr Morris has expressed in a powerful, abrupt manner, some phase of nature – a sullen mood, a windy effect, some peculiar formation in the sky, some lonely rocky spot . . . in every case the onlooker feels the artist has gone below the outward appearance and is seeking to give the spirit of the scene."

Favorably impressed by the James Bay portraits, the Ontario cabinet considered a further commission. In May 1907, Morris received a letter from the premier, James Whitney, authorizing him to proceed west and paint whatever remaining chiefs and head men who had signed the earlier treaties he was able to find.

He enlisted the help of his cousin, Murney Morris of Winnipeg, in finding sources of information on the Plains Indians. Murney suggested Col. A.G. Irvine, a retired North West Mounted Policeman, then Warden at Stoney Mountain penitentiary, as one of the best sources for

71

locating chiefs and head men of the earlier era. Irvine had been a friend of Morris's father and was an authority on the Indian tribes of the plains.

Morris wrote to Irvine and received an invitation to come out to Stoney Mountain as soon as he arrived in the west. He left Toronto in June, taking the C.P.R. to Owen Sound and travelling by steamer to Port Arthur, proceeding from there by rail to Winnipeg. He stayed overnight with his cousin and next morning located the site of his early home. Only the stone gateway entrance remained; Government House and the Hudson's Bay Buildings were all gone. Later, Morris lamented to his cousin that the buildings had not been preserved as an example of early western forts and used as a museum. He spent another night in Winnipeg, then went out to Stoney Mountain to visit Irvine.

They sat up into the early morning hours talking of the west as it had been when Alexander Morris was Lieutenant-Governor. They talked also of the North West Rebellion, during which Irvine had served as commander of a force at Fort Carlton. "The old man," Morris wrote in his diary, "was full of tales."[1] Irvine had been Assistant Commissioner of the North West Mounted Police and was present at the signing of Treaties Nos. 6 and 7. He was able to tell Morris much regarding those who participated and the events leading up to the treaties. Morris learned a great deal about his father's activities as Lieutenant-Governor, and later wrote of this in a sketch on Irvine.

Following the Fenian raids and disturbances in the west, an Act providing for the establishment of the North West Mounted Police force had been passed in Ottawa in May 1873, which provided for the hiring of only 300 policemen. A massacre of Assiniboines had occurred at Cypress Hills in 1872 before the creation of the force. Morris learned from Irvine that Alexander Morris had sent despatch after despatch to the Minister of the Interior in Ottawa. He "believed" wrote Edmund Morris "the Privy Council had not yet fully realized the magnitude of the task that lay before the police in the creation of the institution of civilization in the north west and in the suppression of crime there, and in the maintenance of peaceful relations with the fierce tribes of the vast prairies

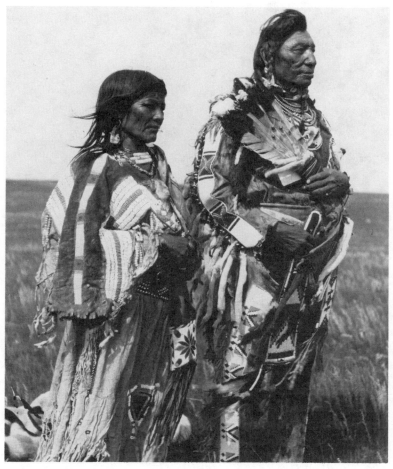

Chief Weasel Calf and his wife (Weasel Calf was a signee of
the Blackfoot Treaty No. 7 in 1877)
Photo: Edmund Morris
Manitoba Archives, Winnipeg

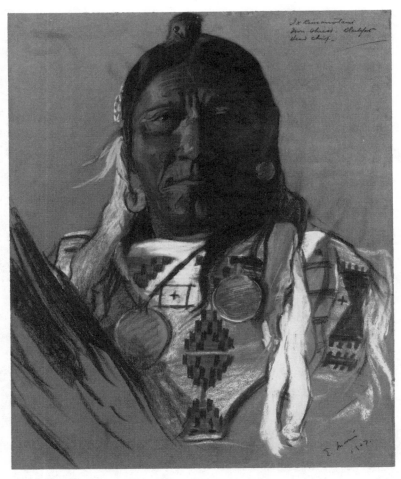

The Blackfoot Chief Iron Shield 1907
Pastel on paper, 64.2 × 52.1 cm. (25-¹/₄ × 20-¹/₂ ins.)
National Gallery of Canada le Musée des beaux-arts du Canada,
Ottawa

beyond Manitoba."[2] The force to be sent was being organized when a change of government took place in Ottawa, Alexander Mackenzie replacing Sir John A Macdonald as prime minister. One hundred and fifty policemen were sent to Fort Garry, but Morris urged reinforcements, and a second contingent was dispatched. War had broken out between Crees and Blackfoot and the Americans had joined the fray.

A letter from Alexander Morris to Mackenzie dated 26 December 1873 explains a situation not resolved by the federal government then or later:

> The Indian question, the American trading and the contending of the Metis of the north west with the new regime, are the problems we have to solve and I believe that all these can be successfully dealt with. The trading question is a very serious one. There are some eight trading posts in our territories commencing 100 miles from the Missouri frontier in the region watered by the Belly and Bow Rivers and running on to the Cypress Hills where the murder of the Assiniboines took place last summer. The country is perhaps the most fertile in the north west where horses and cattle of all kinds feed themselves and excellent coal abounds. I am creditably informed that these Americans imported last summer 50,000 buffalo robes worth say $8 each or $400,000 and to which may be added $100,000 for other furs or a total of $500,000. They sell whiskey, breech loaders, etc. to the Indians and of course they pay no duty. A very serious view of the matter apart from the demoralization of the Indians is the precipitation of the great difficulties we will have to encounter with the Crees and Blackfeet when the buffalo are extinct, an event which, at the present rate of extermination, may be looked for in five or six years.[3]

A second contingent of North West Mounted Police (stationed in Toronto) was sent on and this little force of 300 men crossed the prairie and plains to the junction of the Bow and Belly Rivers. The whisky traders fled south. Later Col. Macleod headed a part of the force and built Fort Macleod with the help of some 8,000 Indians. Col. Irvine joined the police force in 1875. He had travelled

through the United States by way of the Missouri in order to trace the Cypress Hills murderers and told Morris of his experiences in capturing them and bringing them to Winnipeg to trial. Irvine had known Big Bear, the Cree Chief who played a conspicuous part in the Métis and Indian rebellion, and had stopped government surveyors in Saskatchewan. Irvine arrived with some policemen and some Blood and Blackfoot Indians. The assembly outnumbered the forces of Big Bear, who consented to let the surveyors continue their work. However, he later refused to sign the Fort Pitt Treaty and gathered around him many rebels, becoming the most powerful Chief of the Crees following the death of their great leader, Sweet Grass of the Plains Crees.

At one point, Big Bear arrived at Fort Walsh with war-painted braves ready to fight, but Irvine had sufficient forces present to induce a retreat. Irvine eventually persuaded him to sign his adhesion to the Fort Pitt Treaty, but when Louis Riel was rallying all malcontents among the Indians, Big Bear agreed to join the Métis. In relating his experiences, Col. Irvine showed Morris Big Bear's own copy of his adhesion to the Fort Pitt Treaty, which he later gave to the artist. It became one of the most prized items in his collection of Indian artifacts.

Col. Irvine was commander of a force at Prince Albert during the Riel Rebellion. In 1886, the year after the Rebellion, Irvine resigned from the force and became Indian agent "to his old friends, the Blood Indians – that to him was an ideal life – and the Bloods cannot say enough in his praise", according to Morris. "In 1892 he became Warden of the penitentiary at Stoney Mountain . . . he aims to help those who are under his charge more than punish them".[4]

"Stoney Mountain is a plateau rising above the prairie. At night the lights of Winnipeg are seen from his broad veranda and here the colonel has welcomed many visitors . . . all honour should be shown him for he did much to open the distant west to settlement, and quiet the warriors of the plains," Morris noted later in his article on Irvine.[5] Irvine claimed the Blackfoot were one of the most savage tribes in the west.

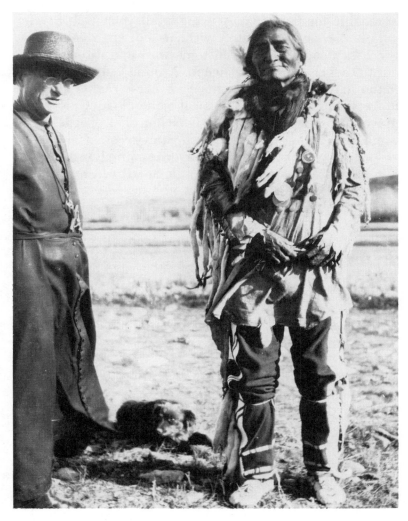

Chief Running Wolf with Father Doucet
Photo: Edmund Morris
Manitoba Archives, Winnipeg

Armed with considerable knowledge of the aborigines, Morris returned to Winnipeg and then set out for Calgary, accompanied by his cousin, Murney. They stopped at Medicine Hat where Edmund found the landscape very agreeable for painting. At Calgary he met Col. Steele, who had been acquainted with his father; Steele knew the Blackfoot and their customs well and directed him out to their reserve at Gleichen. Around Calgary, Morris found many Indians encamped for horse racing and one of his first gestures was to meet some of the Chiefs and present them with drums. At Gleichen, J. T. Gooderham, the Indian agent, gave him an upstairs room as a studio.

Here he met Father J.L. Laverne of the Roman Catholic Mission, who offered to go along with him as interpreter and explain his presence and purpose among the Indians. As they proceeded from camp to lodge to tipi, Morris soon learned that his father was remembered by the elder Indians with respect and goodwill.

He chose for his first portrait *Sisuiake* (The Cutter Woman), widow of Crowfoot and his favourite wife. When Edmund arrived at her lodge and his presence was explained to her, she wondered why he wanted to paint her, as she was "nothing but bones", but, Morris wrote later, "her face lights up when speaking and her smile is very pleasant."

Her daughter, a woman of forty, lived with her. Cutter Woman showed Morris a chain of silver medals presented to Crowfoot by some of the premiers who had visited him, and also a blue velvet bonnet given to her by Col. Irvine. It was here that Morris first learned that Macleod and Irvine were charm names among the Blackfoot. Morris presented her with a shawl and a bright silk handkerchief for her head; also some tea and sugar. She was very pleased with the gifts and agreed to sit for him. He estimated that she was about eighty years old. He described her face and hair as being smeared with paint made from red earth which the Indians baked.

His portrait of the Cutter Woman, once it had been viewed by her kinsmen, established Morris's credentials as an artist and he found his next subject, Chief Weasel Calf, her son, "gorgeous in buckskin trimmed with weasel

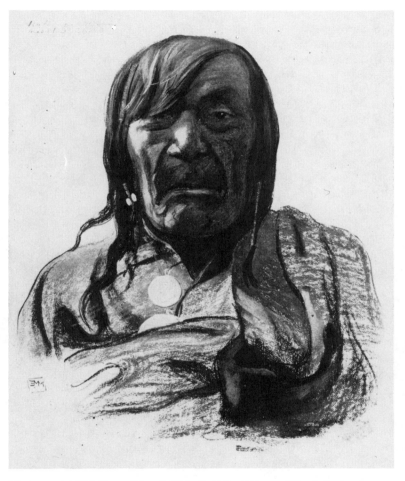

Natosapi (Old Sun, Head Chief of the North Blackfoot when
he signed the Blackfoot Treaty in 1877)
Photograph of the original pastel purchased by the Department of
Indian Affairs, Ottawa)
Photo: Edmund Morris
Manitoba Archives, Winnipeg

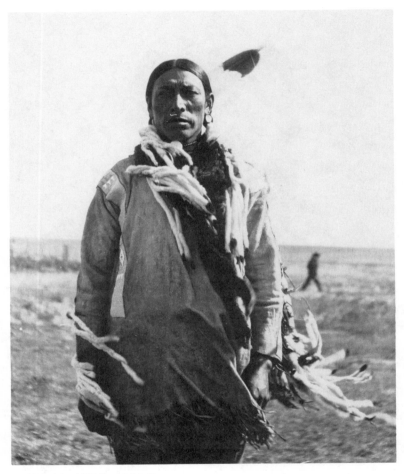

Mike Oka – Blood Indian
Photo: Edmund Morris
Manitoba Archives, Winnipeg

tails and beadwork", very willing to sit for him. Weasel Calf had been a signee to Treaty No. 7.

After completing these two portraits, Morris went to the South Camp of the Blackfoot to meet Head Chief Running Rabbit, and here he heard his first complaints against the federal government. The Indians asked him to carry a message back to "the great chief" in Ottawa to the effect that they did not want any of their reserve sold. In his diary Edmund wrote, "the promise was given to them at the Treaty and if broken will remain a dark spot in our history."

While at the South Camp, Morris visited the Indian cemetery at Blackfoot Crossing where the great chief, Crowfoot, about whom he had heard much, had been buried in April 1890. Crowfoot was Head Chief of the Blackfoot Confederacy and known as a great administrator. Crowfoot had seen the inevitability of white supremacy across the prairies and the coming of white settlers. He had sought a peaceful if compromising settlement with Her Majesty's government when he signed Treaty No. 7 as Head Chief of the North Blackfoot. In signing, only the Stonies of the Confederacy were agreeable to accepting agricultural implements and seed from the government as payment; the Bloods and the Blackfoot asked only for cattle.

The perimeter of their reserve as set out by Treaty No. 7 consisted of a belt of land on the north side of the Bow and South Saskatchewan rivers averaging four kilometres in width along the rivers commencing about twenty kilometres northwest of Blackfoot Crossing and extending to the Red Deer River at its junction with the South Saskatchewan, and a similar belt of land of ten years' duration on the south side of the Bow and Saskatchewan Rivers of an average width of one-and-a-half kilometres along said rivers, commencing at the same point on the Bow river and extending to a point one-and-a-half kilometres west of the coal seam on said river about six kilometres below Blackfoot Crossing.

A look at the Indian reserves map of today shows how the Blackfoot Reserve has altered in size and location, as have all the other original reserves. Morris was

to hear more of the process as he went among the Indian tribes painting portraits.

On his excursion to Crowfoot's grave he came across an old fort of archaeological importance about which he later wrote an article for *Canadian Magazine*. The fort was constructed in the shape of a horseshoe, measuring 128 metres long and 82 metres wide. He was told that it had been built by the Crow Indians in their last stand against the Blackfoot, who came from the timber country north of the site of the present city of Edmonton and drove the Crow out of the country toward Missouri. The Crow Indians then had horses but the Blackfoot travelled on foot.

The site of the fort was about two kilometres south of Blackfoot Crossing on the Bow River. Father Doucet of the Cluny Mission told Morris that he and John Heureux, a half-breed, respected and known throughout the west during the Treaty negotiations as a valuable interpreter and diplomat between Indians and whites, had camped near the fort and were told its story by the Blackfoot recorder, Running Wolf. It was believed that the fort had belonged to an earlier tribe and had been merely used by the Crows. The Indians claimed it had been built by hand with only knives as implements.

Morris hired one of the Indian Chiefs and two Indians, with a team and plough, to turn over some of the ground. Their excavation uncovered a thin gray pottery made of clay and a ground stone with designs cut in it, as well as some human and animal bones.[6] Morris removed some items to bring back to Toronto as part of the collection of Indian artifacts he gradually assembled during his painting assignment in the west. Some of the Cluny items are now part of the Royal Ontario Museum Ethnological Collection. Morris in a later inventory listed them as: (a) fragments of pottery made of clay and ground stone with design, found under the surface of the fort; (b) beads, etc.; (c) buffalo bones found in the pit of the fort; (d) stone with ridges used for some purpose found under the ground of the fort; (e) stones probably used for grinding meat.

What became of the human bones he found is not known. Regarding the age of the site, Dr R.G. Forbis

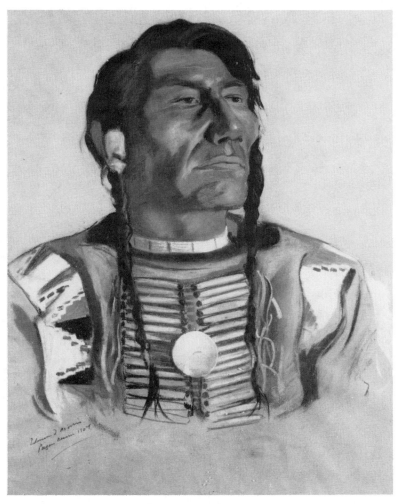

Chief Bull Plume (Stumiksisapo) 1907
Pastel on paper, 64.8 × 50.8 cm. (25-$^1/_2$ × 20 ins.)
Art Gallery of Ontario, Toronto

relates that the Blackfoot historian, One Gun, claimed in the 1960s that Morris's story of the fort's history was erroneous. He asserted that there were two separate tribes of Crows and the occupants of the fort belonged to neither tribe. He also stated that they had never fought the Blackfoot, but instead had made peace with them. Dr Forbis noted that a Hudson's Bay employee, Peter Fidler, in 1800 recorded in his diary when travelling up the South Saskatchewan River, that he had passed a point where there were seven circular mud houses, and noted that they appeared to have been about twenty years old and were described by the Indians as having been built by a small war party from Missouri who lived in this type of habitation. The age of the fort and its occupants appears still to remain a mystery.

Morris found Crowfoot's grave in the Roman Catholic cemetery. The government had put up an iron cross and an inscription bearing the words:

Chief Crowfoot
d. April 25, 1890
Age 69

on one side, and, on the other:

The Father of His People

Morris previously had sketched Chief Crowfoot's portrait from a photograph, which he sold to the Department of Indian Affairs in Ottawa.

Although Crowfoot was gone, some of the other signees of the same treaty were fortunately still living and these he sought out and painted: Old Sun, Head Chief of the North Blackfoot; Bull Head, Head Chief of the Sarcees; Chief Weasel Calf; and Chief Running Rabbit. Running Rabbit had been appointed a minor chief for his bravery when only twenty years of age. During the Red River Rebellion of 1885 he used his influence to keep the peace and was later invited with other chiefs to visit Ottawa. When Crowfoot died in 1890, he was appointed Chief of the South Camp of the Blackfoot Reserve, and later became Senior Head Chief. In 1907 he was seventy-two years old. Morris painted him in his official Indian

Chief uniform and holding a silver malacca wand given to him by Lieutenant-Governor Dewdney.

The Blackfoot Confederacy included the Blood, Piegan and Blackfoot tribes, all having a common language, religion and customs. Later the Sarcees and Gros Ventres joined them. The Blackfoot had moved from north of Lesser Slave Lake southward to the Saskatchewan River in the early days of their history and were constantly warring with the Crees, Crows, Snakes, Kootenays and Flat Heads. In 1816 they conquered a large territory extending from the Saskatchewan to the Yellowstone River and changed from a woods people of former days to a plains people, in keeping with their new land possession. They lived in camps and followed the buffalo upon which they mainly depended for livelihood. They were the most warlike of the Plains Indians.

With the Stonies and Sarcees they signed Treaty No. 7 negotiated by Lieutenant-Governor Laird (who followed Alexander Morris) at Blackfoot Crossing in 1877. This spot had for centuries been a camping and burial ground of the Indians and here "their lodges stretched as far as eye could see along the valley," wrote Morris. He called it "the most beautiful spot in the west."

It was Running Rabbit who gave Morris the name *Bear Robe (Kyaiyii)*, after a great Blackfoot chief, he had heard about as a boy from his father. Most of the Indians thus addressed him in later correspondence. Running Rabbit became one of Morris's many Indian friends.

While at this camp in July 1907, Morris was taken out to the camp of one of the most difficult models he was to encounter – Head Chief Iron Shield. Morris had been told he would never get Iron Shield to sit for him for he hated white people, but Morris was determined to paint him. Iron Shield was about fifty-six years old at the time and occupying the house once belonging to Crowfoot. He had been appointed a chief as a young man because of his good qualities. Later he was appointed Head Chief of the south part of the Blackfoot Reserve by the federal government. Related to Crowfoot through his mother, he was reputed to be very proud and considered himself chief of the entire reserve. Running Rabbit eventually persuaded him to sit for his portrait one morning. He sat like a

statue, never moving and refusing to stop for a rest. Suddenly in the afternoon he jumped up with a yell, tore off his buckskin clothes and walked away. Morris sent his interpreter, Sevres, after him and presently he came back, shook hands and promised to return the next day.

The following day Morris recorded in his diary; "Again painting the chief. All day he sat and opposite him he had a large mirror in which he admired himself. He gave me some hard work." Edmund also noted in his diary that Iron Shield had a beautiful daughter called Holy Pipe, "the only beautiful Indian girl" Morris had seen. There is no record that he was given permission to paint her, however.

On 2 August 1907, he said goodbye to Running Rabbit and the others at the South Camp and drove to the north camp of the Blackfoot to meet old Calf Child, who had been a medicine man and war chief. Before he sat for Morris he turned his back to him and prayed to his deity. Morris said of him, "He and his family are deeply interested in the work. He is tremendously thick through the chest and stands erect. He is nearly blind."

Here also Morris met Crow Shoe, a minor chief or head man, whose head reminded him of Henry Irving's. Unlike most Indians, Crow Show was over six feet tall. Morris reported that he had "a fine bearing and manner."[7]

At the time the Blackfoot signed Treaty No. 7 in 1877, they numbered 20,000. When Morris visited their reserve in 1907, their population had been reduced to 800, largely because of sickness and starvation.

As Morris proceeded from camp to camp, his interest in the Indians grew, augmented by knowledge of their lives through conversations with missionaries such as Father Leon Doucet, who lived near Brocket (near Pincher Creek) on the Piegan Reserve. A dedicated Roman Catholic priest, Doucet had lived among the Indians for sixteen years, sharing their hardships, living with the barest of necessities, as did they. A strong friendship developed between the two men. Later, when Morris returned to Toronto, Doucet wrote regularly, relaying messages from Piegan Indians who had become friends of Morris.

Despite his personal sympathy for the missionaries he met, Morris regarded conversion of the Indian to Christianity as a wasted effort. He well understood the Indian's

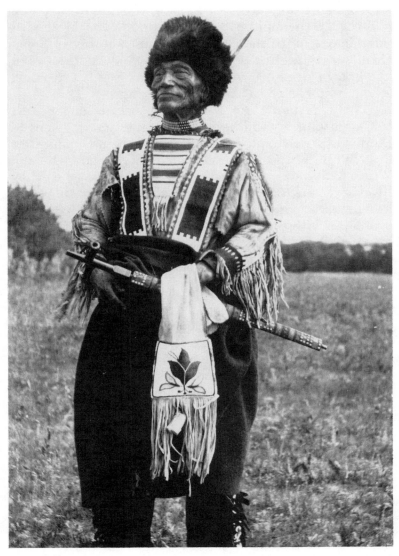

Sitting White Eagle – Saulteau Medicine Man
Photo: Edmund Morris
Manitoba Archives, Winnipeg

spiritual needs and feelings regarding Nature and natural forces. "These old Indians," he wrote, "are sincere in their religion. The sun, which they can see and which carries light and makes all things grow. In the early morning and at night they are heard facing this great force and offering up their prayers." The Catholic and Methodist missionaries with their prayers meant nothing to them. He mentions meeting Rev. Canon Stocken (whom his father had known years before), still there and highly esteemed, "though he has often thought of leaving."

Late in August 1907, Morris's mother and sister came to Calgary for a wedding. Morris met them and went to Banff for a weekend, meeting on the train Comptroller Fred White of the Mounted Police and his son, Donald. White had known Alexander and Mrs Morris when they lived at Fort Garry. White talked of the Treaties in which he had participated. At that time, he said, there was great sympathy with Indians and they were treated like wards by officials. White had been a friend of Edmund and Dalrymple Clark, security guards for Alexander Morris at the time of the signing of the Treaties, and filled in a lot of gaps in Morris's information on the days of his father's tenure in Manitoba.

Leaving the train at Field, Morris was much impressed by the Rockies. "None of our painters," he wrote, "have yet got their spirit but some day some one will come on the scene who can do it." He went on to Vancouver, where he found West Coast Indians, but commented in his diary that they did not compare with the Plains Indians. However, this did not deter him from later offering to paint their portraits for the British Columbia government, but his offer was declined, this commission having been given to a West Coast artist.

In September he returned to Alberta via Kicking Horse Pass and went to the Sarcee Reserve, near Calgary, where R.I. McNeill gave him a room as a studio and dwelling. Meals were obtained at Percy Stocken's, a brother of Canon Stocken. On the reserve Morris found a very interesting Scottish half-breed, George Hodgson, who had been brought up at Fort Edmonton and had lived with the Sarcee for twenty-three years. Hodgson told him many Indian legends, which he later recorded in his diary.

The history of the Indian tribes became more and more a main interest to him, in direct contrast to the urbane life he had lived in Toronto and to his sophisticated artistic pursuits. He began to take numerous photographs of the Indians, their tipis, their ceremonial dances and other gatherings. Later, he sent copies of the photographs to the Indian Chiefs through the Roman Catholic missionaries, and secured their assistance in collecting artifacts and relics for him as part of an ethnological collection he eventually amassed. In exchange for their assistance, he gave the Indians gifts of flags, rings, clothing, and other items, as well as money.

He also began collecting the background family histories of his models with the help of Indian agents and missionaries, and subsequently persuaded some of the Indian chiefs to have their personal achievements painted on buffalo robes, which he provided. Head Chief Little Chief (*Tcillah*), called Bull Head, was one of the chiefs who agreed to this request. These records became part of a valuable collection now owned by the Royal Ontario Museum. Bull Head (*Stumixotokon*) was noted for his "untamable" disposition, having been in trouble with the North West Mounted Police on several occasions. When Morris painted him he was in mourning for the death of his nephew, Jim Big Plume, whom he had named his successor. The Sarcees were of Athapascan stock, originally from the far north, fierce and warlike in temperament. Writing at a later date about this tribe, Morris commented, "They lead an isolated life as none of the other tribes can learn their language." While at their camp he also painted Big Wolf, a minor chief.

On 8 September 1907, it snowed and Morris headed for Calgary, where he lunched with the Macleods (widow and daughters of the late Col. J.F. Macleod, earlier Commander of the North West Mounted Police,) and next day went out to see Superintendent Primrose at the Mounted Police barracks at Fort Macleod, to arrange to have him drive him to the Blood Reserve at Lethbridge. While in Calgary he also met Sheriff Duncan Campbell. Campbell recalled attending a dinner at Fort Garry given by Morris's mother for Dalrymple Clark, then Adjutant of the North West Mounted Police, and his bride, and for R.S.

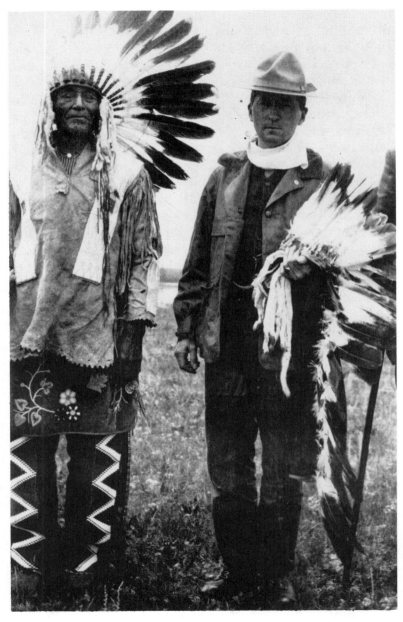

Edmund Morris (Kyaiyii) and Chief Nepahpenais, c. 1908-09
Photo: Edmund Morris
Edward P. Taylor Reference Library, Art Gallery of Ontario,
Toronto. Gift of L.R. MacTavish, 1976.

MacDonnell, a lawyer who had a store at Cluny in the early days and had married one of Crowfoot's daughters. Clark had been one of the signees of Treaty No. 7.

Bob Wilson, the Indian agent at the Blood Reserve, proved to be an ethnology enthusiast, possessing a library on the subject, which was made available to Morris to his delight. At the Blood Reserve he painted Chief Bull Shield, who "comes led by his wife to have me paint his portrait. He is totally blind – has a noble profile," wrote Morris in his diary. His son, Jack, was interpreter at the Indian agency. Coats were exchanged by Morris and his next subject, Strangle Wolf, who gave Morris a blue flannel coat with ermine skins and beadwork. Morris gave him a buckskin coat with beadwork.

Morris also painted Joe Healey (*Potina*) in feathered head dress. His father had been a friend of Mr Healey, a Yukon trader at Fort Benton. When the father died, Mr Healey promised to educate the son. Morris commented, "Joe Healey has the cunning of both white and red men and unlike the other older Indians, speaks English." Other Blood portraits painted by Morris were of Chief Blackfoot Old Woman (*Apinokomita*) and Mike Oka.

In October, Morris received word from J.L. Fleetham, Indian agent at Morley, that the Indians there were gone hunting and there was no point in him coming to the reserve. "I wish," wrote Fleetham, "you would visit on New Year's day and I would have a show that would astonish you. They always come home for that day and are dressed to kill and some three or four hundred men and women are mounted on horseback visiting at the Chief's house where they are entertained in lavish style."[8]

Back in Toronto, Morris had many of the photographs taken during the course of the year reproduced and sent off to the reserves. Running Rabbit, Iron Shield, the Cutter Woman, and John Drunken Chief at Gleichen were pleased to have their photographs, wrote Father Laverne during the winter of 1908. Fr. Laverne had succeeded in drawing some of Running Rabbit's background out of him and sent this history along to Morris. Laverne not only collected much historical data from the Indians but also included the clans to which they belonged, their Indian names, and a French translation. Iron Shield, John

Drunken Chief and the Cutter Woman, he wrote, belonged to the clan *Etseekeenaux* ("*ceux qui ont des souliers*"; i.e., "those who have shoes"). Running Rabbit and Bear belonged to the *Essakay-oke-kay* ("*ceux qui campent loin les uns des autres*"; i.e., "those who camp far from the others"). Weasel Calf belonged to the *Omarketsimanex* ("*ceux qui ont de grandes provisions de viande séche*"; i.e., "those who have large provisions of dried meat").

In January 1908 Morris also sent photographs of the three chiefs of the Piegan reserve at Brocket to Father Doucet: Running Wolf, Big Swan and Bull Plume. In reply Father Doucet wrote,

> I will read your letter to Running Wolf . . . he is a good old man . . . Chief Butcher brought the other day for you a black stone pipe and stem, very old, a good specimen of the ancient Indian art in that line. Also two little fossil stones – amulets – very old. They used them especially for luck hunting buffalo. Butcher got them from some other Indians. He says that he will be thankful if you would send a ring to him.[9]

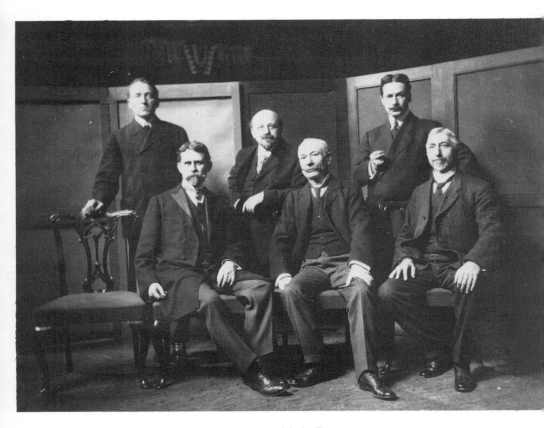

Members of the Canadian Art Club, Toronto
(standing, left to right: Edmund Morris, Archibald Browne,
Curtis Williamson; seated, left to right: A. Phimister
Proctor, Horatio Walker, W.E. Atkinson)
Archives of Ontario, Toronto

Chapter Six

Launching the Canadian Art Club

Edmund Morris had become a member of the Ontario Society of Artists in 1905. It was an exclusive group, membership being by election. Acceptance into the Society was the pinnacle of success for an artist living in Toronto in 1905. However, in 1907 Morris resigned, as did several other disaffected members, to form their own association – the Canadian Art Club. Its purpose was to provide Canadian painters living and working abroad an opportunity to exhibit their work at an annual show in Canada, exposure not offered by the Society. In addition, non-members might be invited to show their work with the Club from time to time.

The initial group consisted of Morris, Horatio Walker, Curtis Williamson, Franklin Brownell, J. Archibald Browne, Homer Watson, and W.E. Atkinson. Homer Watson, of Doon, Ontario, was the first president, and Curtis Williamson acted as honourary secretary. D.R. Wilkie, prominent banker, became their patron and served as honourary president. These men were all friends of Morris, most of whom had painted with him at one time or another.

The Club held its first exhibition in February 1908. It was formally opened by Lieutenant-Governor Sir Mortimer Clark. D.R. Wilkie gave an opening address, saying it was not opposed to the Royal Canadian Academy but intended to produce a "strong, vital and big Canadian spirit . . . like our northwest land."

Morris showed *Northern River, The Mourner, Bull Plume – Piegan Chief, Iron Shield* (loaned by the Government of Ontario), *Cap Tourmente, Old Scottish Mills, Wolf's Cove* (loaned by D.R. Wilkie), *Bout de l'Isle,* and

Willow. A reviewer wrote that his contribution was the work of

> a rising and ambitious artist [who] shows his power of delineating character and representing national types in his admirably painted Indian chiefs . . . the calm, dignified and reserved force of the Indian is convincingly portrayed . . . his landscapes are strong and show a feeling for nature's ruggedness which is refreshing in these days of too much prettiness in pictures. His pictures are entirely unconventional and indicate an originality of conception and execution rarely met in the work of a young man. Here and there one comes across a poetry of art but his pictures appeal more to the sense of strength and vitality of truth than to the ideal.[1]

The Assize Court of the old County Court House, at 57 Adelaide Street, became the home of the Canadian Art Club. In 1909 the names of painter John Russell, of Paris, France, and sculptor A. Phimister Proctor, of New York City, as well as that of Toronto sculptor Walter Allward, were added to the membership. That year, Maurice Cullen, Clarence Gagnon, Robert Harris, and Laura Muntz, all of Montreal, also were invited to exhibit with the group.

From its initial year, numbers of lay members of the club increased steadily, and included prominent people in the arts, professions, politics and other fields. In 1909 lay members included writer W.M. Boultbee, architect Frank Darling, the Hon. Senator Jaffray, writer Newton MacTavish, and many other Toronto personages.

Having helped to launch the Club, Morris was occupied with making plans for another westward journey. From the Blood Reserve agency at MacLeod, Alberta, he received a letter in April telling him that the Bloods were going to Calgary for a parade and that he should come and see his favourite tea dance. A sun dance was also on the programme. The agent suggested Morris might play the role of medicine man.

Also in April, he received word from the Department of Indian Affairs at Ottawa that they would purchase

96

three Indian portraits, unframed, at forty dollars each, the subjects being Old Sun, late Head Chief of the Black-foot, his "celebrated" wife, and Red Crow, late Chief of the Bloods. The same month, the Rev. John McDougall, a missionary among the Crees of Calgary, wrote suggesting he visit *Pakan*, an Indian living at Whitefish Lake, who had been with his father at the Fort Pitt signing, and, as far as McDougall could recall, was the only one living who had taken part in the 1876 Treaty signed there. McDougall also suggested, as subjects, *Piapot*, resident with his band at Long Lake, near Regina, Moosonee and Thunderchild, at Battleford; and Samson and Ermine-skin, at Hobema. He directed Morris to Prince Albert, Saskatchewan, where he thought Morris might find some Sioux. "The old chiefs and head men" he wrote, "are passing out rapidly."[2] McDougall had met Alexander Morris in 1876 at Fort Pitt, where he had been a Methodist missionary and a witness to the 1876 Treaty.

Morris followed up these leads, but in May heard from the Indian agent at Birtle, Manitoba, that *Piapot* had died about a week previously and that no Indian dances by the Sioux were held at that agency.

In June, Morris received further genealogical information on the Blackfoot from Laverne. Black Eagle, he reported, belonged to the *Miopinni-max* clan ("*ceux qui tiennent serre*;" i.e., "those who hold talons or claws"); Slow Coming Over the Hill belonged to the *Etsikinaex* (the same clan as Iron Shield); and Far Away Echoes belonged to the clan of *Eskristsisokeekway* (a word without meaning, according to the Indians). Laverne had been told that Drunken Chief was a false translation of that Indian's name. Taking His Gun was the true translation of the name *Awat-si-na-markaw*; its bearer was a true nephew of Crowfoot. Morris had sent postcards and photographs to these Indians, and Laverne reported that they were very pleased to receive them.

Early in the year, Morris wrote many letters in an effort to locate the remaining chiefs who had signed Treaty No. 4, the Qu'Appelle Treaty. In May he heard from W.M. Graham, Inspector of Indian Agencies at Bal-carres, Saskatchewan, who thought that nearly all of the chiefs participating had died. He suggested that

Morris come out to Indian Head and drive across to LeBret, where Rev. J. Hugonnard ran an industrial school. Rev. Hugonnard had been present at the signing of the Qu'Appelle Treaty. Graham hoped Morris would visit him at his File Hills home, for, he wrote, "I remember your father very well."

In June, the Premier of Ontario officially informed Morris by letter that, although the Cabinet was pleased with the thirty-five portraits he had already completed for them, which were now hanging in the Ontario Legislative Building, the government did not wish to commission further work that summer.

About this time George Eaton Lloyd, Archdeacon of the Diocese of Saskatchewan Divinity School, wrote to Morris from Prince Albert, reporting that the only Indians in the neighborhood of Fort Pitt were at Onion Lake, about 20 kilometres north of the Saskatchewan mission. Rev. J. Matheson there was an "old-timer" and might be able to help him, as he knew more about the past and present Indians than anyone else in Lloyd's acquaintance. Morris then wrote to Matheson and in August received a letter from Onion Lake which reported that the best representatives of the Cree could be found there.

"One adopted son of Big Bear," wrote Matheson, "named Thunder Bird is a fine type of Cree Indian, mentally, morally, and physically, and is a Christian." Another was Bad Hand, an "out and out heathen" but a perfect Cree except for being slightly disfigured by smallpox.

> They all knew your father at the time of the First Treaty of 1876 . . . I also knew Governor Morris . . . I do not know of any place in all the northwest of Canada where you can find purer specimens of the Cree tribe. They have not been contaminated by contact with the white man as in too many other places. If you come, I shall be very pleased to have you put up with us . . . be assured of a kindly, old-fashioned welcome without any frills . . . let me know when you are coming. Take the CNR to Lloydminster which is 35 miles south. I will have a team and rig to meet you.[3]

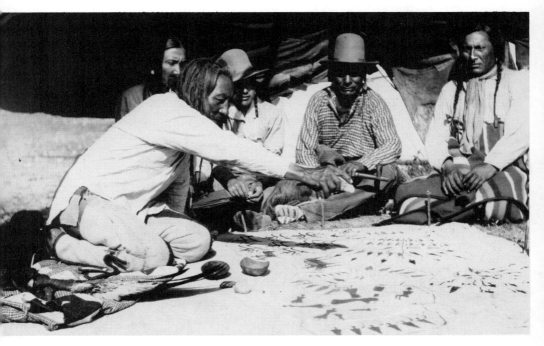

*Several Indian Chiefs were persuaded by Morris to have their
life stories painted on buffalo robes provided by him* (the
chief at the left may be Running Rabbit)
Photo: Edmund Morris
Manitoba Archives, Winnipeg

Despite the Ontario government's decision, Morris left for the west and Onion Lake, where he painted eight Cree portraits during 1908. He was fortunate in having as his interpreter, Peter Hourie, who had acted as interpreter for his father and for General Middleton, whose son had captured Louis Riel. Hourie was able to tell him a lot about the Indians, both past and present.

The Crees had occupied a large territory lying between Lakes Athabasca and Winnipeg, and from Hudson's Bay to the Rocky Mountains, the Churchill River forming the dividing line between their country and that of the Chippewas to the north; their hunting grounds to the south overlapped those of the Dakotas or Sioux. They were closely related to the Chippewas or Saulteaux, with whom they associated. Fire-arms provided by the English trading out of Hudson's Bay in the seventeenth century equipped them to descend on the Blackfoot, with whom they kept up continuous warfare. The Crees, reported Morris, were friendly to the British and would not join the Sioux in their plan to exterminate the whites. Morris considered that the majority of half-breeds in the west were of Cree blood, since early employees of trading companies had tended to marry Cree women rather than native women of other tribes. The Crees surrendered their vast territory to the Crown with the Treaties signed at Fort Carlton and Fort Pitt in 1876.

Cree portraits painted by Morris in 1908 were of Walter (*Ochopowace*), whose father was a chief and son of Loud Voice, principal chief of the Crees who had signed the Qu'Appelle Treaty; Splashing Water (*Chakikum*), one of the troublesome Duck Lake-Willow Crees; Spring Man (*Kahmeeusekahmaweyenew*) Head Man of the File Hill Crees; Feather (*Mequinis*); *Pimotat*; The Front Man (*Nikanabeao*), Head Man of the Crees in Alberta. The latter, wrote Morris, was "in his day a great warrior. Although a very old man, he stands erect and is of great height." Of *Pimotat*, he recorded, "One of the most advanced of the Crees, and like most of his tribe, generally wears European clothes. He has an excellent farm."[4]

While in Saskatchewan during the summer, Morris heard from Father Doucet at the Piegan Reserve. "Chiefs Butcher, Bull Plume and Running Wolf are pleased to

100

have their portraits in the 'Big House of Big Chief' " (referring to the Ontario parliament buildings in Toronto).

> Chief Bull Plume says the straight pipe is very old.
> It is the great beaver pipe used in the beaver dance
> held in the spring. Two beavers are carved on it. It
> cost 10 horses. He has come in and requests me to
> write – "My dear friend, Bear Robe [Kyaiyii] I shake
> your hand. I am glad to hear that you are well. I am
> well but my wife is not quite well. I come from the
> mountains a nice country. I killed many fish. I have
> no rations on the reserve. Chief Butcher has none
> either. I have lots of horses. I will have to sell some
> to get something to eat. I have a good field of pota-
> toes. It will help me . . . I thank you for the flag you
> sent me. I like it and for the medal also. My wife got
> the ring you gave me. She likes it. I have a medicine
> whistle and another rare thing for you. I like if you
> send me a cane," signed Bull Plume.[5]

Sioux and Assiniboine portraits were also painted by Morris in 1908. Writing about the Sioux on a later occasion, Morris commented that when the Canadian government had granted them land after they crossed the border from the United States, Lieutenant-Governor Morris had told them never to let go their hand from the plough. His observation of their large and well-cultivated farms in the west led him to believe that they had taken these words to heart.

At Griswold, Manitoba, Edmund painted a portrait of Antoine Hoke, a Sioux Medicine Man. He was described by the artist as well-built and strong but very old and almost blind. He told Morris that Lieutenant-Governor Morris had told him if his people kept the peace they would see their children and children's children growing up about them and prospering, "and" wrote Morris, "it is true."[6]

Of the Assiniboines, Morris wrote that they belonged more properly to Canada than did the Sioux, from which family they had sprung: "originally they belonged to the Yankton Sioux, separating from them the same time as the Mandans and like this last tribe, were among the most warlike. Withdrawing to the land of the Algonkins,

the Assiniboins occupied the narrow strip of diagonal country from the Mouse River to the upper part of the Athabasca River. They joined with the Saulteaux to fight the Sioux and with the Crees against the Blackfeet."[7] Smallpox in 1786 and again in 1838 wiped out half of the prairie tribes. They moved north, and, when Morris was painting in 1908, their descendents were still at Morley and Lake St. Anne, Alberta, as well as in Saskatchewan. Great hunters and expert canoeists, they were called *Watatopan* – "canoe men". Morris described them as a noble-looking race; "the men being tall and of fine bearing, in this resembling their kinsmen, the Sioux."[8]

Assiniboine portraits painted in 1908 included: Chief Carry the Kettle (*Chagakin*), a great hunter; Big Darkness (*Opazatonka*), a head man, but who had left his reserve and crossed the border without consent of the Indian Department and was thus deposed; Dan Wildman; and Chief Peter Wesley of the Stonies, a great hunter accustomed to go on foot in advance of his camp, the others joining him in the mountains. "This has been his custom all his life," wrote Morris. "The Stonies leave in the autumn and remain in the Rocky Mountains hunting until the New Year."[9]

One of the last portraits he painted before the end of the season and his return to Toronto was of Yellow Quill (*Auqawaquin*), Chief of the Saulteaux Portage Band in Manitoba, "standing six feet tall and still erect at age 76." He had once been appointed Chief of the Band by the Hudson's Bay Company in the absence of Short Bear, the hereditary chief who had left for the plains. When Short Bear returned, recorded Morris, trouble arose. In 1876 Lieutenant-Governor Morris divided the band into two separate sections, acknowledging both chiefs, but during the Treaty negotiations Yellow Quill's life was in danger and he had to be protected by an Indian soldier.

In December, Doucet wrote to Morris from the Piegan Reserve.

> The Chiefs here do not forget you, especially our old friends Running Wolf, Big Swan, Chief Butcher and Bull Plume. They shake hands with you. I told them that you are back home and do not forget them. I

have seen Bull Plume. He sends his best regards. He is the best I know in the reserve to paint skins in the Indian ways. He said first he would rather paint on strong paper in book form but as I told him that you like better to have it done on the buffalo robe, he said he will do it on the robe the way you like it. He is well informed about war paths. He promised to paint the wars, etc. of Old Running Wolf, Big Swan, Chief Butcher, and himself for he has been on the warpath in his young days.[10]

Subsequently, however, Bull Plume insisted on each chief painting his own story, and in March Doucet wrote to Morris that the commissioned robe had been completed. Running Wolf, Big Swan, Chief Butcher, and Bull Plume had each painted their own recollections. Just previous to writing, Doucet had packaged and mailed the painted robe from the Brocket post office. In his letter he included a translation of the pictures drawn on the robe. It arrived in Toronto in time for Morris's major exhibition at the end of March.

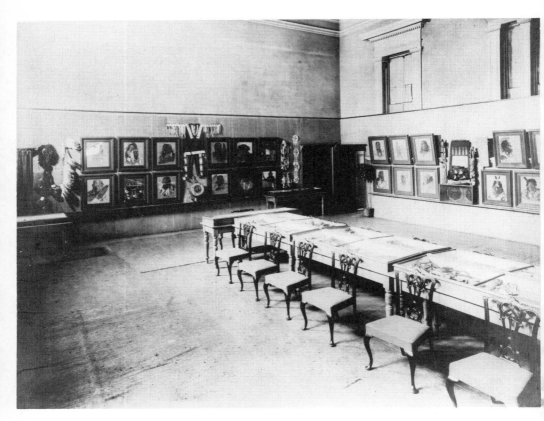

Installation view, Edmund Morris Collection of Indian Portraits and Artifacts at the Gallery of the Canadian Art Club,
57 Adelaide St. E., Toronto, 29 March – 17 April 1909
Edward P. Taylor Reference Library, Art Gallery of Ontario,
Toronto.
Gift of Edgar J. Stone, 1953

Chapter Seven

A Major Exhibition

The second annual exhibition of the Canadian Art Club was held 1 to 20 March, 1909. In his opening address, E.F.B. Johnston reiterated that there was no animosity between the Canadian Art Club and the Ontario Society of Artists or the Royal Canadian Academy. He spoke of artists in other countries who had broken with current painting traditions and set up organizations some of which later became important schools. One such was the Barbizon School in France, with such men as Corot, Diaz, and Millet as members. In Scotland, the Glasgow School, composed of such men as Guthrie, Lavery, Henry, Walton, and others, "made a new and marked departure." Among the Dutch painters of this type he listed Josef Israels, the Maris brothers, Anton Mauve and a few others. Some were painters whom Edmund Morris admired and had come to know while sketching in Europe – for instance, Fraser and Brough in Scotland, along with Henry and Guthrie of the Glasgow School, and the Maris brothers in Holland.

Mr. Johnston referred to the work of Edmund Morris as showing the motive of the Club: "Vigorous conceptions and vigorous executions, his landscapes mark an artist who refuses to be bound by conventional methods of expression and desiring independence of thought and action works out through his own individual temperament the thoughts of art which possess him."[1]

Professor James Mavor, writing about the exhibition, spoke of Morris's "luminous" landscapes and the four portraits of Cree, Assiniboine and Saulteaux Chiefs shown as "vigorous and faithful renderings of remarkable types of which it is very advisable to preserve authentic records."[2]

The Canadian Art Club exhibition was followed at the end of March by what was to be the major showing of Edmund's Indian portraits.

Despite the Ontario government decision not to buy the additional portraits painted in the west, A.H. Colquhoun, Deputy Minister of the Ontario Department of Education, personally wrote to Sir James Whitney, the Premier, on behalf of Morris, urging the Cabinet to reconsider. Paul Kane's work had recently been purchased by E.B. Osler for $20,000 and given to the museum, and Edmund's work would supplement the province's Indian record. Subsequently, Morris obtained an interview with Premier James Whitney and proposed holding an exhibition of his latest work in order to elicit public opinion as to its worth. This proposal was accepted and Morris prepared his work for exhibition under the auspices of the Canadian Art Club, and, at his own expense, had a catalogue printed containing an Indian tribal history, as well as biographical outlines of his individual subjects.

In March he sent off a copy of the catalogue to W.J. Hanna, Provincial Secretary, with a covering letter assuring the Secretary that when he saw the collection he would recognize that it had a definite meaning, adding "I hope you will agree to acquire the last of these relics and in this the province will have a collection it will be proud of in years to come." Morris was not apolitical. He concluded his letter, "I have carried on this work at great inconvenience and look to my party to cooperate in this very important work."

The exhibition opened on 29 March 1909 at the gallery of the Canadian Art Club, 57 Adelaide St. E., Toronto, and ran to 17 April. Fifty-five portraits of Indian Chiefs and Headmen and two women, the Widow Betsy and the Cutter Woman, were displayed. Also shown was Morris's collection of objects of Indian art and curios. The exhibition was well covered by the press. In addition to prominent Toronto socialites, bureaucrats, and Morris relations, the opening was attended by such colleagues as George and Mary Hiester Reid, Archibald Barnes, and Curtis Williamson. In all, over 200 visitors were present. In his introductory address, Sir Edmund Walker, Chairman of the Board of Trustees of the National Gallery of Canada, commented, "I need not tell you these portraits of Mr. Morris are quite different from the often voracious but always inartistic portraits of Indians by most other

106

painters. These are works of art as delightful in colour as they are vigorous in drawing and searching analysis of Indian character."[2]

One lengthy review of the exhibition mentioned Morris's father, the years at Fort Garry, and the background of the portraits on display. Of the latter the reviewer wrote:

> There is something majestic about their air of superiority. For the younger red men who live in houses and wear store clothes, these old fellows have nothing but contempt. They call them dogs and turn with sorrow to the days of their departed glory. The other side of the picture is seen in the letters in Mr. Morris's collection in which old Chiefs plead pitifully with the artist that he will see that the Chiefs down here [the government] send them lots of "grub" and treat them well. This is a long way from the days when these same Chiefs rode the prairies free as the wind, hunted the buffalo and lived in their own way, like princes.
>
> Mr. Morris's earlier Indian portraits which number 35 which already form part of the permanent collection of the Ontario government, represent the head Chiefs of the Ojibway, Blackfeet, Piegan, Blood and Sarcee tribes. Last year he completed 20 more portraying the leaders of the Saulteaux, Assiniboine, Sioux and Iroquois tribes. Practically all the men and women he painted are yet alive but they are advanced in age and very shortly will pass to the Happy Hunting Grounds.
>
> The collection of Indian curios apart from those collected by Mr. Morris himself and those gathered by his late father are the property of D.R. Wilkie and B.E. Walker. They are very valuable and of great interest when their proper significance is understood. Some of the most important things in the collection are the coats presented by Chiefs Sweet Grass and Yellow Quill to the late Governor Morris. Then there is a buffalo skin on which is recorded in primitive picture writing the history of the Head Chief of the Sarcees, Bull Head, and another showing the

history of the Chiefs of the Piegans . . . there is also some beautiful woven transparent beadwork and embroidery in silk on antelope skin made by the half-breed women of the Mackenzie District and presented to the late Mrs. Morris, a wonderful example of Indian handicrafts.[3]

Another review read in part,

These old Chiefs may rightly be regarded as the sole survivors of the great race of redmen in Canada . . . they have all known service on the warpath and they have all given proof of their valor and discretion . . . they are painted with great directness and simplicity . . . the whole collection is a superb index of the different tribes of the West . . . the value of these pictures of Mr. Morris will . . . go on increasing according as they become more and more impossible to duplicate and according as the state of things they chronicle becomes more and more remote.[4]

A reporter from *American Art News*, published in New York, arrived on the scene, and his subsequent review appeared in their 24 April issue. He chose *Iron Shield* and *Bull Plume* as the two most outstanding portraits shown. "When first seen these portraits are criticized for the brilliance of color but when compared with the original garments, some of which Mr. Morris has hung between the groups of portraits, one sees that the artist has really been working in half tones and subdued lights."[5]

Edmund's own collection of Indian clothing and artifacts on view included head-dresses, robe decorations, clothes of Runner, brother of Chief Carry-the-Kettle, who named Morris *Waowan*, meaning "He who transfers us to paper", and a war coat of Chief Strangle Wolf. The two buffalo robes depicting the histories of the Piegan and Sarcee Chiefs formed a unique feature of the exhibition. Edmund's collection, totalling ninety-seven items, consisted as well of numerous necklaces, moccasins, belts, fire bags, Indian implements, pipes, arrow heads, etc. The B.E. Walker collection totalled twenty items and was listed as having been collected by Morris while he was painting among the Indians. The Morris family collection originally

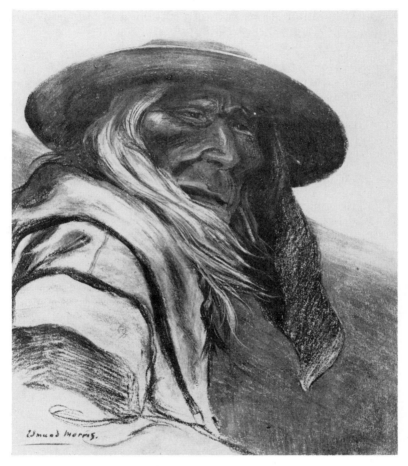

Slow Coming Over the Hill – Blackfoot
(Photograph of original pastel in collection of Royal Ontario
Museum, Toronto)
Photo: Edmund Morris
Manitoba Archives, Winnipeg

owned by Alexander Morris contained twenty-five articles. Small wonder that this impressive display attracted much public attention.

In an April editorial, the Toronto *Globe* took the Ontario government to task for not having purchased the recently completed portraits. "Art is long in this beloved Ontario of ours," stated the *Globe*.

> Mr. Morris has been devoting some of the best years of his life to the painting of rapidly vanishing Indian Chiefs. The Ontario government pays him the by no means munificent price of $100 a portrait and some gentlemen who probably would have difficulty in telling a chromo from a painting are sneering at the purchase. No wonder young Canadian artists go abroad whenever they can earn passage money.[6]

The veracity of Morris's work was affirmed by Father Doucet in a letter to him following receipt of the 1909 catalogue:

> I could easily recognize the different tribes from the portraits – the Piegan, the Blackfeet, the Bloods . . . you have studied with greatest care each feature of their physiognomy, each detail of their costume, all noted with exactitude . . . one would recognize them at first sight . . . The Piegans who have seen their portraits have admired their great ressemblance to the Indians they represent. It is a success which merited your patience.[7]

The closing night of the exhibition, Morris gave a "smoker" for his friends and supporters. In his diary he recorded that Horatio Walker and Phimister Proctor came up from New York for the occasion and that Proctor and he executed a war dance for the amusement of the assembly, Morris beating a tom-tom.

Struck by the general enthusiasm of the press and the public for the exhibition, the Ontario Cabinet approved commission of a further twenty-five portraits.

Having delivered twenty of these to the Legislative Building, Morris left Toronto in July 1909 and headed west again, spending a fortnight in Winnipeg. Writing

later he described the art in that city as "excruciable." He had determined that the Canadian Art Club would not exhibit there until a better gallery was offered to them.

Earlier in the year, Morris had written to the Premier of Saskatchewan, the Honourable Walter Scott, urging a commission of portraits for the new parliament buildings being built in Regina. Having lived among the Indian tribes of northern Ontario, Manitoba, Saskatchewan and Alberta for the past three years, painting "the best types to be found," he had heard from several quarters, that the Saskatchewan government was being pressed to commission a series of portraits of the "former owners of the province" for the new parliament buildings. "No time should be lost," wrote Morris,

> as the Indians who went on the warpath and hunted buffalo are fast disappearing from the scene and the younger generation are losing their identity. I have completed the work for the Ontario government and as I intend to visit the tribes of Saskatchewan again this summer, I shall be glad if you will bring the matter before your ministers. I have become deeply interested and would like to continue this important work, the value of which from a historical, ethnological, as well as artistic standpoint, is very apparent. I may say that the Indians are very friendly to me, my late father, Governor Morris having negotiated so many of the treaties.[8]

The premier was hesitant and Morris wrote to him again in July offering to paint twenty-five portraits representing the Indian tribes of that province within the next two years. The Hon. Walter Scott evinced interest but said he had to bring the matter before his cabinet. Edmund wrote to him again early in September, saying that "some of the best types are liable to shuffle off to the happy hunting ground where they will be again young and have lots of horses and buffalo."[9] Finally, late in September, he received a commission from the Saskatchewan government for fifteen portraits. As the legislative buildings would not open until late 1910, Scott proposed

that five portraits be delivered on or before the first of September 1910, and the remainder in 1911.

About this time, Morris received word from Toronto that there had been a fire in the Legislative Building and that every room in the west wing had been deluged with water. The library had been gutted and would have to be rebuilt. Fortunately, Sir James Whitney and his cabinet personally "took a hand" in saving Edmund's paintings. This incident impressed him with the need for a better-protected and more secure location for his work, a subject that was later to engage his attention and energy.

Meanwhile, in July, Morris had met the Hon. Alexander Rutherford, Premier of Alberta, at Banff and obtained a commission for five portraits for the parliament buildings in Edmonton. Leaving Banff, Morris went to Calgary and again to the Blackfoot Reserve. *High Eagle*, his first portrait for the Alberta government, was painted there. High Eagle was the "best hunter" of the Blackfoot and a brother of Iron Shield. High Eagle and John Drunken Chief, (both nephews of Crowfoot) whom he found at the same camp, had much Indian lore for Morris. Through the interpreter, he questioned them about the bands into which the Blackfoot were divided. Later, Morris persuaded John Drunken Chief to show him the grave of Poundmaker, Crowfoot's adopted son, who had died a tragic death in 1886 after being jailed for his part in the North West Rebellion.

Prior to this, Morris had had a letter from his friend, William Brymner, then at Louisbourg, Nova Scotia. Brymner, in speaking of his experiences among the Indians while in the west, related an account of Poundmaker's funeral in 1886. According to Brymner, a coffin had been made for the Chief which was large enough to hold the belongings he would take to the Other World. When Brymner arrived at the Blackfoot Reserve, he found Dr. Duncan Campbell Scott, the Superintendent of Indian Affairs, with some Crees digging a grave. When the funeral was to take place, Brymner asked if he might represent the Department of Indian Affairs in place of Dr. Scott. Scott had no objections so Brymner set off for the burying ground where he found Crowfoot sitting with two

squaws under a blanket supported by poles. Six or seven Crees were also present.

The burying of Poundmaker was not a simple matter. First of all, the Indians had great difficulty in getting the wagon carrying the coffin near the grave; then the nails used to fasten the coffin lid down flew in all directions and would not go into the wood. Brymner finally took a hand, when asked by Crowfoot to do so, nailing the lid down and helping to remove the coffin from the wagon. Then the casket was found to be too large for the grave and had to be replaced with great difficulty in the wagon. Eventually, after additional digging had been done, the burial was completed.

Of Doucet, Brymner wrote that he was a fine fellow; when Brymner had visited the reserve he had been with the Piegans already sixteen years "in greater or lesser misery, living without a house, and just as the Indians did, but he told me that up to that time he had not managed to make a single convert."[10] Brymner had spent some time with Bull Bear and had attended sun dances, which he described for Morris in detail.

On visiting it in 1909, Morris found that Poundmaker's grave had fallen in. He engaged John Drunken Chief to fill it in with earth, and bring a cartload of stones from the Bow River to build a mound. Morris then inscribed Poundmaker's name and two crosses on a slab. One of the crosses was in the Indian style indicating the points of the compass, while the other was in the mode of the Roman Catholic faith, which Poundmaker had espoused. Morris considered Poundmaker to be one of the greatest of the Indian race. He related in his diary that he recalled once going into his father's office in Toronto at the time of the Rebellion, and finding his father much distressed over a news report. When he asked him what was wrong, Alexander Morris replied that they had imprisoned Poundmaker.

In his diary, Edmund recorded, "After I had marked the spot of this old warrior . . . I get by post from the Indian Department the book, *People of the Plains*, with my portrait of *Poundmaker*."[11] Dr. Scott had earlier asked Morris's permission to use the painting of Poundmaker that the Department had purchased some years before,

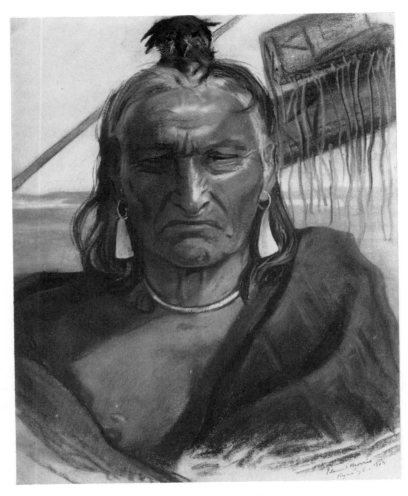

White Buffalo Calf (Child-Unistaipoka)
Pastel on paper, 63.9 × 50.1 cm. (25-³/₁₆ × 19-³/₄ ins.)
Government of Alberta, Edmonton

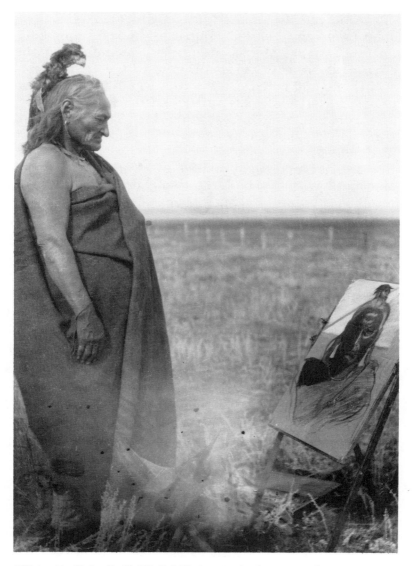

White Buffalo Calf (Child-Unistaipoka) viewing his portrait,
c. 1909
Photo: Edmund Morris
Manitoba Archives, Winnipeg

along with a drawing of *Moonias*. The book was written by Mrs. Amelia Paget, a daughter of Alexander McLean, a factor of the Hudson's Bay Company, who had been captured by Big Bear at Fort Pitt in 1885.

After completing the work on Poundmaker's grave, John Drunken Chief took Morris to the last camp of his uncle, Crowfoot. Morris observed in his diary that the circle of stones with the small circle for the fireplace was still there, and noted, "It was in a beautiful spot in the prairies, overlooking the valley and Blackfoot Crossing. The Indians encamp in beautiful places. The Indians will mark for me the spot where the Blackfoot Treaty was made in 1877."[12]

Morris had brought to the west several buffalo robes on which he hoped to have the history of additional chiefs recorded. Running Rabbit was one of these, dressing in his traditional costume, while his son recorded his recollections on the robe provided by Morris.

Still at the Blackfoot Reserve, Morris painted *Chief Spring Chief (Ninan Rsis Rum)*, his second portrait for the Alberta Government. Described by Morris as a fine, strong specimen, Spring Chief was a headman and minor chief and a son of the late Chief Three Bulls, whom Crowfoot had named as his successor.

Wolf Collar, a relative of Alexander McLean and Mrs. Paget, came to the camp to be painted. He was a Blackfoot Medicine Man, his Indian name being *Makoyoki-na-si*. He had abandoned his original profession and was now employed by the Anglican Church. This portrait also became part of the Alberta government's collection.

Going to the north camp of the Blackfoot, Morris stayed with David Brereton, son of Judge Brereton, who had many stories to tell about the Indians, including Crowfoot, and about the Blackfoot actions during the Rebellion of 1885. These Morris later put down in his diary. He also went out to see old Calf Child, whom he had painted in 1907. Old Calf Child's wife, a Sarcee woman whom he had captured when a girl, was then very ill, but as she was old the Indians approved of her dying. Morris had brought a buffalo robe along and hoped old Calf Child would consent to have his history recorded. Too blind to record his own history, he agreed to relate it to Peter

Erasmus, a veteran interpreter who had acted as inter-preter at the signing of Treaty No. 6 at Fort Pitt in 1876. Calf Child spoke Cree and related his history in that language for Erasmus.

Erasmus, himself now elderly, related some of his own interesting history to Morris. As a young man he had acted as a guide to the Palliser expedition of 1857-8, crossing from Carlton to the mouth of the Bow River and into the Blackfoot country. His father, a Sarcee chief who married a Swampy Cree woman, wanted Peter to go into the church. Peter had translated the Gospel of St. John into Cree and acted as interpreter for the Rev. Thomas Wolsey, missionary to the Stonies, later assisting two clergymen in preparing a Cree dictionary. Morris re-corded that his influence at the time of the Rebellion was a "godsend" to the authorities involved.

Old Slow Coming Over the Hill was the oldest man on the reserve. Writing of him later, Morris recorded that he had a herd of 200 horses and expected to take them with him when he went to the "happy hunting grounds." He speaks of seeing "his old stooped figure with staff in hand walking far over the plains . . . when I arrived he came and sat taking it all in – then got active in carrying in my outfit and arranging it for me."[13] At this camp Morris also painted the wife of Water Chief.

Wherever he went, Morris continued to collect the history of the individual Indians. He engaged Spring Chief (son of Three Bulls) to drive him through some sand dunes to a slough where Indian coffins had been piled. Here he later painted a picture of Indian death lodges. Then on 25 September, he drove to Gleichen to meet his friend, Phimister Proctor, who had arrived from New York City. Proctor's father was an Englishman from Cornwall who had come to Canada, and after went gold mining in Colorado. Phimister had lived an outdoor life in the mountains of Colorado and Montana and had hunted and killed big game animals. He anticipated trouble with the Indians in Canada similar to that which he had encoun-tered in the Colorado and Montana mountains. Proctor "could hardly accustom himself to our peaceful Indians – always had a gun ready," wrote Morris.[14]

117

Proctor was looking for "big game" but went with Morris to camp in the Bow Valley for awhile not far from the deserted St. John's Mission. Morris described the scenery as a "splendid variety of grass and shrubs" among the sand dunes.

Spring Chief offered to drive Morris and Proctor through the dunes. They visited Running Rabbit and his wives, who were preparing their lodge for winter. Morris and Proctor sketched for several days and on 5 October struck camp and went back to Gleichen, where the intrepid Proctor, called by Morris "a great hunter," was outfitted to go into the foothills in search of mountain sheep. Morris went on to the Piegan Reserve and stayed with his old friend, Father Doucet. In his diary he noted, "The chiefs all drive down to see me."[15] He had brought presents for them and long conversations ensued.

Commenting on the work of Paul Kane, Morris wrote that Father Doucet considered Kane's work to be "trash" and did not "count him an artist." Morris observed "In reality Paul Kane was an adventurer-explorer but his works have a value, and in craftsmanship, they are better than the other Indian painter, Catlin."[16] In Morris's opinion, George de Forest Brush, who had lived among the Indians for awhile, had done much better work. He, like Morris, had been a pupil of Gérôme in Paris.

Among the historical spots visited by Morris was an old buffalo pound of the Piegans in the Porcupine Hills, near a place Colonel Sam Steele had marked as a refuge for the people of Fort Macleod in case of a tribal uprising in 1885. It was a wild place, with a steep, sheer wall of rock over which the Indians used to drive the buffalo. Falling off the cliff, the buffalo would break their limbs and were easily clobbered to death by the Indians. In his diary, Morris reported finding buffalo horns piled three feet deep in the pound below, where he also came across flint arrowheads.

Not far from this site was an ancient Indian burial-ground where Father Doucet said he had seen many remains of Indians in his early days among the Piegans. Doucet spoke of the different ways in which the Piegans and Blackfoot buried their dead: the Blackfoot built death-lodges, usually in a grove of willows, and placed the dead

118

within the lodges, while the Piegans left them exposed to the elements.

By the end of the season, Morris had completed the five Blackfoot portraits commissioned by the Alberta Government, namely, *High Eagle (Pit Anspitan)*, *Chief Spring Chief (Ninan Rsis Run)*, *Chief Water Chief (O'Cena)*, *White Buffalo Calf* or *Child (Unistaipaka)*, and *Wolf Collar (Makoyokinasi)*; the remaining works were intended for the Ontario Government.

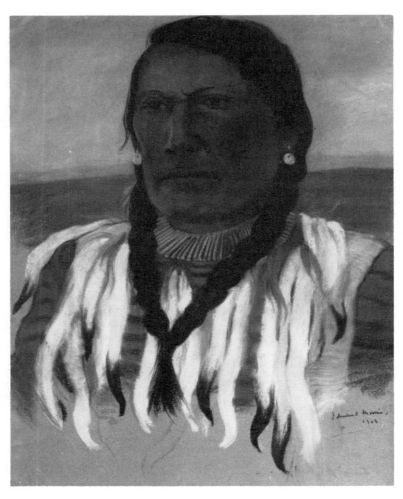

Chief Water Chief (Okena) 1909
Pastel on paper, 63.9 × 50.2 cm. (25-³/₁₆ × 19-³/₄ ins.)
Government of Alberta, Edmonton

Chapter Eight

Champion of the Indian

Throughout the three-year period he spent among the western Indians, Morris's concern for their welfare and future had continued to build as their problems were reiterated to him over and over in correspondence or on his visits to the reserves. Numerous letters written to Morris and now among the Morris Papers attest to the natives' hope that he could act on their behalf to present their case more clearly to "the government" or "the Big Chiefs", as they called the prime minister of Canada and his cabinet.

Representative of these frequent appeals is a letter from Chief Running Rabbit dated 24 January 1909,which was forwarded from Gleichen to Morris in Toronto by Father Laverne. In substance, it states that Running Rabbit and his children are hungry and have no rations, their work in the coal mine being their only source of livelihood. "All are working hard in the coal mine," writes Running Rabbit, adding plaintively, "I have a pipe and a pair of moccasins I could sell."

Iron Shield also wrote in January 1909 to tell Morris how badly the government was treating his people. "We have nothing to eat," he exclaimed. "We are starving and now the government are trying to buy our reserve." Iron Shield vowed it was the best land on earth and had been given to the Indians by the Queen, complete with the hay and coal found upon it, which was to be for the Indians and their children. "I do not want to sell it," wrote Iron Shield, "and Yellow Horse should not be chief any more on account of his willingness to sell it. Tell the chiefs down there to treat us better."

In June the same year Father Doucet reported by letter that the Department of Indian Affairs were trying to get the Piegans to sell part of their reserve and some of them had consented to do so, but some "would not part

with their land at any price." He invited Morris to come "as usual" and stay at the mission in the upper room which he had used before as a studio.[1] A later letter reported that part of the reservation had been sold. Morris also heard that the Saulteaux at Fort Qu'Appelle had agreed, under pressure, to sell part of their lands to the government, their Treaty already having been broken.

Although the stories of tribal wars and horrendous episodes told to him over the three years of his sojourn among the Indians showed why the white interlopers had tended to call them "savages," Morris still retained a feeling of sympathy and concern for the race through those whom he had met and come to know well. Word sent to him reporting the deaths of some he had painted, only increased his concern for those who remained. From Doucet he had heard in July 1910 that Old Running Wolf was in good health. "He is a fine old Indian," wrote Doucet, but, a month later, he reported that "our old friend, Chief Running Wolf" had died suddenly, possibly of heat or old age. Also, he had heard that Bull Shield had had an accident earlier when chasing coyotes and had broken a shoulder and arm; through Doucet, Bull Shield passed on a message to Morris, stating "I shake hands with *Kai-ihye* [i.e., Kyaiyii] and like to see him soon."

By the fall of 1910, Father Doucet had left the Piegan Reserve, having been called to the "immense" Blood Reserve at Standoff, Alberta. "The old Indians", he wrote to Morris, "remember Col. Irvine. They call him *Omark-sistamik*. They loved him for his kindliness and fair dealing with them." A poignant note is added in Doucet's letter: "Brother John did not accompany me to this reserve. He remained with the Piegans, his old friends. He is used to them. It would be hard for him to part with them. I miss him – we have been a long time together.[39] He had heard that Bull Shield had died.

While at Fort Qu'Appelle, Morris received word from David Brereton at Gleichen that old Running Rabbit was sick, partly as a result of the disappearance of the reserve land and the willingness of his band to sell off further portions of the reserve. He also learned that "old Slow Coming Over the Hill passed in his checks" that summer.

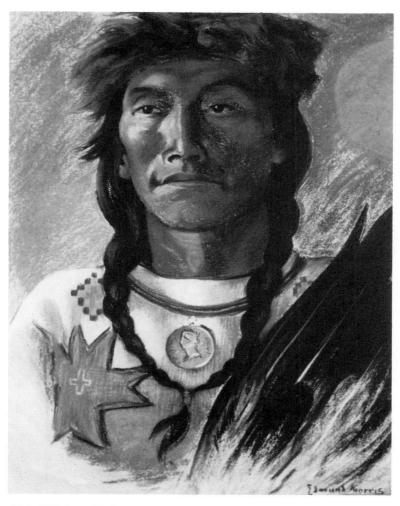

Chief Walter (Ochopowace) 1910
Pastel on paper, 63.9 × 50.1 cm. (25-$^3/_{16}$ × 19-$^3/_4$ ins.)
Saskatchewan Government Collection, Regina

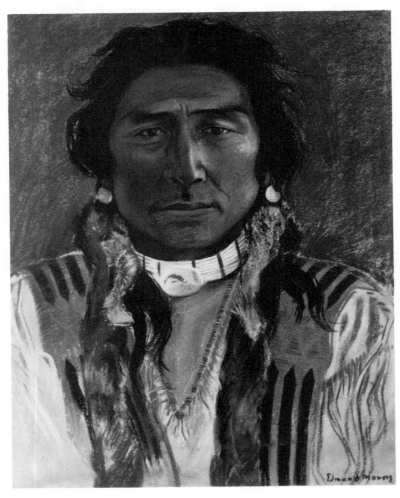

Chief Moses 1910
Pastel on paper, 63.9 × 50.1 cm. (25-³/₁₆ × 19-³/₄ ins.)
Saskatchewan Government Collection, Regina

"Joe Calf Child is still the same old stick," wrote Brereton, "but the old lady died."

In defence of the Indians, Morris in 1910 wrote a lengthy letter to the *Winnipeg Free Press* in which he took to task the writer of an article entitled "Indian Savagery in the West." The article had condemned the religious rites still practised by the western tribes. In his letter, Morris told how he had camped among the Indians for the past four summers and wanted to point out a few things not generally recognized. When the Indians surrendered their land to the whites, they were sun worshippers. "Hardly any of the old generation have given up this faith or in any way conformed to the rites of the church and it would be a breach of confidence for the government to interfere." In the treaties not one word had been said against their religion. He continued, "One of the gravest mistakes has been the forming of missions of different denominations on the same reserve. It only confuses the Indian mind." One old-time Indian he had met had been preached to by a priest, a clergyman, and a minister. Morris related that he had pondered, then said: "When you are all one, I will listen to what you have to say." "They are called savages," wrote Morris,

> yet they are more sincere in their beliefs than many of the whites who are good for one day of the week and play the devil the other six.

> Often I have been awakened by hearing one of the old Indians offering prayers to the sun as it rose above the horizon and it is not singular that these sons of nature should worship the sun. They are realists with a deep-rooted traditional religion . . . they were free men formally leading an active, exciting life full of the chase and warfare. Now all is dull monotony. These people had devolved a way of living that suited their requirements. They were a robust martial race and what are we reducing them to by thrusting upon them our so-called civilization? It would be wise if the government would take advantage of their willingness to form companies of regiments on the different reserves. This has proved successful with the Brantford Iroquois who are attached to the Haldimand regiment.

I have spoken to the young men and all are anxious to have this done. Gen. French and Lt-Col. Irvine of the Royal North West Mounted Police urged this very strongly. Col. Irvine was for a time agent to a portion of the Bloods and brought the question before the department but the then Assistant Commissioner discouraged it . . . what they require is work that interests them. Give them their native dress of buckskin as a uniform and the desire for [offensive] parades will vanish. The discipline will help them and would not interfere with their work of raising cattle.[2]

The historian, E.M. Chadwick, wrote to Morris later about the article, agreeing that it was a mistake to insist on the Indians abolishing their traditions. In his opinion, they should be encouraged to retain their old-time characteristics. "It is from whites," wrote Chadwick, "that the Indians have learned dishonesty, untruthfulness and immorality . . . It is not possible in our times for them to live as hunters but I think they should be encouraged to live as near as circumstances will permit, in the nomadic and open-air life to which they have been accustomed for many generations. Unrestricted nomadic life is impossible but open-air life is quite possible." Chadwick thought it a mistake to educate Indian children with white children, and asserted that, if resident schools were required, the children should sleep in tents. As for the adults, he thought cattle-ranching would prove agreeable, but he believed they should be encouraged to manufacture for sale many of the articles they had been accustomed to making for their own use. He thought the women, especially, could use their handicrafts to advantage, and also that they should be encouraged to wear their native dress rather than the white man's clothing. In Chadwick's opinion, "the complete Indian dress is the handsomest garb in existence excepting that of the Scottish highlanders to which it has a remarkable resemblance in many parts." It was his view also that the Indian would make an excellent soldier and should be encouraged in military service.[3]

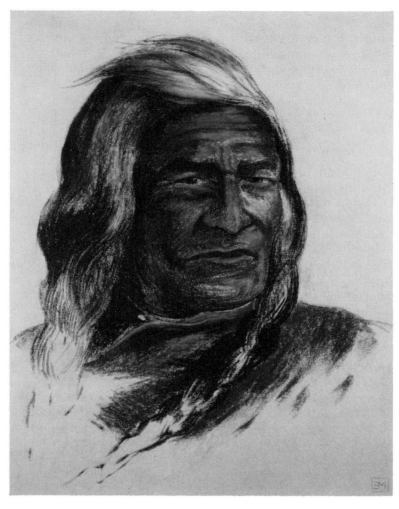

Chief Piapot 1910
Pastel on paper, 63.9 × 50.1 cm. (25-³/₁₆ × 19-³/₄ ins.)
Saskatchewan Government Collection, Regina

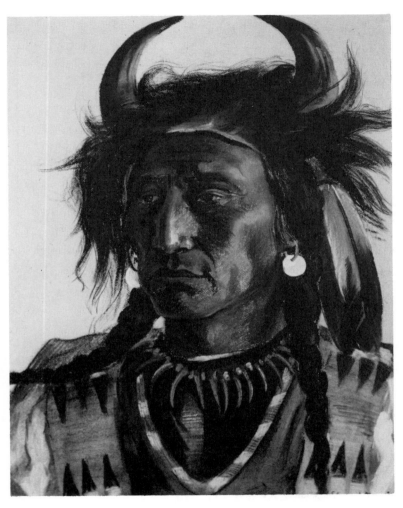

Big Darkness (Opazatonka) 1910
Pastel on paper, 63.9 × 50.1 cm. (25-³/₁₆ × 19-³/₄ ins.)
Saskatchewan Government Collection, Regina

Morris replied that,

Yes, I have often coupled the native dress with the Highlanders, two of the most beautiful dresses of our country, and the Indian costume should be preserved in the same way as the Highlanders.

Regarding the native arts which, of course, appeal to me, a number of us have grouped ourselves together to encourage and preserve it. Sir Edmund Walker, Colonel Merritt, D.C. Scott of Ottawa, myself – may I add your name to the little group? I am most interested in the work of the silver-smiths . . . I believe there is still one on the Brantford reserve . . . I wish you would enquire about him and induce him to teach the art to some of the younger men . . . I know how deeply interested you are in the Iroquois.[4]

Chadwick responded that he would be glad to be counted in the small group to encourage Indian native arts. He had joined Colonel Merritt two or three times in offering prizes at the Brantford Indian fairs for native costumes, "with a measure of success. I will see if I can do anything about the silversmith."[5]

Morris wrote to the Manitoba Club in Winnipeg in the summer of 1910, saying that before he left Winnipeg to complete the final Saskatchewan portraits he would like to place a proposal with them to commission ten Indian portraits for their smoking room, another Indian portrait for the space between the doors, and a decorative landscape of the prairie. Whether or not it was favourably received, or if so, Morris completed the commission, is uncertain. Only two paintings are currently owned by the Club, *Strangle Wolf* and *Iron Shield*, and Manitoba Club records do not indicate other purchases.

Late in 1910, Morris received a letter from W.J. Chisholm, Inspector of Indian Agencies for the North Saskatchewan Inspectorate, stationed at Prince Albert. Although most of the Indians in his district revealed a mixture of Indian and white blood, there were still a few individuals left whose features expressed the distinctive Cree characteristics. Chisholm named the latter as follows:

Chief *Kahmeustotin* and one or two of the *Aht-ahkakoop's* band in the Carlton Agency; in the Battleford Agency, Young Poundmaker, *Wahpas*, and Fine Day, men of middle age; and one or two elderly men who would have been young men when Treaty No. 6 (Qu'Appelle Treaty) was signed. At the Onion Lake Agency, there was Louison, in the *Sekaskootch* band; *Kahmistatim*, at Frog Lake; Peter Thunder, at Long Lake, a son of the late Big Bear; *Mycheechee*; and a few others at Island Lake. Further west were Chief *Pakan* at Whitefish Lake and Thomas Hunter at Saddle Lake. There were also one or two "fair" specimens of the Sioux nearby, and a good specimen of the Stoney type on the reserve at Battleford.

"It is gratifying," wrote Chisholm, "that these measures are being taken to preserve the features of the primitive tribes of these regions before they have quite disappeared for each generation brings a marked change and very soon no examples will remain of the Plains Indian as he was before he entered into treaty relations. Of these mentioned, *Pakan*, Thomas Hunter and Louison were all associated with the negotiations of 1876 and are much more interesting characters on that account." He invited Morris to stay with him and his wife when in Prince Albert.[6]

Back in Toronto in October 1910, Morris wrote to Col. Irvine, urging that the records of his experiences as a commissioner with the North West Mounted Police be put into print, for, as Morris pointed out, "the truth has so often gotten twisted that every scrap of information about early days of the west is invaluable." He was hoping that Irvine (about whom Morris himself was soon to write) would give a reputable historian access to letters written to his sister in Montreal during the days on the western plains, and suggested that the Champlain Society would be glad to publish such a volume.

From Chisholm in December 1910 came a letter thanking him for the catalogue containing some of his Indian portraits, and saying that he would endeavour to secure exact information on the Treaty negotiations of 1876. Chisholm had written to the Department of Indian Affairs some time previously to suggest that the graves of those massacred at Frog Lake in 1885 and some other

events of the Rebellion year be marked in an "appropriate way." Lately, he said, the graves at least had been marked.[7]

Chisholm also included some historical lore in his letter. Poundmaker, he noted, had two sons, the younger of whom Gabriel, had died in 1897 at the Duck Lake boarding school at the age of seventeen.

> The elder is now 40 and lives on his own reserve. His Cree name is *Sackamootayee* though among whites he is called Young Poundmaker. He has clear cut features and is a good type of Cree. Poundmaker had two wives. One is now the wife of the Indian named *Kahmeukeesekaye* (Fine Day) of the Sweet Grass band and the other, her sister, is now wife of Peter Tomkins, formerly farming instructor of this locality but now Agent of Dominion Lands of Lesser Slave Lake.[8]

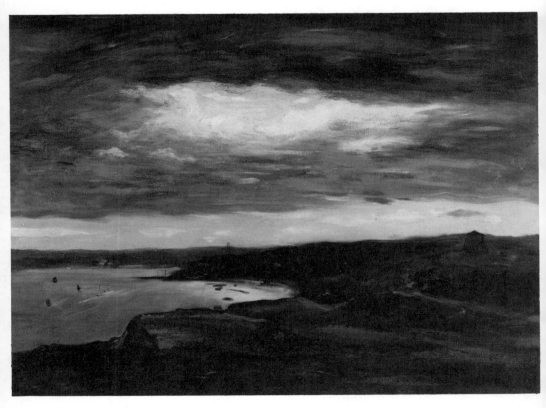

Cove Fields, Quebec 1909
Oil on canvas, 75.6 × 101.6 cm. (29-³/₄ × 40 ins.)
The National Gallery of Canada le Musée des beaux-arts du
Canada, Ottawa

Chapter Nine

The Skillful Organizer

During this period, while travelling to and from western Canada, Morris still managed to attend to his responsibilities with the Canadian Art Club. This was probably possible because as was said of him "he was a great organizer," and skillfully allotted his time to cover his various interests. From its inception, the Club held annual exhibitions in Toronto, in which Morris participated, generally showing both Indian portraits and landscapes.

The group also held an exhibition in Montreal in February-March 1910 under the auspices of the Art Association of Montreal, at its gallery on Phillips Square. Morris showed the following paintings: *Coming Storm, Alberta, In the Foothills – a Scout, Chief Bull Plume, Head Chief Iron Shield, Big Darkness, Meguinas, a Cree,* and *The Cove Fields, Quebec.* In all, the Club exhibited seventy canvases. A press review gave the greatest attention to the works of William Brymner, Morrice Cullen and Clarence Gagnon, all well-known to Montrealers. Of Morris's contribution, the reviewer stated,

> Four interesting Indian heads in pastel loaned by the Ontario government and three canvasses comprise the contribution of Mr. Edmund Morris. The heads are noble types of a race quickly losing its characteristics and will be of educational value . . . In "The Cove Fields of Quebec" a fine sense of colour is developed in the craft-littered river beneath a sunset . . . There is a fine suggestion of spaciousness in "Coming Storm, Alberta," with herds of buffalo on the plains and good colour characterizing "In the Foothills – A Scout".

The reviewer welcomed the Club to Montreal, saying that "the show indicates emancipation from old effete

standards and ideals . . . the work as a whole strikes a higher level than that to which Montrealers have been accustomed in collections where artists are of native birth."[1]

When Professor Goldwin Smith died in 1910, he left his residence, The Grange, to the City of Toronto. In 1913 the Art Museum which had been incorporated in 1900, moved its collections into The Grange, where they remained until 1918. Edmund Morris became a member of the Board and his time and energies were divided between the Canadian Art Club and the Museum. He saw great potential for the Art Museum (which became the Art Gallery of Toronto, later renamed the Art Gallery of Ontario), yet was reluctant to let the Canadian Art Club dissolve as a natural course of events, due to its financial difficulties.

While awaiting for The Grange to be turned into an art gallery, the Museum arranged to hold exhibitions in the Toronto Public Library at College and St. George Streets, and invited the Canadian Art Club, along with other art organizations, to hold their annual exhibitions there. Some Canadian Art Club members opposed any association with the Art Museum, but Morris worked to resolve the differences. He recognized the Art Museum and its future as a necessary link between the artists of Toronto and the public, and could not ignore its potential. By his diplomacy he was able to bring the Canadian Art Club under the Museum's wing. The C.A.C. held its annual exhibition in the Library in 1910 and again in 1911.

As an enthusiastic board-member of the Museum, Morris was instrumental in bringing into public view the work of some early Canadian artists, of whom little was known at the time. An exhibition of their work was held at the Museum in January 1911 and Morris previewed it with an article in *Saturday Night*. Subsequently, his material appeared in pamphlet form, with the title, *Art in Canada: The Early Painters*. Morris nominated François Beaucourt, son of Chevalier de Beaucourt, the military engineer of Count Frontenac and one-time governor of Montreal, as the first native Canadian painter. Beaucourt (1740-1794), born in Montreal, had studied in Paris. Also included were George Theodore Berthon, Cornelius Kreighoff, Otto Jacobi, John A. Fraser, Wyatt Eaton,

Daniel Fowler, Lucius O'Brien, Blair Bruce, Paul Peel, Henri Julien, Benoni Irwin, Henri Perré, Henry Sandham and Allan Edson.

Having a small membership, the Canadian Art Club suffered from lack of funds, and much of Morris's time was spent in seeking ways and means to improve its financial position. Despite disagreement with his friend, William Brymner, he sought a grant from the province. Writing to Morris in March 1912 from Montreal, Brymner criticized this move, saying that he did not believe the Club would be eligible for a government grant unless it became a Society, which would defeat its original purpose. As a Club, there was no reason for antagonism from either the Royal Canadian Academy or the Ontario Society of Artists, both of which institutions had broader mandates. Brymner was then President of the R.C.A. and "on friendly terms" with the O.S.A., and although he upheld the view that the Club should be setting a high standard of work, he advised that it was necessary to have a group like the O.S.A., which would include promising beginners and outsiders in their exhibitions. "Even though we are a great institution," he ended his letter, "we should not turn outselves into firebrands and become a general nuisance to others."[2]

Morris was deemed by *Canadian Magazine* editor Newton MacTavish "the Canadian Art Club's *'pièce de résistance'*":

> His enthusiasm seldom waned and he was a kindly, big-hearted, whole-souled, generous artist, a natural antiquarian and relic hunter. As a result his studio contained numerous pieces formerly dear to the red man: rugs, blankets, bows, arrows, knicknacks and curios.

> Except when he had a model posing, his studio was an open door. As a result there oftentimes foregathered a conglomerate array of fantastic individuals ranging all the way from university professors to worn-out jockeys. But he never abused a confidence. His outstanding characteristics were his malleable nature and sensitive disposition.[3]

A lighter side to Morris is revealed in a description by MacTavish of an annual Christmas "frolic" at the Arts and Letters Club in Toronto, during which Morris distinguished himself by "executing an Indian war dance in a manner he would never have attempted without the excitement of the rum." (At the same event, MacTavish recorded in his book, *Ars Longa*, two well-known artists, J.W. Beatty and William Cutts, were "sparring around and glaring at each other like a couple of game roosters.")

MacTavish suggested that only a painter of independent means, such as Morris was at the time, could have kept the Club going. Morris's inheritance from his father's and his uncle's estates, had made it possible for him to live independently of his income as an artist. He was thus free to engage in some of the "causes" he undertook, at various times, with concentrated effort. Nevertheless, he had a good business sense and managed his affairs, including painting commissions, in a business-like way to ensure a continuing income. Growing up in a political family, he already knew some of the more influential and wealthy men in Toronto before he reached an age convenable with the espousing of worthy causes. He was able to enlist the financial support of interested non-painters and attracted wealthy art-collectors, such as Edmund B. Osler and Sir Edmund Walker, to the exhibitions of the C.A.C. thereby sustaining interest in the aims of the Club.

Initially Morris had thought the Club would exhibit annually in various cities, but this proved impractical from a financial standpoint, as he had been warned by William Brymner in 1907. Brymner became a painting member of the Club in 1910. In 1911, Ernest Lawson, of New York City, and James L. Graham, of Toronto, were invited to show with the group. William Hope, of Montreal, Ontario-born George B. Bridgman, of New York City, and Hamilton's W.H. Clapp, then of Montreal, were added to the painters invited to exhibit with the Club. That year, Morris became honourary secretary, and an executive council was formed, composed of Walter Allward, W.E. Atkinson, Archibald Browne, Homer Watson, Curtis Williamson, and Edmund Morris.

Morris's sister, Elizabeth, had died in 1907, followed a year later by his mother, but the remaining family members (all single) stayed on in the Jarvis Street house until 1911, when the old home was sold, becoming for a time St. Joseph's High School. While his brothers moved to Hallam Street and later to a house on Warren Road, Morris turned his studio at 48 Victoria Street into a bachelor apartment. It is not known whether or not his sister, Christena, moved in with the two other brothers.

In March 1911, five of Morris's Saskatchewan portraits had been despatched to the premier in Regina. Writing to him, Morris related that a representative of the Goupil Art Gallery, the oldest in London, England, had arranged to take some of his Indian portraits and landscapes and later to hold a one-man exhibition of his work. He had also received an invitation to send work to the Salon in Paris and an invitation from New York to submit work to the National Academy of Design.

Morris was urging Walter Scott, the premier of Saskatchewan, to accept a sculpture by his friend, Phimister Proctor, and Premier Scott later replied that "there is no lack of room for the bronze buffalo whenever the government here finds itself financially capable for the same. I think I told you Mr. Proctor was here for a couple of days last summer. He had with him two small buffalo models and he promised to make another couple and let me have them."[4] Proctor was one of Morris's more amusing correspondents; commenting on the commission, he wrote, "I am glad I don't have to sit on a thistle till the Regina buffalo job comes along."[5] Proctor generally addressed Morris as "*Kayijii*", after the fashion of the western Plains Indians.

Morris appears to have experienced some ill-health in 1911 and Proctor, writing from New York, advised, "Why in thunder don't you slow up? I'll lose my eyesight watching the bend in the road for you". He invited Morris to visit with him and his wife and three daughters at their New York "shack."[6] Later, Proctor wrote to say he was taking his wife on a twenty-one day pack-horse trip to the timberline beyond the end of the Grand Trunk Pacific railway line. He invited Morris to join them. "Why don't you get a shotgun, learn to shoot and ride horseback.

137

You'd have a much better time."[7] Morris went west again to paint in 1911 and arranged a rendezvous with the Proctors at the Stoney Agency in Alberta, an event Proctor later reported as being still talked about by his wife.

In a letter to Horatio Walker written in the fall of 1910, Morris spoke of being disturbed all summer by the Reciprocity question: "People would talk of nothing else but I have got some landscapes, big Prairie stretches, western skies and groups of lodges, and I am presently struggling with a figure subject – workmen cutting a railway through the forest. I did four Indian portraits to keep myself. I sold one out there."[8] (It is believed to be the one sold to Mr. Norman Mackenzie, a Regina barrister and now in the Norman Mackenzie Art Gallery: *Chief Star Blanket.*)

W.P. Winchester of the Goupil Gallery, in answer to a letter of Morris's written in November 1911 exclaimed, "What a great time you must have had on the plains this summer." He urged Morris to send one of his paintings over.[9] Morris also heard from E.A. Hornel, of Scotland, who was sending a painting to the Canadian National Exhibition in Toronto. He hoped Morris would come over again "and do some more brilliant work here."[10]

The Saskatchewan portraits were completed by September 1911 and despatched to the government for hanging in the Legislative Buildings in Regina. Of the fifteen commissions, six were of Algonkin-Crees. Of these subjects, Chief *Pimotat* (The Walker) and Chief He Ties the Knot (*Kahtokope Chamakasis*) were from the File Hills Agency; Chief Walter *Ochopowace* was from the *Ochopowace* Reserve, located about sixteen kilometres northwest of Whitewood; *Piapot*, Chief of the *Piapot* Band, living forty-eight kilometres north of Regina in the Qu'Appelle Valley, was the only one who had participated in the signing of the Qu'Appelle Treaty of 1876. Chief Poundmaker (*Peetookah-han*), who had sided with Riel in the 1885 Rebellion, was painted from a photograph. Another Chief who had caused the government a lot of trouble during the 1885 Rebellion was Chief Big Bear (*Mis-Tahamus Qua*). Some of his band had been sentenced to hang and he himself spent a term in the penitentiary.

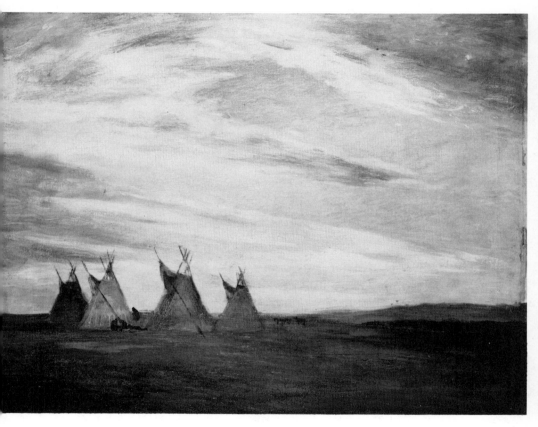

Indian Encampment on Prairie n.d.
Oil on canvas, 61 × 76.2 cm. (24 × 30 ins.)
Art Gallery of Ontario, Toronto

The Algonkin-Ojibway-Saulteaux were represented by: Chief Thunder Bear (*Peeaysen Musquah*), and Chief *Nepahpenais* (Night Bird), both from the Qu'Appelle Valley; and Chief Gambler (*Ometaway*), who lived on the Muscowpetung Indian Reserve, situated about fifty kilometres north of Regina. Thunder Bear was about sixty years of age when Morris painted him; Night Bird, aged around seventy-two, was considered to be one of the best buffalo hunters on the prairie. He assisted those in charge of Indian Affairs by giving good advice to younger Indians.

From the Assiniboine Carry-the-Kettle Band, Morris painted Chief Big Darkness (*Opazatonka*), Chief Carry-the-Kettle (*Chagakin*) and his relative, Chief Runner, all living on Carry-the-Kettle Reserve at Sintaluta, Saskatchewan. The latter two were from Dakota. Big Darkness had been present at many of Sitting Bull's skirmishes with the U.S. Army. He was seventy years old when painted and lived to be nearly one hundred. Chief Moses Old Bull was a Dakota Sioux of the Standing Buffalo band who had come to Canada after the Minnesota massacres of 1861. An author of a biography of Sitting Bull, the Sioux leader, claimed that Moses Old Bull provided him with much of the Sioux history. Although he had been associated with Sitting Bull in his youth, he was said in later years to have had a quiet nature and always tried to make an honest living.

From the Sakimay Band of the Crooked Lake Agency, Morris painted Chief *Pahnap* (medicine man), a Saskatchewan Cree, and Chief *Acoose*, a Saulteaux. Chief *Pahnap* was nearly seventy years old when painted and lived to be nearly ninety. Chief *Acoose*, painted at age seventy, had a reputation as a great hunter, being capable, in earlier years, of running on foot after a herd of elk for two days and nights and capturing them after playing them out.

For some time Morris had been seeking approval of a plan to commemorate the signing of the Treaties at Fort Qu'Appelle, Fort Carlton and Fort Pitt, thereby giving recognition both to the work of his father in his capacity as Lieutenant-Governor of Manitoba and to the Plains Indians themselves. The Saskatchewan Branch of the Western Art Association adopted the idea and formed a

140

special fund-raising committee in August 1911 to purchase a site and erect a monument to commemorate the signing of the first Treaty with the Indians of the North West Territories at Fort Qu'Appelle in 1874. The committee was composed of Mrs. G. Spring-Rice, President; Miss MacDonald, vice-president; G. Spring-Rice, honorary secretary; Mrs. Gwynne, of the Grenfell Chapter of Daughters of the Empire; W.M. Graham, Inspector of Indian Agencies, File Hills; Barnet Harvey, of Qu'Appelle; and Edmund Morris. In Toronto, Morris approached his friend, Walter Allward, a well-known sculptor, to design the memorial, and John Pearson, Toronto architect, who was to act as architect. Morris had found a sacred carved stone used for rituals by the Crees and offered to purchase it as his family's contribution to the memorial.

In launching its project, the Committee issued a brochure which states;

> At the last meeting of the Saskatchewan Branch of the Western Art Association, a committee was appointed to put before the public an appeal for funds with the intention of erecting a memorial at Fort Qu'Appelle to mark the spot where the Treaty with the Indians was signed which handed over this country to the use of the white man forever.
>
> It is proposed that the memorial should take the form of a slab of native rock with names of the Signatories to the Treaty carved upon a bronze tablet which would be let into the face of the stone. This enscribed stone will then be erected on the site pointed out by Mr. Archie McDonald and Rev. Father Hugonnard of the mission who were both personally present at the signing of the Treaty.[11]

It was estimated that $3,000 would have to be raised to complete the project.

Morris, though stating that Allward might suggest an obelisk or needle for design, had himself drawn a more elaborate motif, in which the sacred stone was to be flanked by two stone pillars representing the two races; the pillars were to be joined at the top by a slab of granite symbolizing "brotherhood". On the memorial would be inscribed the names of all participants.

Morris also expected to launch similar drives to commemorate the signing of the Treaties at Fort Carlton and Fort Pitt. He was particularly excited by the Qu'Appelle project. Writing to Miss MacDonald early in 1912, he stated his expectations that Fort Qu'Appelle would become a "drawing card" of the west. He thought a plan for a city should be laid out: "the little hamlet is still in swaddling clothes but I see a great future ahead of it."

At the same time, he was trying to stir up public interest in commemorating other historic events in the west, a plan probably anticipating the historic plaques we now see coast to coast placed by the Historic Sites and Monuments Board of Parks Canada. In this he sought the help of Sir Edmund Osler, influential financier and patron of the arts, who had a deep interest in the west and who later purchased the G.W. Allan collection of Paul Kane canvasses and donated it to the Royal Ontario Museum. Morris wrote to Osler in April 1912:

> I hear from Colonel Irvine who is advocating that the Dominion government purchase from the Hudson's Bay Company, lower Fort Garry – the one spot left in the west, now that Fort Edmonton gave way to the parliament buildings, which represents the past phase of Canadian life – by all means it must be done. He proposes to make it the historical museum of Manitoba . . . if it is carried out, it means that dear old Col. Sheriff Inkster, old Macdougall, and many others will place their valuable collections there for preservation, possibly also Paul Kane's collection of Indian relics owned by George Allan. Regarding the old-timers, so little has come their way it would be a graceful thing for the present government to recognize their past services which were invaluable in the Conservative interests and purchase of their collections, a full evaluation . . . [12]

Later, he met with Osler and talked the whole matter over in depth.

By May 1912, Morris, in a letter to Sheriff Inkster, said that he was preparing a report on certain ancient monuments of the aborigines, their old forts, the few Hudson's Bay Company posts still remaining, spots where

Treaties were negotiated, and the battlefields. "All of these must be preserved and marked," wrote Morris, "And Sir Edmund will get an appropriation from the government for this purpose."

To get the plan off the ground, Morris suggested the creation of a committee composed of the Governor, Sir D.C. Cameron, Sir Edmund Osler, Col. Irvine, Sheriff Inkster, Col. Sam Steele, Capt. Gautier, Charles Mair, T.W. Tyrrell, Father Morrice, Agnes Laut, T.C. Wade, D.R. Wilkie, D.M. Graham, and himself. Some of these people were already working for the Qu'Appelle Memorial.

At the same time, Morris concerned himself with a memorial to be commissioned in Toronto to commemorate the heroes of the War of 1812-14. Representing the Canadian Art Club, he had met with Lieutenant-Colonel Hamilton Merritt, Chairman of the Memorial Committee, who had thought of chosing Paul Romain Chevré, sculptor of the memorial to Champlain in Quebec City. Writing to Merritt later, Morris chided him:

> Surely a military man will understand the necessity of using his own forces, yet you would call on one from France to do the work over the heads of better men – Canadians. Had it been Barye, Fremiet, or the present great Rodin, all hats would have been doffed – but they are beyond our reach . . . believe me one of the objections of the Canadian Art Club is to war against the indifference and prejudice which has existed in Canada regarding the higher arts. Some of our ablest men have left the country in disgust. I am sure you will see how disastrous such a cause would be if persisted in. So under the existing conditions, I have no desire to entertain a sculptor you speak of . . . I should think the Committee of which you are president would call for competitive designs from the Canadian sculptors which would be only just. Of Allward I need say nothing. His work is well-known in Canada. With Proctor it is different – he is one of those who has joined our Club. His superb statues adorn the squares and parks across the border and his work is known the world over. He could give us an allegorical design – a lion or a

143

puma at bay. Rev. Mr. Scott of Quebec has suggested that he be called upon for a heroic lion on the Plains of Abraham. Then Hill of Montreal who made the statues of D'Arcy McGee and George Brown of Ottawa.

I doubt if the French-Canadian sculptors could grasp the spirit though they should be called upon for designs – Philippe Hébert and his son, Henri, and Laliberté . . . I am doubly interested – my grandfather Hon. William Morris having taken active part in the capture of Ogdensburgh in 1813.[13]

Morris had long known Merritt, who was married to Janet Morris of Brockville, a first cousin of his father. Merritt, like Morris, had been honoured by the Indians, the Iroquois at Brantford having given him the name *Roconoungowane*, and counting him one of them. The Memorial to the Heroes of 1812-14 Association included some Mohawk and Cayuga Indians.

A lot of Morris's time in 1912 was taken up with his concern over the new museum in Toronto. Writing to Sir James Whitney, the Premier of Ontario, on 2 May, 1912, Morris asked if the Royal Ontario Museum was to be a civic or provincial museum or if it was to be a university museum. "I think it would be fatal," he wrote,

> to link it to any institution. It is of sufficient importance to stand alone and a civic museum has a much wider appeal and should be for the people. Many would stand aside if it were linked to Toronto University. Why not keep it clear of all strings and appoint an energetic man of experience with a staff of specialists to control it. Mr. Sims, a Virginian and one of the ablest men in the field, tells me he would be willing to drop his position as Associate Director of the Field Museum in Chicago and accept such a position . . . he is a scholar and man of wide experience.

Morris went on to say that he was anxious about a grant for the Canadian Art Club, for it was badly needed. He was concerned lest a recent grant to the Ontario College of Art might jeopardize the chances of the C.A.C. getting

their grant, "as it will be useless to turn out more painters and sculptors were such a mature society not backed well."[14]

Whitney's Bill No. 138, An Act to Establish a Provincial Museum, went through the Ontario Legislature in 1912, but the cost of maintenance written into the Act was to be borne one-half by the province and one-half by the governors of the University of Toronto, and it was this latter clause that worried others besides Morris. Charles Trick Currelly (1876-1957) was the successful appointee to head up the Museum, and in October 1912 he was writing to Morris that when they started to arrange the Indian gallery he would seek his assistance. He also thanked him for the offer to loan his collection of Indian relics and some paintings.

Meanwhile, although the Qu'Appelle Memorial fund-raisers worked hard, donations apparently did not flow in rapidly. In August 1912, David Brereton wrote to Morris from Gleichen, Alberta, saying that the rock transaction had cost him $925 and he was out-of-pocket. He also said that his wife missed Morris's beautiful smile and he hoped Edmund would call on them if he came west. Of Morris's Indian friends, he reported, "Old Calf Child is looking well, better than he has been for some time past. Wolf Collar, Spring Chief and Water Chief are about the same smooth bunch of coffee coolers." He had spent, he said, twenty-four hours deciphering Morris's letter.

One assumes Morris's friendship was treasured by his many correspondents, otherwise, one wonders why would they have persisted in their efforts to make sense of his illegible handwriting? Some offered blunt advice. Phimister Proctor once wrote from New York, "I am always delighted to get your letter though it takes two men and one woman to read one of them and then must be guessed at. You must buy or hire a typewriter or better yet, marry a typist, a *pretty one*, and then all your troubles will be over."[15] His old teacher, William Cruikshank, declared on another occasion, "Now I can read your handwriting. Send me another exercise." J.W. Morrice, writing from Paris after receiving a letter from Morris which he could read, said so and added sarcastically, "Have you been taking lessons?" Even his revered friend, Horatio Walker, writing from St. Petronille, urged him to *"please*

write plainly" underlining the words several times. Many others offered advice in one form or another. Apparently Morris never found the pretty typist, for he persisted in writing by hand to friends, although his business correspondence was generally typewritten.

In October 1912, G. Spring-Rice wrote to Morris to report that he had no idea that the memorial stone for Fort Qu'Appelle was to be so decorated, and wanted a brochure to be prepared explaining the meaning of the Indian ideographs on the base of the stone. "We would try later to have a bronze relief of your father's head and a typical Indian Chief's," he added.

In reply, Morris reported that T.C. Wade was busy promoting the project in England. Morris wanted the village of Fort Qu'Appelle to lay out a public park and place the monument in it. He spelled out the inscription he desired:

Treaty made and concluded 15 September 1874 between Her Gracious Majesty, Queen Victoria, and the Cree, Saulteaux and other Indians. Commissioners: The Hon. Alex Morris, Lieut-Governor, the Hon. David Laird, Minister of the Interior, Wm. J. Christie, Esq.
Indian Chiefs and Headmen who were party to the Treaty:

Ka-kii-shi-way
Pis-qua
Ka-we-zauce
Ka-kee-na-wup
Kus-kee-tew-mus-coo-mus-qua
Ka-ne-on-us-ka-tew
Can-ah-ha-cha-pew
Kii-si-caw-oh-chuck
Ka-ra-ca-toose
Ka-kii-nis-ta-haw
Cha-ca-chas
Wa – pii-moose-too-sus
Gabriel Cote or Mee-may
Wa-wa-se-capow
Ota-ma-koo-ewin

Wah-pee-makwa
O'Kanes
Payepot
Le-croup-de-pheasant
Kitchi-ka-me-win

The stone on this pedestal was carved by ancient
aborigines. The Crees regarded it as sacred and were
wont to journey north of the Red Deer River to Berry
Creek where on a hill the rock stood. Here they as-
sembled in large numbers and went through certain
religious rites.

Subscriptions for the memorial came in from as far west
as Vancouver and from as far east as Quebec; some also
arrived from England.

The Governor General, the Duke of Connaught, was
expected to visit western Canada in 1912 while on an
official tour. The memorial could not be completed in time
for a proposed visit to Fort Qu'Appelle, but the Committee
decided to hold a dedication ceremony on the site where
the first Treaty with the Indians of the North West Ter-
ritories was signed in 1874. Unfortunately, the Duke of
Connaught did not show up, due to a previous commitment,
but expressed a wish that he might be able to attend at
the final unveiling of the memorial, when completed.

The Regina *Daily Province* reported the event on
17 October 1912, as follows, "Though the memorial is not
yet completed the actual stone was placed in the posi-
tion it is to have eventually. The town was suitably dec-
orated and a large number of people gathered to witness
the ceremony."

In the absence of the Duke of Connaught, Mr.
Archibald McDonald, the last Chief Factor of the Hud-
son's Bay Company, who assisted the commissioners to
negotiate the Treaty, and whose connection with the com-
pany dated back to 1854, took the Governor General's place.
The Rev. H.A. Lewis opened the proceedings and ex-
plained the historic background of the sacred stone, stat-
ing that it had been purchased by the family of the late
Governor Morris. Mr. Spring-Rice described the eventual
memorial to the assembly. Two great columns connected
by another great block of granite would shelter the sacred

stone and thus typify the union of the red and white races in the bonds of brotherhood under the imperial flag. "Situated on the very site of the old fort, the memorial would be visible for many miles up and down the valley and would, he hoped, form one of the province's chief historical landmarks."

There was no mention in the report of the part played by Edmund Morris in instigating the entire project; the eventual monument is described in a later chapter.

While Morris was engaged in worthy causes of this sort, he continued to paint and to keep up correspondence with his friends on the reserves. A typical newsy letter is one from Father Doucet, then based at the Blood Reserve at Standoff, Alberta, dated August 1911:

> I have just received your letter from the Cree camp. I think by this time you have received a letter that I wrote to you a few days ago. I told you that the new agent of the Blood Reserve is Mr. Hyde, a son-in-law of Mr. A.B. MacDonald, the ex-Liberal candidate . . . "Old Blackfoot Woman" is alive yet. "Bull Shield" is dead. "Chief Strangled Wolf" lives yet up the river. This Mission is about 12 miles from the Agency up the river. The Standoff post office is a little over a mile from here. The Indians are pretty much scattered about on the reserve busy with the hay and harvest. Very good crops this year. I think they will get through their work about October and it will be the best time I think to see them. I suppose you have to paint some of them. There is a good place around the Mission to camp . . . You will be welcome to this Mission . . .[16]

From the Balcarres, Saskatchewan agency came word that a few Indians came regularly to search the mail box for photographs that Morris had promised of two groups, one consisting of Red Dog, *Catasse*, and Alan and Adelaide Star Blanket, and the other of Red Dog and Star Blanket.

Still involved with the new Toronto museum, Edmund wrote to Sir Edmund Walker in December, telling how, some years previous, he had heard that the late Governor of Saskatchewan, Senator Forget, had a buffalo

skin lodge which he had bought from the Crees. "It is probably now the only one in Canada. I dined with him at the Chateau and suggested he present it to the Museum. He agrees to do so. This is a most precious gift. When it comes, a platform should be made and as only the Indian knows how to erect it properly, I suggest our getting *Acoose* down or the old medicine man, *Wapekinewop*, for that purpose."[17]

He also mentions his portraits, noting that he had had no word from C.T. Currelly, and that he supposed they were not yet hung in the gallery.

Chapter Ten

Sunset

One of Morris's most eloquent and faithful correspondents was Haldane MacFall, British novelist, art critic, and man of letters, who had written a *History of Painting*. They had met in the west when Morris was painting among the Indians. Apparently MacFall had done some painting and was offered a lay membership in the Canadian Art Club. Writing to Morris in February 1912, he expressed his appreciation in being invited to become "one of the brotherhood." He made a few scathing remarks about the Royal Academy, saying the Brangwyns, Turners and Constables were British-bred but not academics. He approved the founding of the C.A.C. and urged Morris to go across Canada telling the country to create its own art (in effect paving the way for the Group of Seven).

In 1911, following the appearance of Edmund's article on Col. Irvine in the *Canadian Magazine*, Mr. Wise, a representative of the Macmillan Company of Canada, had approached Edmund to write a history of Irvine. Morris declined and suggested MacFall. He promised to introduce MacFall to Indians who had known Irvine. He thought MacFall should expand on Irvine's experience and write a history of the North West Mounted Police, pointing out that there were still a few of the leaders of Irvine's day around who could give first-hand accounts of their experiences: for example, Sir George French, 1st Commander, who organized the North West Mounted Police and who had been in command of the School of Gunnery at Kingston when Sir John A. Macdonald passed the Act instituting the establishment of the Force. Another named by Morris was Colonel White, more recently commander of the Force, who was living in Ottawa. Lieutenant-Colonel Irvine, the third commander, "who has recently come

from Winnipeg to live at Kingston, thinks the work essential," wrote Morris, who continued:

> I dined with him last week and had a long talk on the subject. He thinks it would be better for the author not to go west because the whole character of the country is now changed. The commander could describe the trail of the Police to Mr. MacFall and besides his recollections he could place his most valuable manuscript in his hands. He has also articles giving full accounts of the work of the second Commander, Lieut-Col. [James F.] Macleod [1836-1894]. I also could be of service for I have the despatches and letters of my late father who was Lieut-Governor of Manitoba. They are deeply interesting and have not been dealt with and are of particular importance as many of the official documents of the Royal North West Mounted Police were burned in a fire in Ottawa. Apparently none of the gentlemen I have named were [sic] interviewed later . . . unless the work is done these old-timers will die and with them will go their knowledge.

Morris ended his letter by requesting, "Please send on MacFall at once. His little trail is between Toronto, Ottawa and Kingston but a short distance apart so the expense would not be heavy as you anticipated were it necessary for him to travel through the northwest."[1]

Despite considerable correspondence between Irvine, Macmillans and MacFall, with Morris pressing his point, the publishers withdrew, put off by a book which had appeared in 1910 under the authorship of A.L. Haydon, entitled *Riders of the Plains*, which covered, they said, the same ground.

The irrepressible, irreverent MacFall wrote to Morris on 3 March 1913 as follows:

> Dear old man,
>
> Don't fret about the Macmillan failure. Kismet. . . . keep on singing, Morris, you son-of-a-gun, singing all the time or you're lost and Canada can't do without *your* stuff . . . Tell Archie Browne I'm sorry he's dead . . . let me know how it happened. Have they

made a dammed gunboat of Homer Watson? Give
Homer's soul whiskey and charge it up to me, Archie
Browne's will take anything[2]

In mid-March, MacFall wrote again:

Dear Morris:

Your good companionship stirs my heart like a bugle
call. We are of the adventure blood, Edmund, you
and I, my lad but . . . Archie Browne made sure of
getting me onto the big Canadian Magazine to ed-
ucate Canada in art. Not a word! Not a sign! . . . the
dice was loaded against me, therefore against you . . .
the good God be good to you for all your pluck and
energy I shall always remember the comrade-
ship of Edmund Morris out in the Great West . . .
there is wide talk of my giving a series of addresses
all over the United States in autumn. If I go and can
get near Canada, I'll pop over if only to grip the great
fist of you . . . all good luck to you for one of the best
fellows that was ever born.[3]

MacFall's name appeared as a lay member of the Canadian
Art Club in their 1913 brochure. He did not see Morris
again.

Winchester had come over from London early in 1913
with some paintings and had been entertained at the
Morris establishment. He had met Phimister Proctor on
his way home and found him an interesting fellow. He
adopted Proctor's name for Morris and in writing to thank
him for his hospitality while in Toronto addressed him
as "Dear old Kyaijo." He sent his regards to Miss Morris
and Morris's two brothers and invited them all to London
for a visit.

Morris was experiencing some ill-health in May of
1913 and was advised by Proctor to "cut out the cigarettes
and booze and you'll be alright." His old friend, William
Boultbee, had died late in 1912, and in June 1913 he lost
another long-standing friend, "banker" J.M. Mackenzie,
treasurer of the C.A.C. Despite depression over his dwin-
dling circle, Morris whirled on with his many involve-
ments.

153

For some time he had been part of a controversy with the Ontario government and the authorities of the new provincial museum, and lengthy correspondence had taken place. Writing on the C.A.C. letterhead to Dr. A.H.V. Colquhoun, Deputy Minister of Education, Edmund complained,

> Months ago, Sir Edmund Walker wrote me that the government was willing to hang my portraits in the Royal Ontario Museum. The galleries are ready. All the other departments are being developed. The one concerning our own country, the work of the government, was passed by and there is no room for us. I wrote Sir Edmund Walker that the late Governor Forget would present a buffalo skin lodge – possibly the only one obtainable and priceless – nothing is done. I offer the loan of a most valuable collection of Indian relics and have kept myself poor obtaining it. Nothing is done. Do you wonder I turn my eyes to Ottawa – [i.e., the Victoria Memorial Museum, later the National Museum of Canada] – Ottawa was once my grandfather's constituency. I am glad, however, to think that you have been sympathetic in these troubles I am encountering and it is possible things may yet be arranged satisfactorily if and when a suitable Director is found for the Royal Ontario Museum.[4]

Though not active in politics, Morris nonetheless expected government support for his worthy causes only as a last resort, calling indirect attention to the Morris tradition as staunch Tories. Had not his grandfather been a member of the Family Compact, his father and his father's uncle and his father's first cousin all Conservative members of Parliament? The name Morris was synonymous with Conservatism as understood in Canada. And Morris himself, though not involved in politics, was a political man astutely seeking the assistance of prominent men of the establishment in his various cultural causes.

At the end of June, Morris wrote to the Hon. R.A. Pyne, M.D., Minister of Education, stating,

Following your wish I shall state my views regarding the most voluable ethnological and archaeological collections owned by the government.

1. I regard as of the utmost importance that these should be at once transferred to the Royal Ontario Museum with which the Ministry is so strongly identified and where these collections should be suitably displayed.

2. The life work of the late David Boyle, the government archaeologist, is invaluable. He has a wide reputation and in his writings was careful to speak only of the things of which he knew – this collection and the 65 portraits I was commissioned to do and the Paul Kane and George Catlin Collections of pictures of Indian life presented to the Royal Ontario Museum by Sir Edmund Osler, should be brought together as it is their ultimate destiny. Sir Edmund Osler wishes this as I do and Sir Edmund Walker has repeatedly said the same.

3. I am prepared to lend the collection of Indian relics made by my late father as well as my own very large collection. Also a collection made by Mr. Hodgson of the Sarcee Reserve. I believe the collection made by Mr. Flaherty among the Eskimos might also be lent. Mr. R.C. Wade urged me to send my collection to Vancouver. I have declined to do this and I sometimes thought of Winnipeg. My intention is to lend it to the Ontario government where it will be accessible for my future work.

4. The present urgency is in case of fire – much was lost at the time the university was burned and my portraits had a narrow escape when the west wing of the Parliament Buildings were burned. However, there are repeated calls from Ottawa to have the collection intact for the coming to Toronto of the 300 scientists from all parts of the world. It would only be appropriate that the work so long carried on by the government should hold a conspicuous place in the Museum it has taken a part in founding.

5. At least two of the large galleries should be reserved for the government collection and the head

of the department with his knowledge could quickly transfer them.[5]

The Victoria Memorial Museum in Ottawa was that year preparing for the twelfth Session of the International Geological Congress, to be held in Toronto from 7 to 15 August, an event which would bring, as Morris said, 300 scientists to the city. He had been requested by Mr. W. Stanley Lecky, Secretary of the Congress, to have his work on display for the scientists. Morris continued his efforts to have his work and that of the other painters of Indians hung in the Royal Ontario Museum in time for the Congress, but later, rendered desperate by the delays, offered his work to the Victoria Museum on loan.

In a letter dated 9 July 1913, addressed to R.W. Brock, Director of the Geological Survey of Canada, Ottawa, he wrote,

> Mr. Lecky wrote me some time ago requesting to have my collection on view for the visit of the scientists. I have tried to arrange this but owing to some dispute between the officials of the new museum [R.O.M.] and the old provincial one, one can come to no satisfactory arrangement . . . I visited the Victoria Museum and saw the superb gallery at the entrance and hope it would be devoted to American Archaeology and ethnology. Could you at once supply a number of cases. If so, I am willing to lend, for a certain time, my collection which includes some gathered by my late father when he was governor of Manitoba and my very large collection made during eight summers amongst the tribesmen. There are a number of buffalo robes with the history of famous chiefs. Col. Irvine recently gave me his collection. I have also a rare collection made by Mr. Hodgson who for many years was Interpreter to the Sarcees. Amongst this is a huge robe with the history of the late Sarcee, Head Chief Bull Head. This last collection is for sale and I would recommend that the government purchase it. Regarding my collection, if you are in a position to accept the loan, I shall send down the agreement to be signed and I hope the Geological Congress will see their way to pay my expenses and I shall come and arrange my collection.[6]

In a letter of the same date he wrote to Sir James Whitney,

> I have failed to make any headway at all and am
> sick and tired of it – we shall all probably be dead
> before the museum question is settled and I should
> like your permission to again re-hang the portraits
> your government commissioned me to do, in their
> old accustomed place in the west wing which is now
> fireproof. The expense of doing this is a mere trifle
> and the public as well as the scientists who come
> next month would be able to see them. I saw both
> Dr. Pyne and Dr. Orr and it seems hopeless at pres-
> ent.[7]

On 15 July he heard from R.W. Brock that the Survey
would be pleased to have the loan not only of his collection
of Indian relics on display at the Victoria Museum but
of his Indian portraits, as considerable space was avail-
able. Furthermore, the building was fireproof. Delighted
by this response, Morris invited Brock to a smoker at the
Canadian Art Club and said he would try to arrange a
small exhibition at The Grange to coincide with the Con-
gress.

Meanwhile, he renewed his onslaught and wrote to
the Minister of Education, William Howard Hearst, re-
iterating his views, and concluding; "My own collection
is a loan and there are no strings attached to it – it is at
all times at my disposal as I see fit . . . We shall arrange
the collection but kindly keep an eye on the situation.
This is the property of the government and the govern-
ment desires it to be suitably displayed when 300 scien-
tists visit Toronto in August." He mentioned men who
had built up the R.O.M. Ethnology collections, such as Dr.
David Boyle, Dr. Rowland Beatty, his successor as curator
of the Provincial Museum in Toronto, and Dr. Orr, who
worked as an archaeologist among the Hurons and Iro-
quois; himself, among the Indians between Lake Superior
and the Rockies; and, more recently, the documentary
film-maker, Robert Flaherty, "who is studying the Es-
quimaux and the Indians of James Bay . . . They have all
carried on the work in a way deserving of considera-
tion . . . I should be sorry to see a government official
deposed. Dr. Orr is most useful, was associated with the

157

late Dr. Boyle who made and built up that section and is in touch with men in the field and throughout the country."[8]

In another letter to Dr. Colquhoun, Morris emphasized that "both Sir James Whitney and Mr. Hearst realize the government must not relinquish control of the Ethnology and Archaeological Departments [formerly under the direct jurisdiction of the Ontario Government] . . . if it is impossible for Dr. Orr to transfer his collection at once to the new provincial museum, let it be understood that this will follow and he as government official, remains in charge – at all events," Morris writes wearily, "I have done what I could and hope the dry rot of the academics will not supersede the work of the men in the field and if Mr. Hearst regards me as a redhead I am glad of the fact and if I showed anger, it is that I have been too much exasperated."[9]

To Sir James Whitney, Morris later wrote, "Dr. Orr is excellent . . . I found friendly cooperation and if it is not possible for him to transfer the other portions of the government Archaeological and Ethnological Collections in time for the coming of the scientists he will at all events, see that it is suitably displayed when it is in temporary quarters."[10]

Finally, a letter dated 17 July came to Morris from the premier's office, stating that the portraits would be moved to the provincial museum "tomorrow". Mr. Hearst, of the Department of Lands, Forests and Mines, wrote to Morris on 29 July to inform him that he appreciated the loan of Edmund's private collection to the Museum.

An effort to determine if, in fact, the portraits and the collections of Indian relics were displayed in the Royal Ontario Museum's new building at the time of the Congress has not been successful, as there appears to be no record definitely stating so. However, it appears that the scientists did have the privilege of viewing these artifacts during their stay in Toronto.

While the tussle with the Museum authorities was going on, Rupert Brooke, the English poet, arrived in town during the course of a journey across Canada and the United States, which he was making as roving correspondent for the *Westminster Gazette*. A note on King

Edward Hotel stationery, dated Friday 18 July, 1913, addressed to Morris, reads:

> Dear Sir:
>
> Dr. Duncan Campbell Scott very kindly gave me a letter of introduction to you. I pushed it, through your studio door today – there didn't seem to be anybody at home – I am sending this to say that it's there in case you don't go into your studio for a day or two. I am in Toronto till Monday or Tuesday.[11]

Morris received the note and promptly took Brooke round to the Arts and Letters Club, where Brooke met a few of the members still present in the city, which was then suffering a heat wave.

Brooke who went on to Niagara and Sarnia, wrote to Morris to remark that

> I'm sorry we didn't meet again but I hope we shall sometime. I'll send you an address for the photographs of Scott, of Laughing Earth and one or two others you kindly promised . . . I shall always be grateful to Scott for sending me to you in Toronto. It was very good of you to take me around . . . If I don't see you again before I go back, let me know when you're coming across – King's Cambridge will always find me and we'll foregather again. There were one or two introductions you said you'd send me. Could you send them to me c/o Howard Falk, 301 Edwin St., Winnipeg, where I shall be for a week. And tell me which of the Indians on the Stoney Reserve I'm to give your greeting to. Also, should I take them some tobacco as a gift, or anything else?
>
> I hope I'll see any of the C.A.C. who are in England. Tell [Archibald] Browne I'm sorry I didn't see him again . . . when he comes to England he must let me know and we'll meet together in Cambridge or London. I'll promise not to paint dreadnoughts on his head. It was a very interesting evening with [Arthur James] Glazebrook. He's a clever chap.[12]

Writing to Brooke on 26 July 1913, Morris enclosed letters of introduction to help him on his journey across Canada:

You came like a breeze I knew from the meadows of your dear country. The photos of Forestal Patience and my old girl, Laughing Earth, I shall send to you and as both are to be your companions you will find that old 'Mother Earth' will laugh in gladness as you come along the trail. I send you good medicine, the wandering trail and the four winds. Our Indians fear and love the four winds and the plainsmen offer up prayers . . . Be sure and let me know when you are coming to Toronto and remember some year to come with me to the habitants of Quebec and again to the dusky plainsmen of the west. In August I shall go to my old friend, Mme. Langlois and to Col. Irvine in Quebec. Drink deep, old man, of the medicine Frank Darling handed me and sends you.

P.S. Graham, the Inspector of Indian Agencies, wrote to me to come to him but I send you in my stead and both you and he will enjoy it. Be sure to go – in part because I want him to take you in his automobile to Lebret to see Father Hugonnard and the beautiful Qu'Appelle Lake and valley.[13]

In a later letter to Brooke, Morris wrote,

Keep in touch . . . and let me hear from you and Laughing Earth on the trail. You are going to the South Seas. Why should you not make a collection showing the arts and crafts of those Isles for our Royal Ontario Museum. I think I might induce some dear citizen to invite us up. Today I placed my collection in the cases. It is splendid. Wish you might have seen it . . . I have still difficulties with the new man . . . My old pal, William Cruikshank, the philosopher says – 100 years hence who will know the difference.[14]

Brooke mentioned "Laughing Earth" in his narrative for the *Gazette*, but did not indicate the source of his information. It was a photograph taken by Morris of a seventy-year-old Indian woman named "Laughing Earth", dressed in brightly-coloured petticoat and blouse, her grey hair blowing in the wind. Brooke described her as the epitome of laughter – she is looking over her shoulder at the photographer, her weathered face wreathed in merriment,

160

having, said Brooke, "withal a kindly and noble beauty."
Morris was still providing the Indians with photographs,
and from William Graham, the agent at Balcarries, Sas-
katchewan, he heard in July that "the photos came . . . I
have given them to Star Blanket with your compliments
and he was greatly pleased. The pipes came sometime
before the photos. I have given them to your old friends
here who remembered you quite well . . . Why do you not
come out and pay us a visit this fall. We would all be
glad to see you. Do try to come . . . Mrs. Graham and Miss
Foye send their kindest regards and we all hope to see
you in the near future." Mrs. Graham added a note to
her husband's letter, "I hope you are coming west and
will come and pay us a visit and talk over old times and
also the Indian Treaty Memorial. We hope to get it up
this fall sometime . . . "[15]

In a letter at this time to Professor James Mavor,
Morris reported that his trouble with the Museum had
been overcome, but that he was not feeling well and ex-
pected to go to Quebec by 15 August to visit the Langlois
and then to see Col. Irvine. It appears that Archibald
Browne was to accompany him, for among the Morris
Papers is a letter written by D.R. Wilkie dated 9 August
1913, addressed to G.F. Love, Manager of the Imperial
Bank of Commerce, Quebec City, introducing his "artistic
friends, Edmund Morris and Archie Brown of the C.A.C."
He enclosed this letter in a letter to Morris in care of
Horatio Walker, Saint Petronille, Île d'Orléans.

"My dear Morris," wrote Wilkie,

I enclose a letter to our manager at Quebec, Mr.
Love, whose father is the Minister of St. Andrew's
Church. I would suggest that you should both while
in Quebec attend church regularly and in that way
allow your handsome face to become familiar to the
members of the congregation who are not only wealthy
but artistic . . . I have a nice letter from [C.T.] Cur-
relly thanking me for the loan of my curiosities for
the Royal Ontario Museum. I met Dr. Strachan at
dinner last night but before your letter of blank date
had been *deciphered* (ha, ha). It is quite impossible
for me to get through that important duty without
the aid of an *expert chirographer*. Give my kindest

161

regards to the great Horatio Walker and tell him that he should not keep his blind eye on Toronto . . . We expect him to do his duty.[16]

Just over two weeks later, Morris's body was found floating near Cap Tourmente in the St. Lawrence River. He died on 26 August 1913. A news report said that he had been missing from the home of Horatio Walker for several days. An inquest was held. One newspaper account stated that it was believed he had been sketching on the railway bridge at Port Neuf and fell into the river and drowned.

The Toronto *Globe*'s account hinted at suicide:

Mr. Morris had acted somewhat strangely of late which gave his friends and relatives cause for alarm. His untimely end seems to have been the result of a severe illness which unbalanced his mind. The news came as a shock to an exceptionally wide circle of friends. An inquest was opened at Quebec last night and the body was subsequently shipped to Toronto in charge of his brother-in-law, Mr. Cochrane of Lennoxville . . . unlike the majority of artists, Mr. Morris possessed a marked business capacity and organizational ability which have been a real service in holding together the membership of the Canadian Art Club . . . not only was he an artist himself but he was an enthusiastic promoter of art in Toronto and had given much valuable time and unselfish service in the arrangement of art exhibitions. The Toronto Art Museum loses a valuable member in the late Mr. Morris who was a Member of its Council up to the time of his death . . . [17]

The Toronto *Daily Mail and Empire* reported:

Edmund Morris, A.R.C.A., secretary of the Canadian Art Club, the Toronto artist whose body was found near Quebec, died as a result of accidental drowning in the opinion of the coroner's jury at Quebec, according to a private message received by relatives here. The body of Mr. Morris is being brought to Toronto for interment.[18]

162

The body of Edmund Morris was interred in the Alexander Morris family plot in Mount Pleasant Cemetery, Toronto.

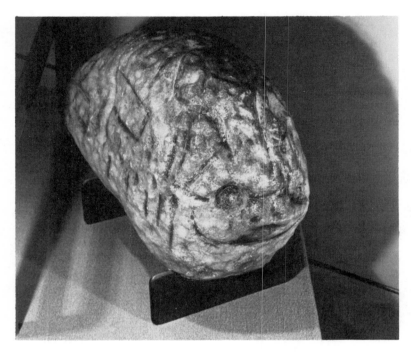

Ancient Indian Ceremonial Stone chosen by Edmund Morris
for the Fort Qu'Appelle Memorial
National Museum of Man, Ottawa (NMC 77-6347)

Postscript

It was known by Morris's friends that he had been seriously depressed by several situations in his life during his latter years. Newton MacTavish, in his book *Ars Longa*, spoke of a painting Morris had shown in the Canadian Art Club Exhibition of 1909. Called *The Slave*, it depicted the body of a deceased Indian, wrapped in a blanket and reposing on the limbs of an old tree in the sandhills. Horatio Walker, then President of the Club and generally so sympathetic with artists, seemingly took exception to it, and Morris felt the silent criticism deeply. He later withdrew the painting from public scrutiny.

In more recent years, a descendent of one of the Indian agents in Alberta, who knew Morris, recalled seeing the painting in 1911. "He asked me what I thought of it. I said it was wonderful and that very few artists would get the opportunity to paint such a picture. He said: 'Well, apparently it was not appreciated here because I submitted it to an exhibition and it received no recognition.'"[1] The Indian agent's son recalled that Morris seemed depressed at the time.

MacTavish wrote that at the time of his death Morris was "known to be drinking, perhaps too deeply," but in any event his death by drowning is still a mystery. "His body was found a day or two later floating in the St. Lawrence just off the island [Île d'Orléans] and within good sight of Cap Tourmente, a spot favoured by the artist himself when sketching."[2]

Rupert Brooke, then in Victoria saw the notice in the *Globe* and wrote to Duncan Campbell Scott:

> I have just seen with the quick catch in the throat one gets when skimming the paper and lights on bad news, that Edmund Morris was drowned lately. It must be a fortnight ago, but I've only learned of it

by the chance of picking up an old Toronto paper. He was very good to me when I was in Toronto and we had made half-plans for some great excursion north the next time I could get away to Canada for a summer. It was a light ahead, a pleasant thing to contemplate.

He was in rather a sad and solitary mood in Toronto. Poor man. I feel rather sad and lonely . . . I leave Canada tomorrow. San Francisco will be my address.[3]

Apparently, Scott had not yet heard of Morris's death, for in October 1913, Brooke wrote from San Francisco to Scott: "I'm sorry I broke the bad news about Morris so abruptly. I never guessed my letter would be the first tidings or wouldn't have written it in that way . . . "[4]

Dr. Scott later wrote what some consider to be one of his finest poems that which he entitled "Lines in Memory of Edmund Morris", in which he exclaimed,

Dear Morris – here is your letter –
Can my answer reach you now?
Fate has left me your debtor
You will remember how;
For I went away to Nantucket,
And you to the Isle of Orléans,
And when I was dawdling and dreaming
Over the way and means
Of answering, the power was denied me,
Fate frowned and took her stand;
I have your unanswered letter
Here in my hand.
This – in your famous scribble,
It was ever a cryptic fist,
Cuneiform or Chaldaic
Meanings held in a mist.

Dear Morris (now I'm inditing
And poring over your script)
I gather from the writing,
The coin that you had flipt,
Turned tails; and so you compel me
To meet you at Touchwood Hills:

166

Or mayhap, you are trying to tell me
The sum of a painter's ills . . .

In his poem, Dr. Scott referred to some of the Indians
whom Morris had painted and whom he too, had known:

I can feel the wind on the prairie
And see the bunch-grass wave,
And the sunlights ripple and vary
The hill with Crowfoot's grave,
Where he "pitched off" for the last time
In sight of the Blackfoot Crossing,
Where in the sun for a pastime
You marked the site of his teepee
With a circle of stones. Old Napiw
Gave you credit for that day
And well I recall the weirdness
Of that evening at Qu'Appelle,
In the wigwam with old Sakimay,
The keen, acrid smell,
As the kinnikinick was burning;
The planets outside were turning,
And the little splints of poplar
Flared with a thin, gold flame
He showed us his painted robe
Where in primitive pigments
He had drawn his feats and his forays,
And he told us the legend
Of the man without a name,
The hated Blackfoot,
How he lured the warriors,
The young men, to the foray
And they never returned . . .

I remember well a day
When the sunlight had free play,
When you worked in happy stress,
While grave Ne-Pah-Pee-Ness
Sat for his portrait there,
In his beaded coat and his bare
Head, with his mottled fan
Of hawk's feathers, a man.
Ah, Morris, those were the times . . .
Here, Morris, on the plains that we loved,
Think of the death of Akoose, fleet of foot,

167

Who, in his prime, a herd of antelope
From sunrise, without rest, a hundred miles
Drove through rank prairie, loping like a wolf,
Tired them and slew them, ere the sun went down.
Akoose, in his old age, blind from the smoke
Of teepees and the sharp snow light, alone
With his great-grandchildren, withered and spent,
Crept in the warm sun along a rope
Stretched for his guidance. Once when a sharp autumn
Made membranes of thin ice upon the sloughs,
He caught a pony on a quick return
Of prowess and, all his instincts cleared and quickened,
He mounted, sensed the north and bore away
To the Last Mountain Lake where in his youth
He shot the sand-hill cranes with his flint arrows.
And for these hours in all the varied pomp
Of pagan fancy and free dreams of foray
And crude adventure, he ranged on entranced,
Until the sun blazed level with the prairie,
Then paused, faltered and slid from off his pony.
In a little bluff of poplars, hid in the bracken
He lay down; the populace of leaves
In the lithe poplars whispered together and trembled,
Fluttered before a sunset of gold smoke,
With interspaces, green as sea water,
And calm as the deep water of the sea.

There Akoose lay, silent amid the bracken,
Gathered at last with the Algonquin Chieftains.
Then the tenebrous sunset was blown out
And all the smoky gold turned into cloud wrack.
Akoose slept forever amid the poplars,
Swathed by the wind from the far-off Red Deer
Where dinosaurs sleep, clamped in their rocky tombs.
Who shall count the time that lies between
The sleep of Akoose and the dinosaurs?
Innumerable time, that yet is like the breath
Of the long wind that creeps upon the prairie
And dies away with the shadows at sundown . . . [5]

The will of Edmund Morris, dated 5 August 1913, was
probated and some of the contents were made public, which

eventualities prompted, in January 1914, an editorial reading in part as follows:

> There was a fine spirit in Edmund Morris, the Canadian painter who died last summer. Reserved and at times even taciturn, he did not make many close friends but those admitted under his plaid, such as Archibald Browne, for instance, knew well his passion for efficiency, his love for this sunlit country, his pride of ancestry, and his continual interest in the better things of Canadian life.
>
> As an artist he distinguished himself in two fields first by his portraits of famous Indian chiefs in which he excelled, and secondly by the virility and charm of his landscapes. The natural dignity of the savage appealed strongly to his imagination. He felt very much like old Father le Jeune, the Jesuit missionary who wrote in 1645 or thereabouts: 'These people have the heads of Julius Caesar, of Augustus, Othello.' So Morris went miles over prairie and muskeg and wooded wilderness seeking and finding the spirit of the American Indian. His series of portraits are now the property of the Ontario government. They have the same breadth and sympathy of treatment which is found in some of the old Masters. The heart of the artist is shown in his will. His landscapes will be sold and the proceeds will go to found a scholarship in the Ontario College of Art. His collection of fine Colonial furniture will be the property of the Royal Ontario Museum and will be grouped somewhere in the new building. 'It is advisable,' he says, 'that something may appear to remind us of the old colonial days.' . . . Most of the museums in Canada will have some memorial of Edmund Morris. He has remembered them all. But to his friends he leaves something better and nobler even than his work — the memory of a true heart, a lively sensibility, and a vigorous and healthy patriotism.[6]

At the time of death, Edmund's next-of-kin included Christena, Alex and William all of whom were living in Toronto, Eva (Mrs. James Cochrane), of Lennoxville, Quebec, and Major Robert C. Morris, of London, England.

His brothers and sisters were to share equally in the liquid assets from his estate, with the exception of Bob, who was to receive a double share. His paintings were to be sold at public auction or private sale and the proceeds to go for a scholarship in the Ontario College of Art.

To the Art Museum of Toronto he left his books on art, and his etchings and Japanese prints to the Victoria Museum in Ottawa. His collection of colonial furniture he left to the Royal Ontario Museum, with directions as follows:

> The black walnut cabinet given to my grandfather [Wm. Morris] by Dr. [Daniel] Wilson, one of the fathers of geology in Canada, the four old Colonial bookcases, two of which are from the old Military Settlement on the Rideau [Perth] and the other two made of the doors of the old Beverley House [the homestead of Beverley Robinson family, at the corner of Queen and John Streets, Toronto] torn down to make room for the Methodist Book Room, the round table, the set of habitant chairs, Grandfather's armchair, Dutch clock, delft, and such other articles as the Committee think would illustrate the colonial days in Canada, there to be grouped together in some section of the Museum . . . to remind us of the old Colonial days.[7]

He bequeathed his negatives and photographs, taken while painting among the western Indians, to the Victoria Museum in Ottawa, with direction that some be enlarged and hung as a collection. He also wished that a selection of his Indian photographs might be given to the British Museum, the Winnipeg Museum, and the Art Association of Montreal, as well as to the Dick Institute, Kilmarnock, Scotland, and the Museum of Calmer, Alsace.

He left his valuable collection of Indian relics to the Royal Ontario Museum, to be kept as the Morris Collection, which the Museum has done, including them as part of the Morris Collection of paintings which were transferred to the R.O.M. by the Government of Ontario.

Morris's will named paintings to be distributed to various galleries, as well as to the care of the eponymous town of Morrisburg, Ontario, Glen Morris, and Morris,

170

Manitoba. His books on Canada and the American Revolution he left to Queen's College Library, Kingston, and his books on Indians to the Ethnology Department of the Royal Ontario Museum; other books were to go to the Arts and Letters Club of Toronto.

When the Canadian Art Club held their 1914 Exhibition, eight paintings of Edmund Morris were included:

Cape Diamond from the St. Lawrence (lent by D.R. Wilkie)
The Corn Fields, Ste. Anne de Beaupré, Quebec (lent by D.R. Wilkie)
The Coast of Île d'Orléans (lent by Miss Morris)
Buffalo Willows
Cove Fields, Quebec
Willows, Haddingtonshire, England
Cap Tourmente (lent by Wm. Morris)
A Cree

Among the unfinished business Edmund Morris left behind him was the Fort Qu'Appelle Treaty Memorial. The Great War in Europe interrupted the Committee's plans. As committee members were all engaged in supporting Canada's war efforts, work on the memorial was temporarily halted in 1914.

The Department of Indian Affairs had promised to provide a grant of $1,000 toward the memorial if the province would come up with an equal amount. In its 1914-15 estimates, the Government of Saskatchewan approved $1,000 toward the memorial. Despite Morris's preparations and designs, the final choice was made by the Saskatchewan Branch of the Western Art Association, to "keep it as much of a western enterprise as possible." They chose Sherwood Williams, a western architect, to make the final design but construction was held in abeyance until 1915. The old school-site in the village of Fort Qu'Appelle, the original location of the signing of the Qu'Appelle Treaty with the Indians, was indicated by the local council to be the desired situation for the memorial.

The Regina *Leader* of 9 November 1915 carried the story of the unveiling by His Honour, Lieutenant-Governor Lake. The memorial was described as an obelisk —

a single tapering column – quite unlike the post-and-lintel design prepared by Morris.

The brochure produced for the occasion by the Saskatchewan Branch of the Western Art Association indicates that "The village [of] Fort Qu'Appelle has agreed to keep the grounds in order as a park. The monument is composed of Tyndall stone from the province of Manitoba, with four granite panels from the Province of Quebec on which the inscriptions and Coats of Arms are shown." Further, "The Coats of Arms, one on each side of the monument above the panels, represents the different forms of government under which the country has been administered in the past and present – Great Britain, the Hudson's Bay Company, the Dominion of Canada and the Province of Saskatchewan."

The names of the commissioners, Indian Chiefs and witnesses and dates and places where the Treaty was signed, are inscribed in the granite panels.

There was no recognition of Morris as the initiator of the memorial concept, either in the Art Association brochure or in the newspaper account of the unveiling. The latter reads in part:

> The territory ceded by the Indians extended from a point on the United States frontier south of Moose Mountain, thence north-easterly to Lake Winnipegosis, through Fort Ellice, thence in a southeasterly direction to the source of the Qu'Appelle river and to the mount of Maple Creek thence west of the Cypress Hills, south to the International boundary, thence east along the boundary to the point of commencement; a territory comprising the greater part of the present province of Saskatchewan.

> The monument was erected through the efforts of the association and by individual subscriptions from members and others interested in different parts of Canada, as well as the United States and England. Among the more prominent subscribers are Lord Minto, former Governor-General of Canada; Lord Bryce, former British Ambassador to the United States; Hon. Edgar Dewdney, formerly Lieutenant-Governor of the Northwest Territories and Minister

172

of the Interior; the Hon. R.S. Lake, Lieutenant-Governor of Saskatchewan; Bishop Grisdale and many others, with substantial contributions from the Dominion Government, the Provincial Government of Saskatchewan, the Women's Canadian Club at Winnipeg, and a number of Chapters of the Daughters of the Empire.

The Treaty was signed by twenty-one Indian Chiefs and the three Indian commissioners, the Hon. Alexander Morris, Lieutenant-Governor; Hon. David Laird, Minister of the Interior, and afterwards Lieutenant-Governor, and the Hon. William Christie. There were thirty-six witnesses to the treaty of which there are only seven alive today. All the Indians and the commissioners who signed have passed away . . .

The Department of Indians Affairs has arranged for two delegates from each band within the treaty to be present at the unveiling. A large number of Indian children will be present from the Indian industrial school at Lebret, with the brass band of that institution. Several hundred Indians are expected to be present also from the various reserves throughout the province and more particularly those reserves in or near the Qu'Appelle Valley.

The monument is the first of its kind in Canada as a mark of the signing of a treaty between the aborigines of Canada with Great Britain.[8]

The wording on the monument relating to the Treaty reads as follows:

This monument was erected
A.D. nineteen hundred and
fifteen by the Western Art
Association, Saskatchewan
Branch, to commemorate the
First Treaty between the
Indians of the North West
Territories and Queen Victoria
represented by Her Commissioners:
The Hon. Alex. Morris
Lieut. Gov. N.W.T.

Hon. David Laird,
Indian Commissioner and
W.J. Christie
at Fort Qu'Appelle
September fifteenth,
eighteen seventy-four
known as "The Qu'Appelle
Treaty Number 4."
Whereby the Indian Chiefs
Ceded all their rights, titles
and privileges to all lands
wheresoever situated within
Her Majesty's North West
Territories to Her Majesty
The Queen and her successors
Forever.

The fate of the sacred stone purchased by Morris for the original memorial remained a mystery for many years. On 26 January 1957 the Regina *Leader-Post* published an article entitled "Missing Indian god turns up in Ottawa." It told how Morris's missing "sacred stone" was located by a very circuitous route. John Martin of Rosebud, Alberta, in 1912, had been paid $75 to cart the stone 160 miles to the railhead at his home town, Gleichen, from which it had been shipped to Fort Qu'Appelle. The trip took him five days and he had never forgotten it. In 1955, John Martin, getting on in years, became curious as to whether the eventual Fort Qu'Appelle monument actually included the stone, and wrote to the Provincial Museum in Saskatchewan. Mr. Allan Turner, then Archival Assistant, confirming that it had not been used in the final memorial, learned from local investigation that the stone had been crated, loaded on a stone boat and hauled away from the Hudson's Bay Company site where it had temporarily been placed for the memorial ceremony, which took place in 1912. Mr. Turner wrote to the National Museum in Ottawa, which had no record of such a stone arriving there. However, Mr. Turner continued his research. A Mr. Chris Higginbotham of C.B.C. did a story on the missing stone in his *Points West* radio programme in 1956. The story attracted the attention of a Mr. J.G. MacGregor of Edmonton, who wrote to Turner, saying

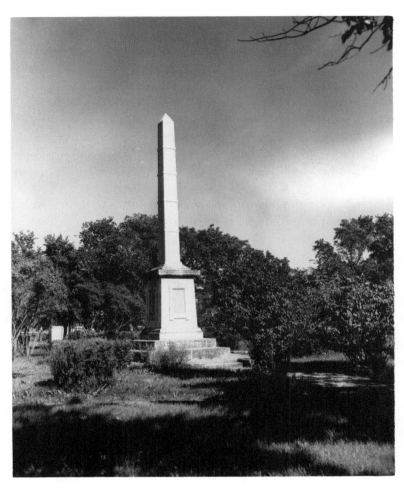

Monument erected at Fort Qu'Appelle commemorating signing of Treaty No. 4 in 1874
Saskatchewan Archives, Regina

that he had a photograph of the stone and had shown it to Dr. R.S. MacNeish, Archaeologist of the National Museum. When he saw the photograph, Dr. MacNeish stated, "That's the one we have in the Museum." It had arrived from Fort Qu'Appelle without any information or documentation being supplied by the donor. The news was passed along to Mr. Martin, but the Museum in Ottawa was unable to explain why it ended up there.

As to why the stone was not used in the eventual memorial at Fort Qu'Appelle, several clues have come to light. Although Morris does not mention it in his correspondence, a face was carved on the surface of the sacred rock and it was recently learned that the features had been outlined in black paint by Mr. Martin for the purpose of photographing it. The startlingly grinning face was probably not acceptable to the Women's Art Association of Saskatchewan when it arrived from Gleichen, Alberta, for it was reported that the stone "caused quite a stir" at the dedication ceremony held in October 1912. It was subsequently and unceremoniously shipped off to Ottawa.

As for Morris's hope that the signing of the treaties at Fort Carlton and Fort Pitt would be similarly recognized, no one came to take his place for the realization of this project.

Edmund Morris's interest in history included genealogy, and, following the death of his mother in 1906, he had begun to collect information on his maternal ancestors, intending to write a memoir of both the Cline and Vankougnet families. He corresponded with distant relatives and visited the home of the first Cline family to settle in America, at Johnstown, New York, the settlement that grew up around Sir William Johnson. The Cline family had come from Germany in 1764, and Edmund learned that Michael Cline (or Klein as it was then) had taken an Oath of Allegiance and would not fight against the King of England. He was a gunsmith and joined Sir John Johnson's 2nd Battalion of the Royal Regiment of New York and, as a Loyalist, drew land in the township of Cornwall, Canada.

Morris haunted auctions for old journals and rare books and had agents looking out for anything that would relate to the ancestral history. John Scopes of Albany,

N.Y., writing to him in January 1913, reported an estate collection: "We think we have coming a copy of Major Robert Rogers' Journal in the lot . . . also a fine letter from Sir Wm. Johnson." Through Scopes he acquired one of Governor John Graves Simcoe's rare *Military Journals* "first published as a memoir of the author," and [Sir John] *Johnson's Orderly Book*, kept during the Oriskany Campaign of 1776-77. Morris never completed the family chronicles that he intended to write.

A daughter of Eva Morris recently recalled her uncle Edmund's visits to Compton, Quebec, where he was welcomed by his nieces. He was dark-skinned, as she remembered, and could "easily have passed for an Indian himself", and looked every inch the part when he entertained his nieces by executing Indian war dances for their amusement. She recalled with nostalgia the carefully chosen, imaginative children's books he would send or produce on a visit.

From time to time Morris's landscapes appear in auctions – for instance, those held by such Toronto firms as Sothebys, D. & J. Ritchie, and Waddingtons; occasionally, one comes across one of his paintings in a commercial art gallery.

In March 1928, the Art Gallery of Toronto held a memorial exhibition of seventy-six of his work simultaneously with the annual O.S.A. exhibition. The Art Gallery loaned *Chief Bull Plume* and *The Poppy Field* for the occasion, and ten of the Royal Ontario Museum's collection of Indian Chiefs were shown. Seven other paintings were loaned by private collectors. The remaining fifty-seven pictures were offered for sale. A reporter covering the exhibition remarked that Morris "was active in the O.S.A. and the Canadian Art Club of Toronto before his death in 1913. He painted in what was then considered a broad manner but would now be considered conservative."

Early reviews praised his landscapes. "He is most at home in oil colours, his control over this medium being truly remarkable," wrote a reviewer in 1901.

He has also a true eye for colour and the quality of his line has considerable strength and charm. Mr.

177

Morris in his landscape work is especially fond of the varied and elusive manifestations of light . . . the extensive rolling country with its constantly shifting play of colour, the brilliant skies and varied grand masses of trees and the quaint villages with their unconventionalized inhabitants speak strongly to him . . . In 'A Canadian Landscape,' the delicate purples and greys over the surface of the foreground give an effect of transient shadows of the lightest quality.[9]

Professor James Mavor described Morris's landscapes "as luminous as is his manner." Morris's style of landscape painting did not change over the years, remaining broad in treatment. His Indian portraits, striking and colourful, obscured the gentler landscape work. Not all were in agreement as to the quality of the portraits. Dr. J. Russell Harper reports that J.W. Morrice "himself admired Edmund Morris. This respect was not based on his Indian head pastels; Morris was not at all the same man when he turned to landscapes in oil. His *Quebec Terrace* (Poole Foundation, Edmonton) has delicate beauty and sensitivity, his early pastorals have a low-keyed tonal harmony which even Whistler would have admired, and at least one pastel study of a girl has the softly textured beauty of a Morrice painting."[10] Dennis Reid detects a late alliance of the opposing tendencies in Morris's work in his *Indian Encampment on Prairie*, dated about 1910 (Art Gallery of Ontario), which he describes as being "notable for the rich and subtle modulations of the immense sky: with its dark Dutch tonalities and its avoidance of any Kane-like documentation, it must have seemed strangely modern. Its interlocking range of moody earth-tones, from blue-black through to red, is unusually successful in evoking the binding forces of nature . . . Dark, sonorous canvases like *The St. Lawrence Near Quebec*" – in the National Gallery of Canada – "of about 1912 seem to presage his tragic end."[11]

Morris finally received his due both as an artist and as an amateur ethnographer in 1984, when the University of Regina's Norman Mackenzie Art Gallery mounted a retrospective exhibition entitled *Edmund Morris "Kyaiyii"*

178

1871-1913. In his catalogue introduction Geoffrey Simmins sums up his subject's *oeuvre* as follows:

> Morris' reputation as an artist rests largely on his Indian portraits which have long been recognized for their sympathetic attitude to each sitter and their accurate depiction of native costume. They preserve a valuable record of the last generation of Canadian Indians who could remember life before the white man . . . Although regarded by many of his contemporaries with less favor than the portraits, the best Morris landscapes have a compelling force and depth of vision that makes them equally memorable. A work such as *Cap Tourmente* for instance (NGC . . .), painted c. 1903, features a cool silvery atmosphere contrasted against the rich brown tones of the landscape. Morris' juicy blobs of pigment and bravura brushwork impart to the painting a dramatic quality reflecting the elemental force of nature. Its loose handling marks it among the most advanced landscape paintings executed during these years by any Canadian artist.[12]

Elsewhere in the catalogue Simmins attempts an assessment of Morris both as a portraitist and landscape painter working within a specific cultural and historical context, which is worth quoting at length:

> Given such a broad-based revival of interest in Morris as a person, therefore, it seems appropriate to ask, after the nearly three-quarters of a century since his death, just how good a painter was he? The Indian portraits stand up well. They are superior to anything produced by his close contemporaries. Executed with a pleasing freshness and freedom from convention, they are non-sentimental and at times, such as in the portrait of Blackfoot Chief *Iron Shield* (NGC . . .), achieve a monumentality that raises them to heroic scale.

Simmins continues,

> . . . Morris distances himself from the underlying social implications in all his portraits, including those

of Indians. We may regret this to a certain extent, because we can not read from his portraits what he believed. Yet precisely *because* Morris remains aloof from his subjects, in the end his portraits are more successful than had he succumbed to the allure of showing the tragedy of the Indians' plight. To do so would have left pathos teetering dangerously near the precipice beyond which lies bathos. By eschewing a moral stance in his portraits, Morris allows the viewer to make up his own mind about the underlying implications of what he sees.

With regard to his landscapes, I am inclined to agree with many of his early reviewers, who typically termed his work "spirited and sketchy", and "full of promise". Like them, I admire his verve in handling; but also like them, I feel that not all his landscapes achieved the full expression of his early promise. Still, the best Morris landscapes can approach the monumental scale of his Indian portraits In Morris' smaller landscapes, especially the cigar-box-sized *pochades* such as *Indian Tepees: Manitoba* . . . , – the bravura brushwork seen in the foreground of *Cap Tourmente* is applied even more freshly; the same subtle varied palette is found; and once more the richly-textured surface is juxtaposed against a deep pictorial space.

Morris did not always achieve such spontaneous results in his work, however; to my eyes, and I suspect others' as well, many of his landscapes appear overworked and too dark.

As for his approach to composition, Simmins goes on,

It is true though that many of Morris' large landscapes adhere to a parcel of consistent and repetitive compositional formulae: a dark repoussoir element in the foreground is juxtaposed against a distant infinite landscape; the middle ground links the fore – and background by means of a diagonal receding into depth. Often this diagonal is a river. Above, a bruise-hued sky rent by jagged sunlit openings casts an uneven, dramatic light.

180

Any discussion of Morris' landscapes would be incomplete without discussing his stylistic debts to other artists and schools. In fact, Morris' style reveals a veritable stew of the previous fifty years or so of European art, with pungent traces from Holland, particularly the Hague School The Hague School, distantly inspired by the great landscape painters of Holland's Golden Age in the seventeenth century, and more closely inspired by the French Barbizon painters of the mid-nineteenth century, was the most important influence in Canada besides Impressionism, and was especially attractive to collectors . . . Morris was doubtless familiar with Hague School work, since he had painted in Holland during the summer of 1895 . . . *Girls in a Poppy Field* was executed that year while in Holland, and its debt to Dutch painting contemporary with it is clear

However, Simmins cautions,

The style of Morris' landscapes seem to have a good deal in common with the Hague School, but are actually closer in spirit to contemporary American work

It is important to realize just how dominant this tonal approach to painting was among Canadian painters during this period. And while tonal painting is particularly associated with Morris and his colleagues in the Canadian Art Club, future members of the Group of Seven were also painting in this manner.

He concludes with the suggestion that

. . . Morris' tonal paintings should not be regarded with eyes made severe by several generations of earnest Canadian landscape painters. It is not fair to criticize him simply because he did not break through the prevailing stylistic idioms of the period. For to follow this line of reasoning – that Morris and other tonal painters were only precursors of the Group – leads one onto boggy intellectual fields. We are on shifting ground if we assert that the Group broke through the fetters of the foreign styles epitomized

181

by the painting technique of Morris. Not only does such a position go against the evidence – because manifestly the future members of the Group painted with the same tonal palette as Morris – but then we must define as a 'breakthrough' the replacing of Dutch tonalism characteristic of Morris with Fauve-colored Scandanavian [sic] Impressionism mixed with traces of international *art nouveau*. And does Algonquin Park serve as a more potent symbol of the Canadian psyche than the great northwest? Who knows if Morris would have adapted his palette to meet the changing perception of the Canadian landscape if his career had not been so tragically cut off?[13]

Finally, in his own contribution to the 1984 catalogue, Michael Parke-Taylor declares that

Edmund Morris was an artist with a mission. But this should not disguise the fact that he was first and foremost an artist rather than an ethnographer. Although Morris sought and justified commissions from the provincial governments on the basis of his works' lasting historical significance, it was the artistic potential of the Indian portraits which motivated the work . . .

While the biographies and anecdotes gathered by Morris in his *Western Diary* provide a fascinating account of his subjects, it is the portraits which best reveal him as a sympathetic observer of the native people. Morris wanted to portray the individual, not a stereotype. From photographs taken by the artist of his subjects, it is clear how faithful he was to appearance . . . These photographs were never slavishly copies, but rather acted as a record for consultation by Morris if further work on costume or finishing touches were required after the sitting. Generally, however, Morris' method was to establish the principal facial characteristics and compositional elements in the field, thereby imparting a sense of immediacy to the work . . .

By the time Morris executed the works for the Saskatchewan commission in 1910, he was at the height of his powers as a portrait painter. Whereas his first

efforts for the Ontario Government at James Bay in 1906 concentrated exclusively on the head, his later work encompassed the entire sheet of paper allowing details of costume to contribute a significant role . . .[14]

Parke-Taylor observes that Morris' Indian portraits, notably those in the Legislative Building, Regina, served as a probable source of inspiration to the British-born western artist and illustrator Inglis Sheldon-Williams (1870-1940), and also "paved the way for future Indian portrait painters in Saskatchewan such as James Henderson (1871-1951) and Augustus Kenderdine (1870-1947)." However, "Although contemporaries, Henderson and Kenderdine painted Indian subjects some years later than Morris in a more romantic and less individual way . . . " He ends his tribute with the remark that "By the twenties, Morris' fears regarding the imminent disappearance of the last 'Indian who went on the warpath and hunted the buffalo' had come all too true. It is due to the foresight of Walter Scott and his Government's commission to Edmund Morris" – as indeed it is to that of Duncan Campbell Scott, the Department of Indian Affairs, and the governments of Ontario and Alberta – that the country has been endowed with "not only a lasting historical record of importance but also a collection of works which rank among the finest Indian portraits in the history of Canadian art."[15]

Edmund Morris's pictorial, photographic and written documentation of Indian chiefs, head men and women and their vanishing way of life remains, therefore, an important aesthetic as well as ethnographic record of the various tribes of northern Ontario and the prairie provinces. This rich legacy would have been lost to posterity had not he been encouraged to produce his valuable work – work for which Morris was admirably suited, psychologically, artistically, and historically.

Edmund Morris
Manitoba Archives, Winnipeg

Chronology

1871 Edmund Morris born 18 December at Perth, Ontario, to the Hon. Alexander Morris and Margaret Clive Morris.

1872 Family moves from Perth to Fort Garry, Manitoba. Alexander Morris holds post of Lieutenant-Governor of Manitoba and the Northwest Territories.

1878 Family returns to Perth. Alexander Morris elected M.P.P. for Toronto East.

1880 Morris family moves to Toronto.

1885-1888 Edmund Morris attends Jarvis Collegiate Institute, Toronto. Begins diary in 1886.

1889 January: enters office of Fraser and Darling, architects, Toronto, as apprentice to Frank Darling. Meets Ernest (Seton) Thompson, the nature-writer and artist. Alexander Morris dies, 28 October 1889.

1890 4 January: begins studies with William Cruikshank.

1891-1893 Morris studies at New York Art Students' League, September 1891 to Spring of 1893, under Kenyon Cox, William Merritt Chase, and possibly George de Forest Brush. Later, studies drawing under H. Siddons Mowbray.

1892 Summer: sketching near Toronto at Weston, the Humber River Valley, Toronto Island, and Old Fort York. Fall: returns to New York, where he may have seen an exhibition organized by the American Fine Arts Society of pictures to be contributed by Sweden, Norway, and Holland to the World's Columbian Exposition, Chicago, 1893.

1893 October: to Paris to study at Académie Julian under Jean-Paul Laurens and Benjamin Constant.

1894 Summer: painting in Scotland during vacation. Is given letters admitting him to École des Beaux-Arts, Paris. Fall: returns to Paris.

1895 Painting in France, Belgium and Holland

1896 Spring: completes Paris studies under Jean-Léon Gérôme. Visits galleries in England before returning to Canada *via* New York City. Matthews Art Gallery, Toronto, holds exhibition of his paintings. Studio at family residence, 471 Jarvis St., Toronto. Spends summer in Muskoka, doing little painting.

1897 Paints in Ste.-Anne-de-Beaupré, Québec, with William Brymner, Maurice Cullen, Edmond Dyonnet and Horatio Walker. Takes studio in Imperial Building, Toronto. Exhibits for first time with Royal Canadian Academy (and annually thereafter to 1912).

1898 Elected Associate, Royal Canadian Academy, 4 March. July-August: paints with Brymner, Cullen and Dyonnet at Louisbourg, Ste. Anne Falls, St. Feréol, and Beaupré.

1899 Takes studio at 32 Adelaide St. E., Toronto. August-September: paints with Brymner and Cullen at Beaupré and Baie St. Paul.

1900 One-man exhibition at Matthews Art Gallery, Toronto. Pen-and-ink drawings of Chief Big Bear and Chief Crowfoot sold to Lord Minto. Sketches near Ste. Anne and Cap Tourmente, Québec.

1901 Morris's sister, Mrs. Malloch, dies. Morris exhibits at International Exhibition, Glasgow, Scotland, and at Pan American Exposition, Buffalo, New York; at the latter, his *Girls in a Poppy Field* (Art Gallery of Ontario) wins a bronze medal. Studio in Yonge Street Arcade, Toronto.

1902 Goes to England, and Scotland, painting numerous landscapes. Studio at 9 Toronto St., to 1906.

1903 Painting at Beaupré with Cullen and J.W. Morrice.

1904 Exhibition at Messrs. Scott and Sons, Montreal. Exhibition at Matthews Art Gallery, Toronto. Becomes

member of Women's Canadian Historical Society, Toronto. Paints again in Québec.

1905 One-man exhibition in Ottawa at studio of J. Wilson and Co. Elected member of Ontario Society of Artists.

1906 Commissioned by Government of Ontario to travel with James Bay Treaty Party to northern Ontario to paint portraits of Indian chiefs and headmen. July-August: accompanies Treaty Nine Expedition to James Bay Territory. Returns to Toronto, having remained longer than treaty party to execute portraits. Exhibits with O.S.A.

1907 One-man show at Scott and Son Gallery, Toronto. Paints portraits of Brantford Six Nations Indians. Exhibits with O.S.A. but later resigns to co-found the Canadian Art Club with other artists. Receives a commission from Government of Ontario to go west and paint, for Ontario Legislative Building, Toronto, Cree, Assinniboine, Sioux and Salteaux chiefs and headmen who had signed earlier treaties. Leaves 28 June for the west, going first to the Blackfoot Reserve near Calgary, and travelling as far as British Columbia.

1908 Studio at 43 Victoria St., Toronto, to 1913. First exhibition of the Canadian Art Club, Toronto, with Morris participating. "Edmund Morris, Painter", by W.M. Boultbee, appears in June issue of *Canadian Magazine*. 26 June-October: makes second western journey, visiting Indian reserves in Manitoba, Saskatchewan and Alberta. His mother, Mrs. Alexander Morris, dies.

1909 March-April: one-man show of Indian portraits and Indian artifacts at C.A.C., Old Court House, 57 Adelaide St. E., Toronto. In conjunction, publishes *Portraits of the Aborigines of Canada and Notes on the Tribes: Catalogue of the Morris Collection of Indian Portraits at the Gallery of the Canadian Art Club*. Appointed member of Council of Art Museum of Toronto. Successfully persuades Government of Ontario to commission more Indian portraits. July-October: third western journey to complete Government of Ontario commission. Visits Manitoba and Saskatchewan, where Morris tours Indian reservations to find subjects for portraits. Most of summer spent at Blackfoot Reserve, Gleichen, Alberta. Receives a commission

187

from Saskatchewan Government to paint fifteen portraits for planned Legislative Building, Regina, and later a commission from the Alberta Government for five Indian portraits for Legislative Building, Edmonton.

1910 Arranges group exhibition of Canadian Art Club to be held in the gallery of the Art Association of Montreal. Elected member of Arts and Letters Club, Toronto.

1911 Morris family residence on Jarvis St. sold. Morris turns his studio at 43 Victoria St. into apartment. March: sends second installment of five commissioned Indian portraits to Saskatchewan Government. August: Saskatchewan Government receives final portraits. September: paints Saskatchewan Indian portraits and tipis. Publishes *Art in Canada: The Early Painters*. Begins fundraising campaign to erect a monument to the signing of Treaty No. 4 at Fort Qu'Appelle, Saskatchewan.

1912 Involved with new Art Museum of Toronto and various other causes. Dispute over the Government of Ontario collection of Indian portraits being hung in the new Royal Ontario Museum building, Queen's Park, Toronto; Morris willing to give his collection of Indian artifacts if appropriate space can be allocated for ethnological collections. Wishes his paintings to be kept with artifacts as a collection.

1913 International Geological Congress to be held in Toronto, Morris trying to get his collection of 60 Indian portraits in place at R.O.M. for the visit of the scientists to Toronto. Finally appeals to the Victoria Museum, Ottawa. Meets English poet Rupert Brooke, then correspondent for *Westminster Gazette*, London. Provides Brooke with addresses in the west. Morris showing some signs of ill-health early in the year. Goes to Québec in August, visiting Horatio Walker near Portneuf. 21 August: drowns in St. Lawrence River, believed to have fallen from the railway bridge near Beaupré, while sketching. Buried 27 August at Mount Pleasant Cemetery, Toronto.

1928 3 March - 8 April: *Edmund M. Morris, A.R.C.A. Memorial Exhibition* held at Art Gallery of Toronto.

1967 6 October - 5 November: Morris included in exhibition, *Painting in Saskatchewan 1883-1959* mounted by Mendel Art Gallery, Saskatoon.

1974 4 December - 2 February: Morris included in exhibition, *Portraits of the Indians*, mounted by Glenbow-Albert Art Gallery, Calgary.

1977 Former Morris family residence at 471 Jarvis St., Toronto, designated for preservation under Ontario Heritage Act by Toronto Historical Board.

1984 20 January - 26 February: retrospective exhibition, *Edmund Morris "Kyaiyii" 1871-1913*, held at Norman Mackenzie Art Gallery, Regina. Morris's *Western Diary, 1907-1910* published by R.O.M.

Notes

A Geneological Introduction
1. For details of settlement, see Jean S. McGill, *A Pioneer History of the County of Lanark* (Toronto: Best Printing Co. Ltd., 1968).
2. John Ross Robertson, *Landmarks of Toronto*, Vol. 1 (Toronto: J. Ross Robertson, 1894; reprinted Belleville, Ont.: Mika Publishing Co., 1976), p. 278.
3. Edmund Morris, "Historical and Biographical Sketches of the Hon. Wm. Morris et al.", Edmund Morris Papers, MG.30.D.6, Public Archives of Canada, Ottawa.
4. Edmund Morris, "Historical and Biographical Sketches . . . ", Edmund Morris Papers.

Chapter One
1. W.J. Morris, "Old Fort Garry in the Seventies", William Morris Papers, Metropolitan Toronto Library.
2. Now part of the Edmund Morris Collection of Indian Artifacts in the Ethnology Department of the Royal Ontario Museum, Toronto.
3. Built in 1875, 471 Jarvis St. was designated in 1977 under the Ontario Heritage Act as one of a number of houses which the Toronto Historical Board recommended for preservation for architectural and historical reasons.
4. Edmund Morris, Diaries, 1886-1904, Collection 2140, Queen's University Archives, Kingston, Ontario (copy in Ethnology Department, Royal Ontario Museum).
5. Edmund Morris, Diaries, 1886-1904.
6. J.E. Morris to A. Morris, 21 September 1889. Alexander Morris Papers, MS.535, Archives of Ontario, Toronto.
7. Unidentified newspaper clipping found in Alexander Morris Papers, Provincial Archives of Manitoba.
8. [Illegible] to W. Morris, 26 November 1889. Edmund Morris Papers, MG.14.C.30, Provincial Archives of Manitoba.
9. [Illegible] to W. Morris, 26 November 1889.
10. W.B. Lambe to E. Morris, 23 November 1889. Alexander Morris Papers, MS.535, Archives of Ontario.
11. E. Thompson to Rev. G.M. Grant, 9 December 1889. Alexander Morris Papers, MS.535, Archives of Ontario.

Chapter Two
1. W. Morris to E. Morris, 9 October 1891. Alexander Morris Papers, MS.535, Archives of Ontario.
2. Edmund Morris, Diaries, 1886-1904.
3. Edmund Morris, Diaries, 1886-1904.
4. Edmund Morris, Diaries, 1886-1904.
5. A. Morris to E. Morris, 26 February 1894. Alexander Morris Papers, MS.535, Archives of Ontario.
6. Elizabeth Morris to E. Morris, 17 March 1894. Alexander Morris Papers, MS.535, Archives of Ontario.

7. Morris, Diaries, 1886-1904.

8 – 18. Morris, Diaries, 1886-1904.

19. Lynne C. Doyle, "Art Notes", *Toronto Saturday Night* 9 (7 March 1896): 9.

20. Lynne C. Doyle, "Art Notes", *Toronto Saturday Night* 9 (24 October 1896): 9.

Chapter Three

1. Edmund Morris, Diaries, 1886-1904. Unless otherwise indicated, all quotations in this chapter are from this diary.

2. Mme. Langlois was married to Jean Langlois, LL.D., Q.C., M.P. for Montmorency, Quebec.

Chapter Four

1. W.B. Lambe to E. Morris, 21 March 1905. Edmund Morris Papers, MG.14.C.30, Provincial Archives of Manitoba.

2. Treaty No. 9 contains a curious clause. After outlining the territory to which the signees were relinquishing title, the document in a subsequent paragraph proceeds to encompass "the said Indian rights, titles and privileges whatsoever to all other lands wherever situated in Ontario, Quebec, Manitoba, District of Keewatin, or any other portion of the Dominion of Canada."

3. Edmund Morris, Diary of 1906: Treaty 9: Journey to James Bay, Queen's University Archives (copy in Ethnology Department, Royal Ontario Museum, transcribed by Mary Fitz Gibbon). Unless otherwise indicated, all quotations in this chapter are from this diary.

4. Ethnology Department, Royal Ontario Museum.

Chapter Five

1. Edmund Morris, "The Western Diaries of Edmund Morris, 1907-1910". Transcribed and edited by Mary Fitz Gibbon. The original MS is in the collection of the Ethnology Department, Royal Ontario Museum. To be published as *The Diaries of Edmund Morris: Western Journeys* by the Royal Ontario Museum in the fall of 1984. Unless otherwise indicated, all quotations in this chapter are from this source.

2. Edmund Morris, "Lieutenant-Colonel Irvine and the North-West Mounted Police", Edmund Morris Papers, MG.14.C.30, Provincial Archives of Manitoba.

3. A. Morris to A. Mackenzie, 26 December 1873. Alexander Morris Papers, Provincial Archives of Manitoba.

4. Edmund Morris, "Lieutenant-Colonel Irvine . . . "

5. Edmund Morris, "Lieutenant-Colonel Irvine and the North-West Mounted Police", *The Canadian Magazine* 37 (October 1911): 493.

6. R.G. Forbis, of the Department of Archaeology, University of Calgary, in 1960 conducted an excavation here and verified Morris's earlier report, but asked some questions in his Cluny report: "Where did Morris plough and where did he dig? What became of the artifacts?" (Some appear to be in the collection donated by Morris to the Royal Ontario Museum.) Forbis found no human bones in his excavation. See R.G. Forbis, *Cluny, an Ancient Fortified Village in Alberta* (Calgary: University of Calgary, Department of Archaeology, 1977).

7. Edmund Morris, Introduction, *Catalogue of the Morris Collection of Indian Portraits at the Gallery of the Canadian Art Club* (Toronto: Canadian Art Club, 1909), p. 14.

8. J. Fleetham to E. Morris, 10 October 1907. Edmund Morris Papers, MG.14.C.30, Provincial Archives of Manitoba.

9. L. Doucet to E. Morris, 1 January 1908. Edmund Morris Papers, MG.14.C.30, Provincial Archives of Manitoba.

Chapter Six
1. E.F.B. Johnston, "A Review of the First Annual Exhibition of the Canadian Art Club", in *The Canadian Art Club, 1907-1911* (Toronto: Milne-Bingham, 1911), p. 10. Originally published in *Studio Magazine* 47 (July 1909): 154-158, and *International Studio* 38 (August 1909): 154-158.
2. J. McDougall to E. Morris, 27 April 1908. Edmund Morris Papers, MG.14.C.30, Provincial Archives of Manitoba.
3. J. Matheson to E. Morris, 31 August 1908. Edmund Morris Papers, MG.14.C.30, Provincial Archives of Manitoba.
4. Edmund Morris, Introduction, *Catalogue of the Morris Collection of Indian Portraits . . .*, p. 11.
5. L. Doucet to E. Morris, 24 August 1908. Edmund Morris Papers, MG.14.C.30, Provincial Archives of Manitoba.
6 – 9. Edmund Morris, Introduction, *Catalogue of the Morris Collection of Indian Portraits . . .*, pp. 19-20.
10. L. Doucet to E. Morris, 19 December 1908. Edmund Morris Papers, MG.14.C.30, Provincial Archives of Manitoba.

Chapter Seven
1. E.F.B. Johnston, "The Canadian Art Club", in *The Canadian Art Club, 1907-1911* (Toronto: Milne-Bingham, 1911), p. 27.
2. James Mavor, quoted in *The Canadian Art Club*, 1907-1911, p. 3.
3. E.B. Walker, quoted in "Fine Paintings by Edmund Morris. Indian Portraits are Highly Praised by Mr. Walker . . . ", *The News* (Toronto), 30 March 1909.
4. "A Remarkable Collection of Indian Portraits and Curios", *Globe Magazine* (10 April 1909): 3.
5. "A Painter of Indians", *Saturday Night* 22 (24 April 1909): 2.
6. "Toronto (Can.)", *American Art News* (New York) (24 April 1909).
7. Newspaper clipping, indicated as being from an April 1909 issue of the Toronto *Globe*, found in the Edmund Morris Papers, MG.14.C.30, Provincial Archives of Manitoba.
8. L. Doucet to E. Morris, 27 September 1909. Edmund Morris Papers, MG.14.C.30, Provincial Archives of Manitoba.
9. E. Morris to the Hon. Walter Scott, undated. Edmund Morris Papers, MG.14.C.30, Provincial Archives of Manitoba.
10. E. Morris to the Hon. Walter Scott, 20 July 1909. Edmund Morris Papers, MG.14.C.30, Provincial Archives of Manitoba.
13. W. Brymner to E. Morris, 19 September 1909. Edmund Morris Papers, MG.14.C.30, Provincial Archives of Manitoba.
11 – 12. Edmund Morris, "The Western Diaries of Edmund Morris, 1907-1910."
14 – 16. Edmund Morris, "The Western Diaries of Edmund Morris, 1907-1910."

Chapter Eight
1. L. Doucet to E. Morris, 5 June 1909. Edmund Morris Papers, MG.14.C.30, Provincial Archives of Manitoba.
2. Edmund Morris, "The Indian Problem", *Winnipeg Free Press*, 25 October 1910.
3. E.M. Chadwick to E. Morris, 29 October 1910. Edmund Morris Papers, MG.14.C.30, Provincial Archives of Manitoba.
4. E. Morris to E.M. Chadwick, undated. Edmund Morris Papers, MG.14.C.30, Provincial Archives of Manitoba.

5. E.M. Chadwick to E. Morris, 11 November 1910. Edmund Morris Papers, MG.14.C.30, Provincial Archives of Manitoba.
6. W.J. Chisholm to E. Morris, 7 November 1910. Edmund Morris Papers, MG.14.C.30, Provincial Archives of Manitoba.
7. This was done by the Royal North West Mounted Police for the Department of Indian Affairs in 1909, when the remains of the eight victims were interred in one plot and the little cemetery fenced. Placed at the head of each grave was an iron cross bearing the victim's name.
8. W.J. Chisholm to E. Morris, December 1910. Edmund Morris Papers, MG.14.C.30, Provincial Archives of Manitoba.

Chapter Nine
1. "Art and Artists", *Herald* (Montreal). 19 June 1910.
2. W. Brymner to E. Morris, 27 March 1912. Typescript of original letter, Alexander Morris Papers, MS.535, Archives of Ontario.
3. Newton MacTavish, "Edmund Morris, the End of C.A.C.", in *Ars Longa* (Toronto: Ontario Publishing Co., 1938), p. 118.
4. W. Scott to E. Morris, 11 May 1911. Edmund Morris Papers, MG.14.C.30, Provincial Archives of Manitoba.
5 – 7. Edmund Morris Letter-books: 1897-1913, 2 vols., Edward P. Taylor Reference Library, Art Gallery of Ontario, Toronto. Gift of H.M. Smith, 1943.
8. E. Morris to H. Walker, 7 November 1911. Edmund Morris Letter-books.
9. W.P. Winchester to E. Morris, 30 November 1911. Edmund Morris Letter-books.
10. E.A. Hornel to E. Morris, 23 July 1911. Edmund Morris Letter-books.
11. *Qu'Appelle Memorial Fund Appeal* (Regina: Regina Standard Publishers, 1911).
12. E. Morris to E.B. Osler, 3 April 1912. Edmund Morris Papers, MG.14.C.30, Provincial Archives of Manitoba.
13. E. Morris to H. Merritt, 3 June 1912. Archives of the Glenbow Museum, Calgary.
14. E. Morris to Sir J. Whitney, 2 May 1912. Edmund Morris Papers, MG.14.C.30, Provincial Archives of Manitoba.
15. P. Proctor to E. Morris, undated. Edmund Morris Letter-books.
16. L. Doucet to E. Morris, 28 August 1911. Queen's University Archives.
17. E. Morris to Sir. E. Walker, December 1911. Edmund Morris Papers, MG.14.C.30, Provincial Archives of Manitoba.

Chapter Ten
1. E. Morris to "Macmillans" (London, England), 12 April 1913. Edmund Morris Papers, MG.14.C.30, Provincial Archives of Manitoba.
2. H. MacFall to E. Morris, 3 March 1913. Edmund Morris Papers, MG.14.C.30, Provincial Archives of Manitoba.
3. H. MacFall to E. Morris, 16 March 1913. Edmund Morris Letter-books.
4. E. Morris to A.H. Colquhoun, undated. Edmund Morris Papers, MG.14.C.30, Provincial Archives of Manitoba.
5. E. Morris to R.A. Pyne, 29 June 1913. Edmund Morris Papers, MG.14.C.30, Provincial Archives of Manitoba.
6. E. Morris to R.W. Brock, 9 July 1913. Edmund Morris Papers, MG.14.C.30, Provincial Archives of Manitoba.
7. E. Morris to Sir J. Whitney, 9 July 1913. Edmund Morris Papers, MG.14.C.30, Provincial Archives of Manitoba.
8. E. Morris to W.H. Hearst, undated. Edmund Morris Papers, MG.14.C.30, Provincial Archives of Manitoba.

9. E. Morris to A.H. Colquhoun, undated. Edmund Morris Papers, MG.14.C.30, Provincial Archives of Manitoba.
10. E. Morris to Sir J. Whitney, undated. Edmund Morris Papers, MG.14.C.30, Provincial Archives of Manitoba.
11. R. Brooke to E. Morris, 18 July 1913. Queen's University Archives.
12. R. Brooke to E. Morris, 26 July 1913. Edmund Morris Papers, MG.14.C.30, Provincial Archives of Manitoba.
13. E. Morris to R. Brooke, 26 July 1913. Edmund Morris Papers, MG.14.C.30, Provincial Archives of Manitoba.
14. E. Morris to R. Brooke, undated. Edmund Morris Papers, MG.14.C.30, Provincial Archives of Manitoba.
15. W. and Mrs. W. Graham to E. Morris, 23 July 1913. Edmund Morris Papers, MG.14.C.30, Provincial Archives of Manitoba.
16. D.R. Wilkie to E. Morris, 9 August 1913. Edmund Morris Papers, MG.14.C.30, Provincial Archives of Manitoba.
17. "Body of E. Morris Found in River", *Globe*, 26 August 1913.
18. "Artist's Death Accidental", *Mail and Empire*, 27 August 1913.

Postscript
1. G. Gooderham to M. Cochrane, 23 January 1965. Archives of Glenbow Museum.
2. Newton MacTavish, *Ars Longa* (Toronto: Ontario Publishing Co., 1938), p. 119.
3. R. Brooke to D.C. Scott, 12 September 1913. Duncan Campbell Scott Papers, Thomas Fisher Rare Book Library, University of Toronto Library.
4. R. Brooke to D.C. Scott, 6 October 1913. Duncan Campbell Scott Papers, Thomas Fisher Rare Book Library, University of Toronto Library.
5. D.C. Scott, "Lines in Memory of Edmund Morris", in *Selected Poems* (Toronto: Ryerson Press, 1951), pp. 89-90.
6. "Edmund Morris", unidentified newspaper clipping, *ca.* January 1914, found in Edmund Morris Papers, Edward P. Taylor Reference Library, Art Gallery of Ontario.
7. Edmund Morris, Last Will and Testament, 5 August 1914, probated January 1914, Surrogate Court, Toronto.
8. "Treaty Memorial to be Unveiled by His Honor Lieutenant Governor Lake Today in Fort Qu'Appelle", *Leader* (Regina), 9 November 1915.
9. "Studio Talk", *The Studio* 22 (April 1901): 209.
10. Dr. J. Russell Harper, *Painting in Canada: A History*, 2d ed. (Toronto: University of Toronto Press, 1977), p. 231.
11. Dennis Reid, *A Concise History of Canadian Painting* (Toronto: Oxford University Press, 1973), p. 120.
12. Geoffrey Simmins, Introduction, *Edmund Morris "Kyaiyii" 1871-1913* (Regina: Norman Mackenzie Art Gallery, 1984), p. 9.
13. Geoffrey Simmins, "An Eye for Posterity: Edmund Morris 1871-1913", in *Edmund Morris "Kyaiyii" 1871-1913*, pp. 24-25, 28-29.
14. Michael Parke-Taylor, "Edmund Morris: The Government of Saskatchewan Portrait Commission", in *Edmund Morris "Kyaiyii" 1871-1913*, pp. 51-52, 54.
15. Michael Parke-Taylor, "Edmund Morris: The Government of Saskatchewan Portrait Commission", p. 56.

Illustration and Photograph Credits

Selected Bibliography

Manuscript Sources

Archives, Glenbow Museum, Calgary

Assessment Rolls, City of Toronto Archives

Biographical Scrapbooks of Toronto, Volume 3, Metropolitan Toronto Library

Canadian Art Club Papers, Edward P. Taylor Research Library, Art Gallery of Ontario, Toronto

Canadian Art Club Vertical File, National Gallery of Canada Research Library, Ottawa

Canadiana Collection, Royal Ontario Museum, Toronto

Pelham Edgar Papers, Library, Victoria University, University of Toronto

James Bay Treaty No. 9 Papers, Department of Indian and Northern Affairs, Ottawa

Newton MacTavish Collection, Canadiana Collection, North York Public Library

Newton MacTavish Papers, Edward P. Taylor Research Library, Art Gallery of Ontario, Toronto

Newton MacTavish Papers, MG D278, vols. 3 and 4, Manuscript Division, Public Archives of Canada, Ottawa

James Mavor Papers, MS. collection 119, Thomas Fisher Rare Book Library, University of Toronto Library

James Wilson Morrice artist's file (27 letters to Morris), Edward P. Taylor Research Library, Art Gallery of Ontario, Toronto

Morris Family Papers, MS. 525, Archives of Ontario, Toronto

Alexander Morris Papers, MS. 535, Archives of Ontario, Toronto

Alexander Morris Papers, Provincial Archives of Manitoba, Winnipeg

Edmund Morris Artist's File, Edward P. Taylor Reference Library, Art Gallery of Ontario, Toronto

Edmund Morris Vertical File, National Gallery of Canada Research Library, Ottawa

Edmund Morris Collection (photographs by Edmund Morris, c. 1907-1911), Still Images Section, Provincial Archives of Manitoba, Winnipeg

Edmund Morris Correspondence 1889-1913, MG.14, C.30, Provincial Archives of Manitoba, Winnipeg.

Edmund Morris Papers, G.30 D.6, Public Archives of Canada, Ottawa

Edmund Morris Papers, Collection 2140, "Edmund Morris Diaries 1886-1904", and "Edmund Morris Diary of 1906. Treaty 9. Journey to James Bay", Queen's University Archives, Kingston, Ontario

Edmund Morris Letterbooks, Edward P. Taylor Research Library, Art Gallery of Ontario, Toronto

Edmund Morris Account Book (list of works sold 1897-1912), Ethnology Department, Royal Ontario Museum, Toronto

Edmund Morris, "List of Picture Owners, Displays and Prices from Account Book", typed transcript, n.d., n.p., Ethnology Department, Royal Ontario Museum, Toronto

Edmund Morris, "Western Diaries", and typed transcript by Mary Fitz Gibbon of "Edmund Morris Diary of 1906. Treaty 9. Journey to James Bay", Ethnology Department, Royal Ontario Museum, Toronto

Edmund Morris, Last Will and Testament, probated by Surrogate Court, Toronto, January 1914

James Morris Papers, Metropolitan Toronto Library

Ontario Society of Artists Papers, MS. 1-5, Archives of Ontario, Toronto

Ontario Society of Artists Minute Books, 1901-1915, Ser. III, MU 2254, vol. II, Archives of Ontario, Toronto

Royal Canadian Academy Minute Books, MG 1 126, vol. 7, Public Archives of Canada, Ottawa

Duncan Campbell Scott Papers, MG 30 D100, vol. 3, Manuscript Division, Public Archives of Canada, Ottawa

Duncan Campbell Scott Collection (photographs of 1906 Treaty Expedition), Picture Division, Public Archives of Canada, Ottawa

Duncan Campbell Scott Papers, MS. collection 13, Thomas Fisher Rare Book Library, University of Toronto

Duncan Campbell Scott Papers in the Pelham Edgar Papers, Folders 36-46, correspondence, 1890-1946, Victoria University Library, University of Toronto

Sir Edmund Walker Papers, MS. Collection 1, Thomas Fisher Rare Book Library, Thomas Fisher Rare Book Library, University of Toronto

Homer Watson artist's file, Edward P. Taylor Research Library, Art Gallery of Ontario, Toronto

Writings by Edmund Morris

"An Ancient Indian Fort." *Canadian Magazine* 36 (1911): 257-259.

"Art in Canada: The Early Painters." *Saturday Night* 24 (24 January 1911): 24, 29.

Art in Canada: The Early Painters. [Toronto, n.p.], 1911.

Catalogue of Loan Collections of Objects of Indian Art and Curios on View at the Exhibition of Indian Portraits by Edmund Morris. Toronto: Milne-Bingham Printers, [1909]. Catalogue of exhibition held at Canadian Art Club, 57 Adelaide St. E., 30 March – 17 April 1909.

Catalogue of the Morris Collection of Indian Portraits at the Gallery of the Canadian Art Club. Toronto: Milne-Bingham Printers [1909]. Catalogue of exhibition held at Canadian Art Club, 29 March – 17 April 1909.

"Early Canadian Painters." *The Lamps* (Toronto: The Arts and Letters Club) 1 (December 1911): 8.

"The Indian Problem." *Winnipeg Free Press*, 25 October 1910.

"Lt. Colonel Irvine and the North-West Mounted Police." *Canadian Magazine* 37 (October 1911):

"Old Lords of the Soil: Description of Indians Living Near James Bay." *The News* (Toronto), 9 May 1907.

Compilations by Edmund Morris

"Art in England." Scrapbook, Edward P. Taylor Research Library, Art Gallery of Ontario, Toronto.

"Canadian Art Club" 2 vols. Scrapbook, Edward P. Taylor Research Library, Art Gallery of Ontario, Toronto.

"Canadian Painters." Scrapbook, Edward P. Taylor Research Library, Art Gallery of Ontario, Toronto.

"Wyatt Eaton Scrapbook." 2 vols. Edward P. Taylor Research Library, Art Gallery of Ontario, Toronto.

Writings by Others

Allodi, Mary. *Canadian Watercolours and Drawings in the Royal Ontario Museum*. Vol. 2. Toronto: Royal Ontario Museum, 1974.

"Art in Queen's Park, Members Dislike It. Some Criticism of the Purchase of Mr. Morris' Historic Portraits of Indians." Unidentified newspaper clipping found in "Canadian Art Club Scrapbooks", Edward P. Taylor Research Library, Art Gallery of Ontario, Toronto.

"Artist's Death Accidental." *Daily Mail and Empire* (Toronto), 27 August 1913.

"Body of E. Morris Found in River." *The Globe* (Toronto), 26 August 1913.

Boultbee, William M. "Edmund Morris, Painter." *Canadian Magazine* 31 (June 1908): 121-127.

Campbell, Harry, comp. and ed. Canadian Art Auctions: Sales and Prices 1976-1978. Toronto: General Publishing Co. Ltd., 1980. Morris: pp. 165-166.

Canadian Art Club exhibition catalogues, 1908-1912, 1913-1915.

The Canadian Art Sales Index 1977-80. Vancouver: Published for Westbridge Fine Art Marketing Services by Left Bank Publications Ltd., 1980. Morris: p. 116.

Catalogue of the . . . Edmund Morris Memorial Exhibition. Toronto: Art Gallery of Toronto, 1928. Catalogue of exhibition held 3 March – 8 April 1928.

Catalogue of the Fifth Loan Exhibition, April 11 – May 11, 1912. Toronto: Art Museum of Toronto.

D., V.I. "Clever Artist Painted Names in Portraits." *Sun World* (Toronto), 6 June 1920.

Doyle, Lynn C. "Art Notes." *Toronto Saturday Night* 9 (17 October 1896): 9.

———. "Art Notes." *Toronto Saturday Night* 9 (7 March 1896): 9.

——— [Review of Edmund Morris exhibition.] *Toronto Saturday Night* 9 (24 October 1896): 9.

——— [Review of Edmund Morris exhibition.] *Toronto Saturday Night* 10 (26 December 1896): 9.

Durand, Charles. *Reminiscences of Charles Durand, Barrister of Toronto*. Toronto: Hunter, Rose, 1897.

Eckhardt, Ferdinand. *150 Years of Art in Manitoba*. Winnipeg: Winnipeg Art Gallery, 1970. Catalogue of exhibition held 1 May – 31 August 1970.

"Edmund Morris Bequeathed Valuable Painting to Public" *Telegram* (Toronto), 27 February 1914.

"Edmund Morris (1871-1913)." *The Kennedy Quarterly* (New York) 4 (November 1963): 40-41.

"Edmund Morris Works: Indian Portraits and Canadian Landscapes at Scott's and Son's Gallery." 22 March 1907 (?). Copy in Edmund Morris Correspondence 1889-1913, Manitoba Archives, Winnipeg.

"Fine Drawings of Ojibways" *Telegram* (Toronto), 20 April 1907.

"Fine Paintings by Edmund Morris" *The News* (Toronto), 30 March 1909.

From Out of the West. Regina: Saskatchewan Department of Industry and Commerce, 1975. Unbound folio of the five Indian portraits by Morris now in the Saskatchewan Government Collection, Regina: Piapot, Big Darkness, Gambler – Ometaway, Moses, Poundmaker.

Harper, Dr. J. Russell. *Painting in Canada: a History*. Second edition. (Toronto: University of Toronto Press, 1977), p. 231.

"Indian Portraits and Curios" *The Telegram* (Toronto), 20 March 1909.

Joyner, Geoffrey, ed. *Canadian Art at Auction 1968-1975*. Toronto: Sotheby and Co. (Canada) Ltd., 1975. Morris: p. 140.

——— *Canadian Art at Auction 1975-1980*. Toronto: Sotheby Parke Bernet (Canada) Inc., 1980. Morris: p. 136.

Macdonald, Colin S. "Morris, Edmund Montague", in *Dictionary of Canadian Artists*. Ottawa: Canadian Paperbacks Publishing Ltd., 1974 Vol. 4, pp. 1297-1298.

McGill, Jean S. "Edmund Morris Among the Saskatchewan Indians and the Fort Qu'Appelle Monument." *Saskatchewan History* 35 (Autumn 1982): 101-107.

——— "The Indian Portraits of Edmund Morris." *The Beaver* (Summer 1979): 34-41.

——— *A Pioneer History of the County of Lanark*. Bewdley, Ontario: Clay Publishing Co. Ltd., 1968.

MacTavish, Newton. *The Fine Arts in Canada*. Toronto: Macmillan Company of Canada Ltd., 1924, reprinted Toronto: Coles Canadiana Collection, 1973.

——— *Ars Longa*. Toronto: Ontario Publishing Company, 1938. See especially "Edmund Morris: End of Canadian Art Club", pp. 118-119.

Martin, Sandra, and Roger Hall. *Rupert Brooke in Canada*. Toronto: Peter Martin Associates Ltd., 1978.

Morris, Alexander. *Treaties of Canada with the Indians*. Toronto: Belford, Clarke and Co., 1880.

"The Morris Indian Heads." *The News* (Toronto), 21 April 1909.

Murray, Joan. *Ontario Society of Artists: 100 Years 1872-1972*. Toronto: Art Gallery of Ontario, 1972.

Oko, Andrew. *Portraits of Indians*. Calgary: Glenbow-Alberta Art Gallery, 1974. Catalogue of an exhibition held 4 December 1974 – 2 February 1975.

Paget, Amelia. *The People of the Plains*. Toronto: Ryerson Press, 1909.

Painting in Saskatchewan 1883-1959. Regina: Norman Mackenzie Art Gallery, 1967, pp. 20-21. Catalogue of travelling exhibition held 6 October – 15 December 1967.

"Pictures of Indians." *The Globe* (Toronto)

"Preserving Records of a Passing race" *The Star* (Toronto), 20 March 1909.

Reid, Dennis. *A Concise History of Canadian Painting*. Toronto: Oxford University Press, 1973.

Reid, George A. "Edmund M. Morris A.R.C.A." Typescript, dated 17 March 1924. Archives, Art Gallery of Ontario, Toronto.

"A Remarkable Collection of Indian Portraits and Curios." *The Globe Magazine* (Toronto) (10 April 1909): 3.

Robertson, John Ross. *Robertson's Landmarks of Toronto*. Vol. 1. Toronto: J. Ross Robertson, 1894. Reprinted Belleville, Ontario: Mika Publishing Co., 1976.

Robson, Albert H. *Canadian Landscape Painters*. Toronto: Ryerson Press, 1932.

Scott, Duncan Campbell. "The Last of the Indian Treaties." *Scribner's Magazine* 40 (November 1906), pp. 573-583.

——— "Lines in Memory of Edmund Morris" in *The Poems of Duncan Campbell Scott*. Toronto: McClelland and Stewart, 1926.

"A Shame" [prices paid for many Morris paintings were so low], *Sun World* (Toronto), 21 June 1928.

Simmins, Geoffrey, and Parke-Taylor, Michael. *Edmund Morris: "Kyaiyii" 1871-1913*. Regina: Norman Mackenzie Art Gallery, 1984. Catalogue of travelling exhibition held 20 January – 26 February 1984.

"Studio and Gallery – Cullen, Brymner and Morris discontinue their sketching trip at Beaupre this week." *Toronto Saturday Night* 10 (21 October 1899) p. 9.

"Studio Talk." *International Studio* (London, England) 17 (April 1901): 209-210.

"To Paint Portraits: Edmund Morris Will Visit Brandon Fair to See Sioux Brandon." *Morning Leader* (Regina), 15 July 1910.

"Toronto artist found drowned. Body of Edmund Morris" *The Mail and Empire* (Toronto), 26 August 1913.

"Toronto (Can.)." *American Art News* (New York), 24 April 1909.

[Untitled review of Morris exhibition.] *Saturday Night* 16 (7 March 1903): 2.

"Valuable Indian Portraits." *Crag and Crayon* (Banff, Alberta) 10 (7 August 1909): 2.

Note: for a chronological list of "Reviews of the period", see Simmins and Parke-Taylor, *Edmund Morris: "Kyaiyii" 1871-1913* (Regina: Norman Mackenzie Art Gallery, 1984), pp. 105-107.

Memberships in Societies
Ontario Society of Artists: 1905-1907

Canadian Art Club: 1907-1913

Royal Canadian Academy (Associate Member): 1897-1912

Toronto Art Students' League: dates uncertain, but Society in existence 1888-1904

Exhibitions
Morris contributed work to the following annual art-society exhibitions:

Arts and Crafts Society of Canada Exhibition, Toronto: 1909

Canadian Society of Applied Art, Toronto: 1904, 1905, 1909

Royal Canadian Academy Annual Exhibitions: 1897-1909

Ontario Society of Artists Annual Exhibitions: 1897, 1906-1907

Canadian Art Club Annual Exhibitions: 1908-1914

Art Association of Montreal Annual Spring Exhibitions: 1901, 1902, 1903, 1906

He also participated in the following international exhibitions:

Berlin International, Berlin, Germany: 1896

Pan American Exposition, Buffalo, New York: 1901

International Exhibition, Glasgow, Scotland: 1901

Louisiana Purchase Exposition, St. Louis, Missouri: 1904

Kilmarnock Exhibition, Kilmarnock, Scotland: 1904

Museum of the Plains Indians, Browning, Manitoba: 1962

Morris was represented in the following institutional exhibitions in Canada:

Art Gallery of Toronto: 1922, 1935

Canadian National Exhibition, Toronto: 1906, 1910, 1913, 1939, 1952

Dominion of Canada Industrial Exhibition, Toronto: 1903

Manitoba Exhibition, Winnipeg: 1904

One-man exhibitions of Morris's work were held at the following private galleries:

Matthews Art Gallery, Toronto: March 1896; October 1896; November 1900; 1904

Messrs. W. Scott & Son, Montreal: 1904

Scott and Son's Gallery, Toronto: 1907

J. Wilson & Co., Ottawa: 1905

A comprehensive chronological list of individual works exhibited by Morris is provided as Appendix "A" in Simmins' and Parke-Taylor's Edmund Morris: "Kyaiyii" 1871-1913 (Regina: Norman Mackenzie Art Gallery, 1984), pp. 109-117. In two instances, the only sources for the contents of these exhibitions are entries in Morris's diaries or contemporary newspaper reports. Since the appearance of the above-cited catalogue, copies of handlists of Morris's two early one-man shows have turned up in the Alexander Morris Papers, Archives of Ontario, and in the Edmund Morris Letterbooks, Vol. 2 (E.P. Taylor Reference Library, Art Gallery of Ontario), respectively. The works included in these exhibitions are as follows:

Catalogue of Oil Paintings and Water Colours
by Edmund Morris, Matthews Art Gallery, Toronto, 16 – 17 October,
1896:

Grandmother and Child (Dutch)
Moonlight in the Downs (Holland)
Early Spring (France)
Nedpath Castle (Peebleshire)
Nedpath Castle (Peebleshire)
Rouen
Study of Girl with Irises (n.f.s.)
St. Andrews (Fifeshire)
St. Andrews (Fifeshire)
Market Place (Rouen)
Muskoka
Grenadier Pond (Toronto)
Plains of Barbizon (France)
Study of Child Knitting
Sunset in Holland
Troquair (Peebleshire)
Port du Carrousel (Paris)
Dutch Character Study
Dutch Canal
Portrait au Curé
Study of Dutch Interior (exhibited at the International Exhibition, Berlin,
1896)
Study for a Head in Dutch Interior
Street in York
Near the Downs (Holland)
Portrait of an Italian Girl
Moonlight near St. Andrews (Fifeshire)
The Downs (Holland)
The Downs (Holland)
Place du Carrousel, Paris (n.f.s.)
Study of Girl Knitting
Toronto Island
The Thames near Richmond
The Downs (Holland)
Landscape
Forest of Fontainbleau
"Neeltje"

Matthews Art Gallery,
Toronto, November 17-30, 1900

Oils
Evening Côte de Beaupré
Rapids (lent by E.B. Osler)
Autumn (Leo Moranz)
Between Showers
September
In the Laurentians
Quebec from the St. Charles River
Landscape
October

A Landscape (lent by Wilkie)
A Harvest Field
An Orchard
In North Holland
A Brigand
Landscape
Batteaux (lent by W.D. Matthews)
By a Stream
Two Sketches
Sunset
Sketch

Water Colours
The St. Lawrence (E.B. Osler)
Landscape
Night Effect
Interior (lent by E.F.B. Johnstone)
The Seine, Paris
Evening, Holland
Place du Carrousel, Paris (n.f.s.)
Study of Girl Knitting
Toronto Island
The Thames near Richmond
The Downs, Holland
Landscape
Forest of Fontainbleau
"Neeltje"

Index

205

206